A
BRIEF HISTORY
OF THE
ARTIST FROM GOD
TO PICASSO

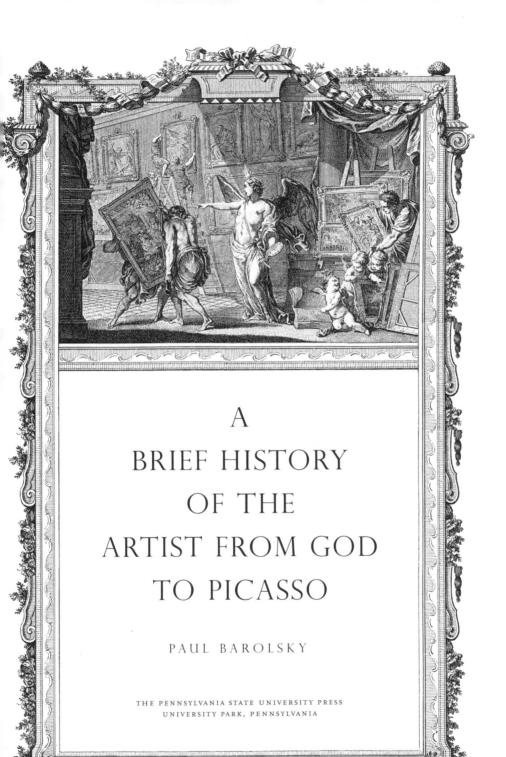

A
BRIEF HISTORY
OF THE
ARTIST FROM GOD
TO PICASSO

PAUL BAROLSKY

THE PENNSYLVANIA STATE UNIVERSITY PRESS
UNIVERSITY PARK, PENNSYLVANIA

ALSO BY PAUL BAROLSKY

Michelangelo and the Finger of God

The Faun in the Garden:
Michelangelo and the Poetic Origins of Italian Renaissance Art

Giotto's Father and the Family of Vasari's Lives

Why Mona Lisa Smiles and Other Tales by Vasari

Michelangelo's Nose: A Myth and Its Maker

Walter Pater's Renaissance

Daniele da Volterra: A Catalogue Raisonné

Infinite Jest: Wit and Humor in Italian Renaissance Art

Library of Congress Cataloging-in-Publication Data

Barolsky, Paul, 1941–
A brief history of the artist from God to Picasso / Paul Barolsky.
p. cm.
Includes bibliographical references and index.
Summary: "Explores art history and imaginative literature to show how
fiction and history inform each other. Traces the modern idea of the artist
to the epic tradition from Homer and Ovid to Dante, leading to
Michelangelo. Examines how Vasari shaped Balzac's idea of the artist,
and Balzac influenced Picasso's"—Provided by publisher.
ISBN 978-0-271-03675-5 (cloth : alk. paper)
1. Artists—History.
2. Art—Historiography.
3. Literature and history.
I. Title.

N8351.B37 2010
709—dc22
2009038199

Copyright © 2010 The Pennsylvania State University
All rights reserved
Printed in the United States of America
Published by The Pennsylvania State University Press,
University Park, PA 16802-1003

It is the policy of The Pennsylvania State University Press to use acid-free
paper. Publications on uncoated stock satisfy the minimum requirements of
American National Standard for Information Sciences—Permanence of
ibrary Material, ANSI Z39.48-1992.

atural, which contains 50% post-consumer waste.

For EMMA *and* HANNAH

A good laugh is a mighty good thing, and rather too
scarce a good thing; the more's the pity.

—HERMAN MELVILLE, *Moby-Dick*

CONTENTS

PREFACE

In the large sweep of time, the emergence of the artist is a very recent phenomenon. Although human beings have been making works of art—by which I mean primarily painting, sculpture, and architecture—for approximately thirty thousand years, it was less than three thousand years ago that they began to be identified as individuals who matter to us. Even in ancient Rome and in the Middle Ages artists were usually not identified or known to a wide public. The modern cult of the artist first began to flower in Dante and Vasari and came into full blossom in the period of Romanticism.

We live in an era when there are more artists at work than ever before in all of human history. Very few of them, only a very small percentage, achieve recognition, fame, or glory remotely like the kind known to Michelangelo or Picasso. One might almost say that the large majority of these artists, like the anonymous artists of prehistory, labor in obscurity. They are largely unknown, their stories unnoticed. The story of the artist in the West is the history of how a relatively small number of artists in a very brief span of time came to be recognized, appreciated, indeed celebrated.

In this brief history of the artist, I attempt to demonstrate the powerful influence of fiction in the history of art and the history of the artist. My approach goes against the grain of art history as an academic discipline, which, emerging in the nineteenth century, sought to follow a scientific model and detach itself from imaginative writing about art and artists. Although that way of thinking may now seem somewhat ingenuous, art historians nevertheless still resist thinking about the origins of their craft in poetry.

It is my contention, however, that imaginative literature, poetry and fiction alike, contributed greatly, often in unsuspected ways, to the history of art in which the artist plays a vital role. After all, imagination is itself an historical fact that needs to be taken seriously. We need to look back in the Hellenic tradition beyond Pliny's *Natural History*, the usual starting point in the history of the artist, to the very dawn of literature, to Homer, in order to understand the origins of art history and the literary origins of the idea of the artist. By "art history" I mean not the kind of overarching story of artistic development or progress which, inspired

by Hegel, often leads to an abstraction far removed from the poetic particularity and wit of good stories about artists that, in Horatian terms, both instruct and delight. I think of history as a form of literary art, art history as artful storytelling about art, which aspires, however imperfectly, to ascertain the historical truth.

The pivotal figure in my essay is Vasari, whose epoch-making *Lives* of the artists has deep roots in poetry, fiction, and myth—in short, imaginative literature. Although in recent years commentators have written increasingly about Vasari's fiction, such fiction (invariably in the service of historical truth) still makes many art historians uncomfortable, and they prefer to dwell instead on the abundant facts or errors of his text.

Vasari's origins lie in part in the biblical or Hebraic tradition, according to which God the Creator is the supreme originary artificer. Reading both Vasari and Boccaccio, in whose tradition Vasari wrote, we can map out the entire history of God's life as an artist from the beginning of the world till the end of time. Seeing the future history of art, Vasari, we might say, writes as a prophet.

In Vasari's worldview, Michelangelo is the godlike messiah who restores art to its divine perfection. In this respect, he is the summit of art history. At the same time, however, his artistic persona, which is modeled on that of Dante, leads us back in time via Ovid to the origins of the history of the artist in Homer. Contemplating Homer, one finds that Hephaistos is the original artist in the Hellenic history of art. The comic persona and deformity of this divinity have a long afterlife in the Western tradition of art history, which is frequently mock-heroic. Indeed, whereas ever so much academic art history, aspiring to gravitas, can be somber in the extreme, poets or storytellers who sing or write about artists in the past, from Homer to Vasari, from Vasari to Balzac and beyond, tell stories that are comic, satirical, ironic, parodic, even farcical.

To understand Vasari's celebration of the artist as hero, we need to explore further the history of the idea of the epic poet as it develops over time. As we will see, Homer, Virgil, Ovid, and Dante are crucial in their poetic self-consciousness to the modern idea of the artist that we encounter later in both Vasari and Michelangelo. In short, the idea of the artist is rooted in the idea of the epic poet.

In the literature after Vasari the novelist, Balzac is the major storyteller in shaping the powerful persona of the modern artist. "The Unknown Masterpiece," the tragic story of the painter Frenhofer and his

heroic failure, provides us with the major myth of the modern artist. Although its various ramifications have been much discussed, the extent of its influence is still imperfectly understood. I will elaborate upon the seemingly infinite variations on Balzac's great narrative and upon its consequences for both fiction and art history alike.

When Rodin, for example, worked on his great monument to Balzac, struggling with the form of the figure in ever so many possibilities over a period of many years, he became a type of Balzac's Frenhofer. To put the point more forcefully, if speculatively, it is hard to escape the hypothesis that as Rodin wrestled with the form of Balzac's body, he identified with Balzac's hero and saw his own difficulties in achieving a masterpiece in relation to Frenhofer's heroic aspirations.

As I will stress throughout these pages, fiction and history illuminate each other. Homer's fictional Hephaistos, for example, is a reflection of the real artists of ancient Greece. Inversely, the real Picasso, who expressly identified with Balzac's Frenhofer, was a reflection of the fictional character with whom he identified. At the same time the imaginary Frenhofer, who captures in many ways the nineteenth-century artist, has his origins in Vasari's obsessive Paolo Uccello and Leonardo, painters who are both real and fictional at the same time. In his relentless pursuit of perspective, Uccello is a quattrocento Frenhofer; in his failed quest to achieve a perfection beyond perfection, to borrow Vasari's language, Leonardo is a kind of Renaissance Frenhofer.

Isolating the threads of history from those of fiction, we can all too easily unweave the larger fabric out of which the image of the artist is woven—woven with facts and fiction both, out of history and historical fiction alike. Even modern academic art history, despite its efforts to overcome the "errors" or distortions of fiction, can be deeply fictional.

We find the interweaving of history and fiction, for example, in the life of Raphael. Vasari tells us that the artist was amorous, painted a portrait of his lover, and refused to work in Agostino Chigi's villa unless he was able to have his unidentified lover with him. It was only long after the painter's death that this lover came to be identified as the baker's fabled daughter, the Fornarina. Although this woman is not inconceivably linked in some unascertained way to the reality of Raphael's love life, whatever the exact facts, which escape us, the Fornarina is essentially a fictional or mythic figure—but one who is nonetheless true to the voluptuousness of Raphael's art.

History was transformed into historical fiction when Raphael's picture of a seated seminude woman covering her breast in a gesture evocative of ancient statues of Venus came to be identified as the Fornarina—an identification based not on fact but on a myth. This fiction has been magnified by those scholars who identify the figure of Mary Magdalene in Raphael's Santa Cecilia altarpiece as a portrait of the Fornarina. No matter that this figure does not even resemble the woman in the portrait said to be the Fornarina. Scholars suspend disbelieve as they accede to this identification, which is rooted in the legend of Mary Magdalene's sexuality and in the alluring gaze of the figure. When Ingres later painted a small group of pictures of Raphael with the Fornarina, his lover assumed a kind of seeming reality. The painter's imaginary beloved now appeared before the beholder's very eyes. She was the subject not of history painting per se, but of pictorial fiction.

When scholars suspend disbelief as they seek out art that reflects Raphael's life story, they build on the fiction of the Fornarina and expand on it. The seed of this fiction is Vasari's several allusions to the painter's lover. These allusions do not permit us to conclude that she was in fact a baker's daughter or that some of the images said to portray her are those of his lover. What I am trying to suggest here is that even those scholars who seek to write history as opposed to fiction can nevertheless write their own (unwitting) fiction in their imaginative reconstructions of Rapahel's amorous pursuits, the evidence of which seemingly appears to our eyes in an altarpiece or in nineteenth-century pictures of Raphael and his beloved. Art historians sometimes do the same things that authors of historical fiction do, despite differences of intention.

If history is sometimes fictional, fiction is often deeply historical. In the life of Brunelleschi, for example, Vasari writes about the artist's work on the dome of Florence, and, as he does so, he refers to the moment when the architect played a trick on a fat carpenter. He alludes to the event as if it really happened, whereas the tale of the fat carpenter, written by Antonio Manetti in the fifteenth century, is a *novella*, a fiction, like the fiction or tales of Boccaccio, in whose tradition Vasari wrote.

It is not my purpose to retell here in full this wonderful story, which is readily available in various translations to which the reader can turn with pleasure; nor will I present a full exegesis of the kind that the story

deserves. I wish only to touch on an aspect of deep historical truth to which the fiction alludes.

According to Manetti, Brunelleschi and his fellow artists are offended when the fat carpenter fails to come to a social gathering, and so they decide to play a trick on him as punishment. Brunelleschi goes to the house of the carpenter and manages to get inside. When the carpenter returns, he finds the door locked. Brunelleschi cries out, "Who's there?" The carpenter, whose name is Manetto, identifies himself, but Brunelleschi addresses him as Matteo and tells him to go away. When finally the incredulous and confused Manetto departs, he runs into Donatello, who, in on the joke, greets Manetto by also addressing him as Matteo.

As the story unfolds, Manetto wonders increasingly who he is. It appears that he has been transformed into somebody other than himself, and the transformation recalls the metamorphoses of humans into animals; for example, Acteon, who becomes a stag in Ovid's *Metamorphoses*. Eventually the simple carpenter Manetto is convinced that he is not himself but is indeed Matteo. (Not only are the names of Manetto and Matteo similar, composed mostly of the same letters, but it should not escape our attention that the author, Manetti, and his antihero, Manetto, share essentially the same name, a fact of interest in a story that is all about identity.) As an early example of identity theft, the joke is both funny and cruel in its various details. It reflects the literary tradition of Boccaccio—for example, the tale in the *Decameron* in which an abbot convinces Ferondo that he has died and gone to purgatory. With delicious irony the fat carpenter himself refers to Boccaccio when he wonders if he is not another Calandrino—a real-life painter presented in a fictional manner in the *Decameron*. If Calandrino is famous as a simpleton, then the carpenter, in his consciousness of his similarity to the simple painter, is, paradoxically, not altogether ingenuous. (We will later encounter a similar ambiguity in the apparent naïveté and self-consciousness of Douanier Rousseau.)

Brunelleschi, the perpetrator of the trick or illusion, was, as Vasari reports, the inventor of modern perspective, a system of pictorial illusion that establishes a fixed viewpoint of the beholder; in other words, the viewer's sense of place in relation to the fiction he beholds. If perspective implicitly defines the viewer's sense of self in relation to the illusion he beholds, it also paradoxically absorbs the viewer so deeply that, suspend-

ing disbelief, he loses himself in its fiction—much as the fat carpenter loses himself, his very identity, in Brunelleschi's illusionistic trick, which is a play on perspective or viewpoint. We might well say that one loses oneself in a pictorial perspective or illusion in the same way that one loses oneself in a good book.

Manetti's fable or fiction, a parable of perspective, seemingly becomes a fact in Vasari's biography of Brunelleschi, where it is alluded to as an event that really happened. It is more accurate to say, however, that the fable is true to the type of story told by Boccaccio and his followers about simpletons—many, like Calandrino, themselves artists— who are duped. A parable of perspective, Manetti's tale is profoundly true to the character of Brunelleschi's perspectival art, to the artist's illusionistic trick to which one yields oneself as one loses oneself in its fiction. As history becomes fiction in the life of Raphael, fiction becomes history in the biography of Brunelleschi, a fictional story true to what the artist in fact did when he made his perspectival illusions.

Quoting Brunelleschi's epitaph in his biography of the artist, Vasari alludes to Filippo's "Daedalic art." Likened to the great ancient builder of the labyrinth, Daedalus, Brunelleschi is a reminder that the models of artists are often found in ancient history or myth. We have already alluded to Hephaistos as an exemplar whose image remains alive in the modern period either explicitly or implicitly, and we can even describe the idea of God the Creator as originary artificer as a form of Judeo-Christian mythology.

Later, in the period of Romanticism, which contributed so much to what we call Modernism, the mythic models of classical antiquity remain alive as in Balzac's historical fiction of Frenhofer, where Orpheus, Pygmalion, Prometheus, and Proteus are all invoked. But the history of art and fiction about artists is also informed by, or at least brings to mind, myths of the modern world, those of Don Quixote, Don Juan, and Faust. In his obsession with perspective, for example, the simple Calandrino-like painter Paolo Uccello is quixotic; in his obsessive quest for scientific knowledge Leonardo is Faustian; and in his obsessive pursuit of women so important to both his art and his biography Picasso is a type of Don Juan. All three of these mythic beings, Don Juan, Faust, and Quixote, who took form in the early modern period within a century of Vasari, are the epitome of obsession—whether the obsessions of sexual

desire, the obsessive desire for knowledge, or the obsession with chivalric romance or pastoral poetry; in other words, art.

The history of the modern artist is, in short, the story of artistic obsession, the unending pursuit of what is unattainable, and the various stories of obsessive artists all undermine the idea of art history as progress toward an idea or goal, since that goal is ultimately beyond reach. What we call obsession is not unrelated to the older notion of possession, of being possessed by a demon, the devil or Satan. This sense of possession persists in the story of the modern Faustian artist, who is diabolical. Satan's defiance of God evokes Promethus, a type of originary artist who stole from the gods and thus similarly challenged their authority. Here we have the unity of the Hebraic and Hellenic traditions, which come together in Balzac's Frenhofer, who is both Promethean and diabolical. Yes, he is a fictional character, but he is also very real to both Cézanne and Picasso. In other words, fiction is part of the reality of these real-life nonfictional painters. Fiction is essential to the reality of their imagination.

If this essay begins with God's life as an artist, it ends with Picasso, not because the latter is the last artist whose identity is saturated with mythic implications (and here we can't forget Duchamp, Jackson Pollock, or Joseph Beuys). Picasso is a fitting subject with whom to conclude our narrative because his persona is so bound up with the important ideas of the artist that we find in the Bible, Ovid, Vasari, and Balzac.

I have surely not written "the" history of the artist. There is no such thing. For there are many stories of the artist, and mine is only one among many. The major claim of my essay, as I have said, is that the history of the artist is inseparable from historical fiction about the artist. I hope my essay, my attempt to sketch out a possible history of the artist, will stimulate the reader to see other possibilities, to imagine histories of the artist previously unimagined.

Although what follows moves in approximate chronological order from antiquity to the modern period, I conceive of my text, in the root sense of the word, as something woven out of particular threads, above all, Homer, Ovid, Dante, Vasari, and Balzac, who, like Giotto, Uccello, Leonardo, Michelangelo, and Picasso, and their fictional counterparts, above all Balzac's Frenhofer, appear, disappear, and reappear throughout

this book. Each time that they reappear I do not merely repeat the same stories about them or by them. Rather, I try to fill in details from these stories or show these tales in a different light, as I pursue their relations to the larger fabric out of which they are woven—a text, which, I hope, provides clues to future narratives.

ACKNOWLEDGMENTS

Despite the brevity of this work, it is a synthesis of a lifetime of thinking about the idea of the artist. My debts are huge. Countless friends, acquaintances, students, and colleagues have offered advice, suggestions, ideas that I have assimilated here. A list of all of these individuals who have been so helpful would approximate the length of a telephone book. I do, however, want to acknowledge specifically Laurie Schneider Adams, the late Staige Blackford, Roy Tommy Eriksen, Herbert Golder, Józef Grabski, John Dixon Hunt, and especially Nicholas Poburko, who published earlier versions of portions of this book, despite the unorthodoxy of both the form and the content of my essays. An invitation from Joseph Connors to be a visiting professor at the Villa I Tatti in the spring of 2008 was providential, since it allowed me to map out this book. David Kovacs, John F. Miller, and, above all, Jenny Strauss Clay made critical observations on my Homer chapter at a crucial juncture; their help enabled me to see just how my book might compose itself. I have also profited from the help and support of Matthew Affron, Daniel Barolsky, Deborah Barolsky, Anne Barriault, Sarah Betzer, David Cast, Charles Deily, Jessica Feldman, Francesca Fiorani, Alastair Fowler, Virginia Germino, Sanda Iliescu, Walter Kaiser, Judith Kovacs, Fred Licht, Ralph Lieberman, Lene Østermark-Johansen, Louise Putnam, Ricardo Quinones, Dylan Rogers, Susannah Rutherglen, Howard Singerman, Tyler Jo Smith, David Summers, William Wallace, and Daniel Weiss. My debt to my family is beyond measure. My greatest debt is to Ruth; without her this book could never have been written.

In this book, as in my related books on Vasari, I have not used footnotes but have appended a bibliographical essay at the conclusion, which situates my work in relation to previous scholarship. I also include a selected bibliography, which serves as a reader's guide to some of the literature that has mattered most to me in developing the historical suggestions that follow. I am much more concerned with presenting certain patterns in the history of the idea of the artist than with trying to clinch arguments with specific quotations.

ONE

THE ART OF GOD FROM THE BEGINNING OF
THE WORLD TILL THE END OF TIME

As scholars, we usually strive to achieve complexity and profundity in our analyses, both of which require theoretical sophistication. I will aspire here to superficiality—as in the simple consideration of what one sees on the surface of a painted roof or enjoys in a tall tale. I contend that interpretation, which is usually overinterpretation, should be suggestive. "You cannot begin not to tell," the great theorist Peter Whiffle once observed, "until you know more than you are willing to impart." Most of us, however, seek to tell more than we really know. Against the grain of verbosity and reductiveness, I will be very brief. Necessarily so, since the story to which I allude, the history of God's life in art from the beginning of time till the end of the world, is rich in incident, and a full account would exceed the limits prescribed here. Besides, as Voltaire once said, "The best way to bore people is to tell everything." Perish the thought!

We can all envision in our mind's eye Michelangelo's so-called *Creation of Adam,* the powerful figure of God the Creator surging toward Adam, arm extended toward the newly formed man, as Adam, his own arm similarly extended toward God, reclines expectantly upon the earth from which he was fashioned. We take for granted or are unaware,

however, of the fact that when Michelangelo pictured this momentous event he poetically and radically revised the traditional Tuscan way of showing God standing upon the earth from which he created Adam—as he is shown in works by Ghiberti, Uccello, and Iacopo della Quercia, all well known to Michelangelo. By showing God instead in flight, his drapery billowing in the wind, his beard wind-swept, Michelangelo represents God, *Creator Spiritus,* as the personification of spirit, for *spiritus* is the breath of air, a breeze swelling to an almighty wind.

Michelangelo also evokes the spirit of God by emphasizing the finger of his extended hand. This finger, it has been shown, is the *digitus paternae dexterae,* which, according to a deep tradition that has been traced back to the Gospels, also stands for *spiritus.* At the instant when the finger of God, *Creator Spiritus,* touches Adam, the first man will be filled with the breath of life. Michelangelo emphasizes the dualism of body and spirit in accord with the account of the creation of Adam in Genesis. God first formed Adam out of the earth; then he breathed the spirit of life into him. That ineffable breath of life is evoked mysteriously by the touch of the divine digit, which is, as Saint Augustine said, the Holy Spirit.

We should see that by focusing in a singular way, in visual form, on the dualism of spirit and body, Michelangelo is able to clarify his allegorical meaning. Michelangelo's fresco, as is often noted, is an allegory in which the first Adam foreshadows the new Adam, Jesus. We need to see more clearly, however, how the form of Michelangelo's image renders his meaning, how Michelangelo poetically gives form to allegory. Saint Paul speaks of the first Adam as *corpus animale,* the second Adam as *corpus spiritale.* Michelangelo quickens one's sense of how, when the first Adam is touched by the digit or spirit, he will become *corpus spiritale.* By illustrating *Creator Spiritus* not standing upon the earth but soaring spiritually toward Adam, Michelangelo magnifies the heavenly origins of the second Adam, who descends from heaven, *secundus homo de caelo caelestis.*

According to a rich tradition, when God made Adam, he was the first artist, the first sculptor and painter. It follows from this proposition that, depicting God fashioning Adam, Michelangelo is an art historian, as the *storia* of Michelangelo's monumental painting is the story of God making the first sculpture. How queer, how very bizarre, therefore, that Michelangelo should appear nowhere in the by now vast modern historiography of art history, especially since his story of the first sculpture is

one of the very best-known historical accounts of the origins of art in the entire historiography of art.

We know from other evidence external to his fresco that Michelangelo thought of God the Creator as *deus artifex*. In the fragment of a poem about Creation written at the moment he pictured the creation of Adam, Michelangelo speaks of God's *divin'arte*, his "divine art." Depicting the creation of Adam, Michelangelo purposefully tells the story *in medias res,* "in the middle of things." A crucial point! For as he pictures his story, Michelangelo shows God, having molded the body of Adam from the earth, about to impart to his sculpture the breath of life which is promised by the immanent touch of the divine finger as spirit. We should therefore see that although he depicts Adam as awake and conscious, Michelangelo shows him as not yet alive in the spirit. Adam at the very instant, the split second, we behold still lacks the breath or the spirit of life, and in Michelangelo's allegorical double entendre the very spirit which will make him, *homo spiritale,* the second Adam.

We speak of Michelangelo's fresco as the *Creation of Adam,* but this misleading title or label lacks specificity and deforms Michelangelo's intention or meaning. For we should more accurately, more carefully, call the fresco *God Creating Adam* in order to convey that having fashioned Adam's body, God, *deus artifex,* has not yet completed him with the breath of life or spirit. God's sculpture, as we see it in Michelangelo's image, is, strictly speaking, incomplete or *non finito*. We are left to imagine in our mind's eye the moment when, in an instant, Adam was completed: *Deus fecit*. Michelangelo freezes before us, to use the imperfect form of the verb, the image of *Deus faciebat,* for his statue of Adam, as we see him, is unfinished. And this is no accident. For only a brief time before he painted God creating Adam, Michelangelo was one of the first artists of the Italian Renaissance to use the imperfect form of the verb *facere* in the signature of his Rome *Pietà*. When we consider that Michelangelo's *faciebat* on the Rome *Pietà* precedes the implicit or wordless *faciebat* in the scene of God creating Adam, we may conclude that, in a sense, Michelangelo has portrayed God in his own image and likeness.

As Renaissance authors wrote paradoxically of, for example, *discors concordia* or *discordante concordia,* so Michelangelo plays paradoxically on the relations of imperfection to perfection, *perfezione imperfetta,* one might say. In this way, it was said in Michelangelo's day by Vasari in his *Lives* of the artists that God, who created an exemplary art in his Adam,

nevertheless wished to show, in the imperfection of the lump of clay out of which he fashioned Adam so perfectly, the possibility to all artists of transforming their own imperfect sketches into the perfection of their finished works. Vasari similarly observed that, looking at Michelangelo's unfinished sculptures, one saw, could indeed imagine, in the imperfection of his sketched figures the intended perfection of the completed work. In just this fashion, Michelangelo suggests the perfection of Adam, who, at the moment we see him, is still imperfect. For, physically beautiful but not yet touched by the spirit, Adam is both imperfect and incipiently perfect. In the play between imperfection and perfection, each concept necessarily illuminates and illustrates the other.

In Vasari's history of art, which begins with God's creation of Adam, *bella maniera* is the manifestation of perfection. Michelangelo, in his fresco of God creating Adam, renders the Creator fashioning Adam with his right hand, *la mano destra,* with the *destrezza* or dexterity essential to the *perfezione* of *bella maniera.* We know full well that *maniera* has its roots in the word *mano* or *manus,* but we do not dwell sufficiently on the fact that the hand of God, the original hand of artifice, is the model against which all *maniera* is measured. In the history of art after the fall, *maniera* journeyed imperfectly from darkness and error through the hands of artists—*di mano in mano*—to illumination and truth, to perfection, indeed the *assoluta,* as Vasari calls it, epitomized by the "divine hands" of Michelangelo. The perfect manner was, in effect, a conversion, a return to the unsurpassed perfection of the divine hand. In the modern literature on *maniera* and its offshoot, Mannerism, the foundational theology of the word, transmuted into aesthetics, has vanished, even though for Michelangelo, like Vasari an art historian, *maniera* derives its deepest meaning from the *mano di Dio.*

Michelangelo's fresco of God fashioning Adam with his right hand foretells, as we have seen, the fashioning of the new Adam. It is also a prophecy of God's final act of artifice, when, again with his right hand, God fashions the perfected bodies of the righteous at the end of the world: the manifestation, we might say, of God's *ultima maniera.* In a poetically profound condensation, Michelangelo's fresco contains within itself, ostensibly and allegorically, the entire history of God's life as an artist—from creation to the ultimate creation at the end of the world. This final act of creation or recreation in the fashioning of the perfected bodies of the blessed was indeed construed as a work of artifice by Vasari,

who made a stunning *paragone* or comparison when he likened Michelangelo's art to God's final work. Speaking of Michelangelo in a different context, Vasari associated the body of his *Moses* with the perfected body of the resurrection. As God originally made art with his dextrous hand, so Michelangelo made art based on God's, an art that in turn prophetically foretells the final work of God's hand, the perfect, resurrected body at the end of time. Michelangelo's artistic prophecy of God's final artifice is not surprising, since it is rooted in the true example of God's original *mano* or *maniera*.

If the perfection of Michelangelo's art prompted Vasari to contemplate God's perfection in the beginning and at the end of the world, we should finally pause to contemplate the full implications of the imperfect lump of clay out of which God perfectly fashioned Adam in the first place: the origins in imperfection of God's perfection, the very origins of God's life in art. Long before Michelangelo and Vasari contemplated the relations of imperfection to perfection, of perfection to imperfection, Boccaccio did just that in the *Decameron* in a story which, although well known to scholars of literature, has surprisingly been ignored by art historians. A major contribution to the history of art, to the story of God's life in art, Boccaccio's tale is a heterodox alternative to the idea of Adam as God's first sculpture or painting. For Boccaccio presents evidence of God's activity as an artist before he fashioned Adam, at a time when he was, to speak in a peculiarly modern way, a "failure" in art. We might say, in the very spirit of Boccaccio's theological joke, which I am about to retell, that the story explores God's art before he made it big with the success of his tour de force, the splendid sculpture of Adam. Boccaccio's joking account of God's previous lack of success in art, his contribution to the biography of God, to our theme here of God's life as an artist, appears as the sixth *novella* on the sixth day of the *Decameron*—a sly and pointed allusion to God's fashioning of Adam on the sixth day of Creation.

Boccaccio writes of God creating the men of the Baronci family, who were older than any other man, *più antichi che niun altro uomo*—by which he means Adam. He tells us that God fashioned the Baronci when he was still learning to draw. Whereas other men had faces "well composed" and "properly proportioned," the Baronci had faces long and narrow or wide beyond measure; some had long noses, others had short noses, some had chins that stuck out and jaws like those of an ass, some

had one eye bigger than the other, and some Baronci had one eye lower than the other, "as they appear on the faces made by children when they first learn to draw"—*i visi che fanno da prima i fanciulli che apparano a disegnare*. Here we have, in a nutshell, the historical scheme of Vasari's *Lives*. By invoking God's childhood in art, Boccaccio implies a biological development that foreshadows Vasari's more famous historical notion of art developing from its infancy through *fanciullezza* or childhood to maturity. In Boccaccio, God implicitly personifies the entire history of art, recapitulated by mankind in his image and likeness.

In Boccaccio's *novella,* God fashioned the Baronci before he was God, that is, God as we know him, before he came to be the accomplished sculptor and painter best known for his subsequent *capolavoro,* Adam, the true model or *vero esemplare* of all art. Unlike many artists who came after him, for example, Giotto and Bernini, God was no child prodigy! God's early works, his first essays in art, were, according to Boccaccio, lacking in proportion, measure, beauty, and grace. They were made before his right hand was truly dexterous or adroit, before his *recta manus* was capable of achieving the rectitude of correct drawing, before he got things right. Like many works of art throughout history made by lesser artists, God's first works were marked by what was then called *goffezza* or *gofferia,* in a word, clumsiness. Maladroit, they were *goffi,* that is goofy. In short, in his earliest work as an artist, God goofed.

Clues to God's early manner are available to us by analogy in the record of other works similarly defective. Vasari describes, for example, a portrait by Giuliano Bugiardini of his good friend Michelangelo in which one eye appeared above the other, indeed in his temple; here we are reminded of Boccaccio's description of God's juvenilia in art, of the Baronci with one eye below the level of the other. Michelangelo was said to have been amused by Bugiardini's portrait. I hate to think of what Michelangelo might have thought of God's early works.

Boccaccio's playful story has many virtues. It makes a major contribution to art history and the biography of God by drawing our attention to God's neglected early works, which must now be included, along with the universally admired sculpture of Adam, in the divine catalogue raisonné of God's art. As a good story, indeed a good art-historical story, it is a refreshing antidote to the kinds of often lifeless and somber stories we modern scholars write, which are usually devoid of the playfulness or *serio ludere* typical of Boccaccio. In the spirit of the theology that later

informs Michelangelo's *Creation of Adam* and Vasari's *Lives,* however, Boccaccio's jest makes a serious point. We have observed that the idea of perfection can only be defined in opposition to its antithesis, imperfection. Boccaccio's graphic description of God's monstrous renderings from the childhood of his art, deformed, deficient, indeed grotesque, dialectically serves to magnify one's admiration of God's subsequent success in art. Long before the advent of the secular modern art history textbook, Boccaccio believed that God was the single greatest artist in all of history, from the beginning of the world till the end of time.

TWO

HOMER, HEPHAISTOS, AND THE POETIC
ORIGINS OF ART HISTORY

1. From Vasari to Homer

Throughout the history of literature in the West—from Homer to the present—authors have sung or written extensively about what are called the visual arts. Such arts can be defined in various ways. It can mean the arts of design, the interrelated spatial arts of which Vasari wrote in his monumental sixteenth-century *Lives* of the painters, sculptors, and architects—those individuals who gave shape to space, made objects that filled such space or created the illusion of space. Art can also be defined even more broadly as the class of artifacts or things made with skill, knowledge, or imagination. Clothing, jewelry, weapons, furniture, and various household objects are examples of such artifice often displayed in museums of art.

Writing about art and artists is found in many genres: epigrams, epitaphs, poems, anecdotes, short stories, novels, biographies, critical essays, memoirs, guidebooks, theoretical treatises, technical manuals, and what came to be called "art history," which is in fact less a genre of literature than a variety of academic conventions or approaches, that

some might call techniques, tools of analysis, or even "methods," such as iconography, connoisseurship, and the social history of art.

Although the distinction has justifiably been made between history as an investigation of the past and historical fiction, history and historical fiction are intimately related, even intertwined. Indeed, they nourish each other. As history aspires to veracity, so a great deal of historical fiction is similarly devoted to the truth, which it renders with verisimilitude. If history is based on facts, so too is fiction. As novelists and readers of fiction are keenly aware, without facts, fiction would be meaningless. Although facts and fiction often seem to be opposed to each other, they are closely related in one respect. Both are rendered fictively, in the root sense of the word, from *fingere,* to mold or give shape. History, more than an assemblage of facts, is a form of narrative art in which the facts are shaped. So too is fiction. Historical fiction, we might say, is history written with poetic license—sometimes in the extreme.

In the broad history of literature about art, Vasari's epoch-making *Lives* is one of the greatest and most influential books ever written. It has contributed much to modern poetry and fiction about art and has also powerfully shaped the scholarly field of art history. Like modern scholars, Vasari collected documents that contain facts about artists and their works; but at the same time, he also employed tall tales or fables either borrowed from other authors or of his own invention. Some stories in Vasari's pages are undeniably and famously fiction, such as the well-known story of how the painter Andrea del Castagno murdered his fellow painter and friend Domenico Veneziano, a deep fiction about envy and rivalry that Vasari embellished by portraying the satanic painter as a type of Judas. We know that this account, which Vasari inherited from an earlier tradition, is a tall tale, since Domenico Veneziano in fact outlived Castagno.

Sometimes, however, we have no way of confirming that a story told by Vasari is true. Did Leonardo, as Vasari says, in fact employ musicians and buffoons to entertain Mona Lisa and thus elicit the smile that the painter rendered so effectively and unforgettably, as some believe, or did Vasari invent the story in a kind of poetic fiction as a way of celebrating the singular smile of Leonardo's portrait? I would suggest that, like the fable of Castagno, Vasari's story of Leonardo's clowns and music makers is a poetic fiction true to the art of its subject. As Castagno's fictional violence is true to the harshness of the painter's pictorial style,

so Leonardo's fable of entertainers who brought a smile to Mona Lisa's lips is true to the expressive effect of Leonardo's portrait. Vasari's fable has verisimilitude, since it explains why Mona Lisa smiles, which in turn explains why some readers believe it to be a true story.

Many would say that it does not matter whether Vasari's story of Leonardo's buffoons and musicians is true, since it is plausible and thus related to the truth of the picture itself. I would suggest, however, that it matters greatly, because if it is a fiction, then it is a poetic invention and is itself art, literary art. In response to Leonardo's painting, Vasari has transformed such art into his own art or poetry, the poetry of his historical fable, which, incidentally, has contributed significantly to the modern historical legend of Mona Lisa, whatever the facts of her life story might be.

One modern scholar, reluctant to abandon the idea that Vasari's story is, strictly speaking, true, has proposed that because Mona Lisa might still have been alive when Vasari wrote, she might have told him herself about the musicians and buffoons in a story that is tenuous at best. If I am correct, however, the scholar has written his own fable, if unwittingly, given his intention to establish what really happened. For he has, in the words of Walter Savage Landor, rendered an "imaginary conversation" between the author of the *Lives* and Leonardo's subject. Although more than one art historian has said that the characterization of Vasari's tales as fiction diminishes his history, it is more accurate to say, on the contrary, that when we deny or ignore the role of fiction in the *Lives,* we diminish our understanding of the poetic richness of Vasari's historical account. For the whole truth depends not only on facts but also on imagination—human creativity that engages with those facts.

Vasari's way of writing historical fiction, or fictional history, if you will, not only leads us to the modern historical novel about art and to art history, but also carries us back through Boccaccio's tales about artists to the anecdotes about art of classical antiquity, above all, to those stories found in Pliny the Elder's *Natural History.* Many of these stories of Apelles and Zeuxis, among others, which have been retold many times and have sometimes been transformed into modern variations, are appropriately called legends. They endure because they celebrate the skill and power of artistic illusion that we find in ancient art. Pliny's anecdotes are poetic fictions true to the art of antiquity. As ancient Greek art was

true to the appearances of things, so Pliny's fables are true to the mimetic power and skill that inform art.

Pliny famously tells us, for example, that Zeuxis painted grapes so convincingly that they attracted birds. Whether of Pliny's own invention or dependent on an earlier lost source, the story is a fable that is compelling because it addresses the powerful mimetic character of Greek art. Pliny also tells us that Apelles fell in love with his model, Campaspe, the concubine of Alexander the Great, who held the painter in such high esteem that he gave his lover to the artist. Here too the story, though probably not a record of what really happened, nonetheless has a kind of verisimilitude, since it is true to the fact that art is an expression of desire. As such, Pliny's fable is related to the myth of Pygmalion in Ovid's *Metamorphoses,* composed not long before Pliny wrote his book. In Ovid's fable the artist creates his own ideal beauty, embodied in his statue, which he comes to desire and possess.

2. The Arts of Homer

The close relations of history and poetic fiction traceable from Vasari back to Pliny can be pursued even further back in time, to the dawn of ancient Greek literature in the epic poetry of Homer, in which history and poetic fiction were intertwined for the first time. Homer, it might be objected, was the author of great poetry, not history as it came to be defined later by Herodotus, Thucydides, and modern scholars. But, as I have suggested, history is often not easily separated from historical fiction. In fact, classicists and scholars of ancient art history, even when they disagree about details, are forever attempting to demonstrate the different ways in which the world of Homer's poems reflects the real world of Greek history. When Homer invokes the massive walls of Tiryns, for example, he obviously refers to the reality of Greek architecture, of which the imposing evidence is still preserved. When he celebrates the artifice of Hephaistos, Homer sings of a mythological figure, but the god of the smithy is the personification, indeed the deification, of the real smiths of ancient Greece who did wonderful work in metal, smiths to whom Homer's deity is, however imaginatively, related. Scholars of ancient art history and of classical literature know full well that when Homer sings of Achilles' shield and other works of art he is responding

poetically to the facts of art history, no matter how much these facts are transformed. For the great shield fabricated by the divine smith is, in Homer's embellishment, an imaginary record of the kind of craftsmanship in metal practiced prodigiously both in Homer's day and in earlier times.

Hephaistos, the mythological artist, may stand apart from Apelles or Leonardo because the latter were real artists. But in Pliny's account of Apelles and in Vasari's presentation of Leonardo real people are transformed into mythological beings, just as in Homer the real smiths of ancient Greece are deified in the person of Hephaistos. As myth reflects historical facts in Homer, and as history is mythological in Pliny and Vasari, myth and history converge and are intertwined. Both history and mythological fiction aspire to a kind of historical truth that is far more than a chronicle of exactly what happened in the past, and is more than the sum of the facts.

Although Homer's songs are poetry, not history as we conceive it, the historical fiction of his poems has implications for the history of art. Many of these implications have been observed previously, above all in discussions of the shield of Achilles, but there is much in Homer's account of art that is still ignored, taken for granted, or noted only in passing. I believe that this is so because his poems are primarily about war and its aftermath, about the great deeds and adventures of warriors; art therefore plays only a secondary role in the larger narrative. Nevertheless, one could fill an imaginary museum with a multitude of Homeric works of art—above all, armor, but also of different kinds of artifacts—and the catalogue of such craftsmanship would be extensive.

Today art historians aspire to break down the boundaries between the so-called fine arts and the supposedly lesser arts. In this respect, they return to the broad overview of all the arts in Homer, who speaks extensively of what were once called the minor or decorative arts. Clothing, armor, jewelry, weapons, furniture, household goods, and funerary urns are examples of such art, all of which the anthropologically minded art historian refers to as the materials of culture. Whereas the modern scholar seeks to restore works of art to their original context, in Homer all objects of art are embedded in a narrative in the first place and thus have a context—for example, the golden urn made by Hephaistos, in which the remains of Achilles and Patroklos are placed, or all the golden cups used in libations to the gods. In Homer's story, art is never ab-

stracted from this narrative. Whereas Homer is a great storyteller, the modern art historian is often not a storyteller at all. In modern art history, the scholar usually replaces storytelling with analysis and theoretical interpretation.

Yet Homer also presents to his readers a lucid and coherent theory of art, and we can speak of his appreciation of the aesthetic qualities of art objects as art criticism. He gives us a rich anthropology of art when he discusses the uses of artifacts in warfare, worship, banquets, and funerals and dwells on the exchange of artifacts or the giving of such artifacts as gifts. Homer speaks of the materials, scale, and colors of works of art; he refers to the ways in which works of art were made. He dwells on works of art as symbols of power, a subject of great moment for art historians today, and he has a keen sense of how the visual or spatial arts relate to other art forms, above all, music. Granted, Homer's allusions to art are sometimes tantalizingly brief and leave us wanting to know much more about such art, but were we to journey to Hades to engage the poet in conversation, he would no doubt present the charge that we moderns overinterpret works of art and pile onto our often overloaded accounts more information than is useful or relevant.

To survey the arts in Homer, by no means exhaustively or systematically, let us begin with a brief account of his theory of art and his interrelated art criticism, both essential to the Greek tradition of art as imitation. Homer famously describes various vivid incidents from life on the shield of Achilles—for example, a scene in which two lions tear apart the belly of a bull and gulp down its blood and guts as dogs nip at the beasts. Such lively slices of life (or death, as the case may be) are found elsewhere, for example, on a smaller scale, where we see on the face of a brooch worn by Odysseus a hunting dog pinning down with its forepaws a spotted fawn that is convulsed in agony as its hooves fly outward. Both of these vivid descriptions imply a theory of art as illusion, an illusion that the poet celebrates in his art criticism when he says the image on the brooch was "wonderful to behold."

Homer brings the brooch into the larger context of dress by saying that such jewelry, made of gold, was set against Odysseus's purple cloak and close-fitting tunic, which was as fine as dry onion skin, both soft and shining. Here Homer dwells on the art of dress, which depends on weaving. And just as the art of clothing is woven throughout Homer's poems, his songs are themselves the interweaving of various narratives

in the larger web of his art. The tutelary deity of such weaving, Athena, weaves Hera's wondrous gown, and Aphrodite wears a beautiful, glimmering, embroidered robe fashioned for her by the Graces. Many are the women weavers of Homer: Helen, Andromache, Calypso, and Circe. Above all, Penelope is a crucial figure in the world of weaving, for she most famously weaves and unweaves a shroud for her father-in-law Laertes. Buying time, like Scheherazade, with her seemingly endless storytelling, Penelope makes us ponder the threads of the Fates. Sometimes, too, finely woven goods are offered to the gods, as when Hector asks his mother to bring a beautifully shimmering robe to the shrine of Athena and place it on the knees of the goddess's effigy. With wonderful effect, Homer tells us that the brocade glittered like starlight. Athena and the various women who weave in Homer stand for the weaving of countless women whose works have either vanished or been forgotten because weaving was considered a minor art. Homer helps us to remember the gorgeously woven fabrics, the fine linens and dazzling embroidery of the many anonymous but highly accomplished women artists of ancient Greece.

Even more conspicuous in Homer's poem than beautiful dresses or tunics, all of which pertain to the domestic sphere, is the art of armor, in other words military dress: breastplates, helmets, shields. If we were to display in our imaginary museum all the arms described by Homer, along with the artfully crafted chariots of gods and mortals, hundreds of objects would fill its many rooms. Over and over Homer depicts the brightness and brilliance, the glint and gleam, the shine and shimmer of such beautifully crafted armor, some of it made by Hephaistos, but most of it fashioned by anonymous smiths to whom the poet refers by way of scattered allusions to their tools, craft, and materials. Homer rises to great heights when occasionally he poetically compares light-reflecting armor to the stars above, especially in the celebration of Diomedes' arms, which we might almost call an example of the Homeric sublime. In praise of the luminosity of Achilles' shield, he similarly likens the radiance that emanates from this great object of art to the light of the full moon. The reflectivity of metalwork depends on the artifice of smiths who bring their work to a high polish. Homer is not only sensitive to the optical properties of carefully crafted arms; he is also attentive to their sonority, above all, the clang of armor against armor, of metal

against metal, the sounds that ring out in battle. In Homer's rendering of sounds and scintillating sights we have the origins of *son et lumière*.

If Achilles' arms are the most famous of all the martial garb that Homer describes, we should not neglect those of Agamemnon, which are also of great interest as objects of military significance and aesthetic quality. The poet describes them in vivid detail as he pictures the warrior dressing in preparation for battle. Upon his legs Agamemnon first fits beautiful greaves with silver ankle straps. Around his chest he next buckles a cuirass, a gift long ago from Lord Kinyres, which has ten bands of dark enamel, twelve of gold, and twenty of tin and includes dark blue enameled serpents, three on each side, arched like rainbows toward Agamemnon's neck. Across his shoulders and chest he then hangs a sword, the hilt of which bears shimmering golden studs; silver bands gleam on his scabbard, which is attached to a gilt baldric. He next takes up his broad shield with ten bronze circles and twenty tin studs around its rim. (Upon the shield there also appears a terrifying fire-eyed Gorgon with figures of Terror and Rout. The shield strap is made of silver, and upon it there appears a three-headed serpent.) Then Agamemnon dons his ridged helmet with white crests of horsehair. Finally, he takes up two spears with heads tipped with bronze that reflect the gleaming sunlight.

Homer presents the iconography of Agamemnon's shield (the Gorgon and other allegorical figures appropriate to war), the materials of his arms (gold, silver, bronze, tin, and horsehair), their colors (gold, silver, blue, white), their luminosity, and the beauty of such craftsmanship. If Agamemnon is described with an epithet as lord of golden Mycenae, the gold of his arms magnifies his identity. Gold, which is both beautiful and an expression of wealth, tells us much about the social station of the great lord. The overall effect of Homer's appreciation of Agamemnon's arms is splendid in the totality of its details. The modern art historian, who often tends to talk around art rather than describe it in all its particularity, can still learn a thing or two from the poet's vivid rhetoric.

Not all art associated with warfare is made principally of metal. One of the most impressive weapons described by Homer, the bow of Pandaros, is fashioned from the horns of an ibex and capped at the tips with gold. Homer tells us how Pandaros made his weapon by hunting for the animal, first waiting under cover and then shooting it in the chest as it stood upon a rocky cliff. He next took its horns, four feet in length, cut, fitted, fastened, and polished them before adding gold to the tips. Here

too Homer tells us about the specific use of the artifact made by Pandaros, since it was with this bow that he would later wound and draw blood in battle from both Menelaos and Diomedes. So important is the war itself, however, that we can easily overlook the fact that the warrior is also an artificer who crafts a beautiful object with skill.

In addition to speaking primarily of the metals used in making armor, Homer also refers to the leather used for loin guards, both bull's hide and ox hide, and he mentions the teeth of a wild boar adorning the helmet of Odysseus. The poet also observes the scale of things; for example, the shield of great Ajax, which he likens to a tower, or the spear of Achilles, made of Pelian ash, so heavy that other warriors could not even lift it. Scale is especially significant in Homer's architecture. The poet evokes the great palaces of gods and heroes alike. The halls of Olympos are lofty, spacious, and glittering with gold. Some palaces of mortals are truly vast, such as the palace of Priam with its bright colonnades and fifty rooms of polished stone for his sons and their wives, and an additional twelve rooms, also of polished stone, occupied by his daughters and their husbands. Here scale reveals both prosperity and power. Although Homer's descriptions of architecture are more evocative than detailed, he nonetheless offers us some suggestive particulars. In beautiful similes, he evokes the tight-fitting stones of walls, and even alludes to the chalk line used to make a beam straight. He also speaks of the massive stones of buildings, which are made of ashlar and have timber roofs—buildings supported by great piers and bright colonnades. Homer's palaces have silver doors and bronze door sills and are amply furnished with polished tables, great thrones, and beds made of gold and silver, and their rooms are filled with a splendid array of golden amphoras, bowls, and cups.

Homer is exceptionally vivid when, for example, he pictures the palace of Menelaos with its entry wall of stone, its interior spaces glittering throughout and filled with beautiful furnishings and accoutrements, including tall thrones, a polished table, and various vessels such as a silver bowl, a golden pitcher, and cups of gold. No less magnificent is the palace of Alcinous. With a bronze threshold, the palace has a great courtyard and high rooms that are airy and luminous, as if filled with the brightness of the sun and the moon. The palace walls are covered with bronze panels with moldings of lapis lazuli as well as with embroidered stuffs. The entrance to the palace's principal chamber is crafted of shining bronze and gold. The posts and lintels of the room are fashioned of

silver, as are the door handles. Ultimately, for Homer there is no distinction between fine arts and minor arts. Architecture and its decoration are indissolubly one, and even if his descriptions do not permit us to reconstruct the great palaces that he evokes, his allusions to color, materials, scale, and light incite us to imagine these magnificent dwelling places.

Homer's palaces are not only abundantly filled with furnishings and many kinds of household goods; they are also adorned with sculptures, of which we find the most splendid examples in the great palace of Alcinous. At the entrance are statues of two immortal dogs made of gold and silver, which presumably represent the eternal grandeur of the king himself. Within the palace are two golden statues of boys who hold aloft bright torches. Light, whether flooding interior spaces, reflecting from polished stone and polished wooden furniture, or reflected by armor, is a crucial aesthetic phenomenon in Homer and evokes the brilliance of Mediterranean sunlight. Whether speaking of great palaces or of the battlefield, whether speaking of works of art large or small, Homer captures not only the splendor of art, but also the sense of wealth, magnificence, and, above all, power that such art suggests.

Homer frequently mentions one type of object, which, standing for authority, social harmony, and power, is often overlooked. I speak of the ruler's staff, an artifact that belongs in any comprehensive history of art and its objects. As far as I know, however, a comprehensive history of the staff and all its cognate forms—baton, mace, crozier, and even magic wand—has yet to be written. Homer refers throughout his poems to the staffs of Khryses, Achilles, Agamemnon, Odysseus, Telemachus, Calypso, Circe, and Minos. Let us consider the two most elaborately described of these objects.

In Homer's account at the outset of the *Iliad* of the confrontation between Achilles and Agamemnon over a concubine, the poet dwells on their respective staffs, which are seen in opposition to each other. Telling us that Achilles' staff is fashioned with a log that came from a tree in a wooded area upon a hill, a log from which the bark and leaves were removed, Homer does what the modern art historian does when he speaks of the way in which a work of art was made; in other words, he tells us how the work came to be the way it is. In this case, Homer traces the history of the object directly from nature as he outlines the metamorphosis of a tree into a symbol of power. When the poet says

that Achilles' staff was also studded with golden nails, he addresses its status as an object with aesthetic value, like that of so many artifacts mentioned by Homer, but he also speaks of its role as a weapon, since its nails inflict pain upon anybody who challenges the bearer's authority and power. The staff functions in just this way when Odysseus uses his staff to thrash the loutish Thersites after the latter delivers his famously ill-tempered and abusive speech. As an artifact, the staff also serves to bring about social order and harmony. Homer tells us that it is used at council meetings, where all who participate take it in hand as they speak. Binding the body politic and creating community, the staff is thus of deep social significance.

Homer tells us that Agamemnon's royal staff was the work of Hephaistos, who gave it to the all-powerful Zeus, who gave it in turn to Hermes, who gave it to Pelops, who gave it to Atreus, who gave it to Thyestes, who gave it to Agamemnon. We have here a kind of genealogy of art, what the modern scholar calls the provenance of the object, which Homer as an art historian traces from its divine origins to the time of his story. Surely the poet's account of this object and related staffs reflects the realities of Greek history and art history and helps us to imagine a kind of artifact, long since destroyed, that the poet knew well. When we think of art in anthropological terms, we cannot ignore the staff as an object of great significance, linking the human world to nature and to the divine.

3. Homer's Artists

If Homer's poems abound in art, they are necessarily populated with artists, many of whom, as we have observed, were anonymous—for example, countless weavers or smiths, including the smith who fashioned the sword belt of Heracles with beautiful intaglio representations of savage lions, bears, and boars as well as scenes of fighting. We have already encountered two artists, Hephaistos of course, but also Pandaros, who made his beautiful weapon. We might also mention here Paris, who, Homer tells us, built his own palace with the help of others, master builders as the poet calls them, who are among the many anonymous artificers of whom the poet sings. As an architect, Paris reminds us that

throughout the history of art in the West, rulers or patrons of high station were actively involved in the design of their palaces.

Homer identifies other artists by name. He speaks of Phereklos, a man who knew both the art of building and handicraft. He invokes the goldsmith Laerkes, who with his hammer, anvil, and tongs prepares the gold that adorns the horns of a sacrificial heifer. He sings of Ikmalios, the craftsman who fashioned the throne of Penelope with its silver whorls and ivory decoration. And let us not forget Epeios, who built the Trojan horse, a horse that we can consider a sculpture surely, indeed, the ancestor of all the great equestrian monuments, both ancient and modern—for example, the colossal equestrian monuments designed but never fully realized by Leonardo. We have talked about the importance of scale in Homer's art. Although he does not give us a precise account of the dimensions of the Trojan horse, he indicates its large scale when he says it contained the Greeks who came forth to destroy Troy. In the spirit of the Homeric sublime, Virgil would later embellish Homer by saying that the horse was as big as a mountain—a reminder that at least one ancient sculptor wanted to carve a figure out of a mountain.

The hollow horse was an especially clever invention, since horses had a powerful allure for the Trojans, who were trainers or breakers of horses. The horse thus played to the very identity of the Trojans who fell under its spell and took it into their city. We can, I believe, reasonably speculate that if Epeios executed the enormous horse, Odysseus, who was hidden within and who led the expedition against the Trojans, was its inventor. After all, Odysseus, as Homer presents him over and over, is a master of tricks, a master of dissembling, a man of infinite guile, a canny strategist, who excels in deception and invention. Throughout the history of art, the distinction can often be made between the inventor of a work of art and its executor. In this case, I propose such a collaboration between Epeios and Odysseus, a collaboration not explicitly stated by Homer but one that is implicit. The great illusionistic horse, true to the Greek theory of imitation as expounded by Homer, is a masterpiece of mimetic art. It is also a great work of artful military strategy and thus deserves a special place in the pantheon of Homeric masterpieces along with Hephaistos's shield for Achilles.

The invention of the horse is not the only masterpiece by Odysseus. He invented and carved out of an olive tree the nuptial couch he shared with Penelope, a work perhaps too easily forgotten because it is furni-

ture, which is often relegated to the decorative arts. No builder, Homer tells us, had the skill to move the bed, and so Odysseus shaped a room with stone walls and smooth-fitting doors around the bed. Here Odysseus was both architect and sculptor. Odysseus himself recounts how he cut off the branches and leaves of the tree that he metamorphosed into a bed and then gave form to the stump by turning it into a bedpost. He used silver, gold, and ivory inlay to adorn this glorious piece of matrimonial furniture. In his account, Homer is really singing an epithalamium, a song of Odysseus's and Penelope's bed and bedchamber, which is no less a hymn to the craft of its maker.

Odysseus's artistry is deep and extends far beyond the horse and the bed. Odysseus is a great storyteller and, as Homer also demonstrates, a superb orator. He is an excellent illusionist, a master of disguise, as when he shrewdly returns to Ithaca in the guise of a beggar. His fateful deception recalls the illusions of the gods who come to earth in the personae of mortals. Although there are obviously no direct relations between Odysseus's disguise and the subsequent art of theater, I think we can nevertheless speak of Odysseus as a consummate actor, for surely disguise is a form of illusionistic art or artful illusion. We ordinarily do not dwell sufficiently on Odysseus as an artist, because this aspect of his life story, though surely recognized, is secondary to his greatness as king and warrior. But we can put this the other way around and say that one of the greatest artists at the dawn of Greek art history was also a glorious monarch and soldier.

Of all Homer's works of art, the shield of Achilles fashioned by Hephaistos is surely the most famous and extensively discussed. As much as this work has been previously analyzed, I believe there is more that we might say about it and its maker. I would suggest that, like Leonardo's painting of Mona Lisa, the shield is so familiar as a masterpiece of art that we can easily take it for granted or consider it inadequately. For historians of Greek art history, as I have said, it has obvious relations to Greek metalwork from the times of Homer or earlier, though it transcends anything ever made by a smith. For students of art in general, Homer's account of the shield is also the foundational text in the history of rhetorical or poetical descriptions of works of art. As such, it is the great ancestor of a whole tradition of poetic writing about art that flourished later in the pages of Vasari and many, many others, even though this tradition has receded in importance in the age of modern art history.

As an object used in warfare, the shield prompts us to remember that for the pre-Socratic philosophers writing in the wake of Homer, war was the father of all things. War, we might therefore say, was the father of the shield. From the death, destruction, and discord of war emerged the concord of Homer's poetry and, more specifically, the cosmic shield made by Hephaistos. War and peace, life and death, which are Homer's central themes, define each other by antithesis both in the poem in general and on the shield in particular, where Hephaistos juxtaposes images of cities at peace and at war. The city at war upon the shield serves as a foil to the poet's emphasis on peace and harmony. Most significantly, the shield's emphasis on music—the depiction of song, dance, and the making of music by musicians—conveys the dominant theme of harmony, the harmony associated with peace, which is underscored by the depiction of the fruits of husbandry and agriculture, arts that flourish in peacetime. In his microcosmic picture of harmony, social and artistic, which dominates the shield, Hephaistos renders the concord of peace in opposition to the discord of the war, for which it was made. The harmonious image of an ideal city under the rule of law on the shield anticipates Plato's attempt to define a perfect republic or commonwealth; it even foreshadows Lorenzetti's famous allegory of good government in Siena, a fresco of a city at peace, harmoniously rendered with dancing women like those in Homer's city; it is similarly the ultimate ancestor of other pictorial utopias, above all, the serene and harmonious panels of an ideal city associated with Piero della Francesca.

Homer's beautiful and artful, indeed poetic, description of the shield of Achilles, is saturated with images of various kinds of art. Elders are portrayed sitting on benches of polished stone, a reminder of the importance of finish in Homer, as we saw in his descriptions of armor, shields, architecture, and furniture. In the peaceful city portrayed by Hephaistos we behold a wedding seen by torchlight, with singers and dancers and musicians performing on pipes and lyres. Later, in the scene of a vineyard, we behold a boy singing a delicate dirge, while others break into song. Then, too, there is architecture pictured on the shield that also pertains to music. I speak of Hephaistos's depiction of the dancing floor built by Daedalus, in other words, the great labyrinth. Some of the dancers on the shield are related to yet other arts besides music, since the women wear soft gowns of linen and the men have well-knit chitons, in other words, beautifully and artfully woven clothing; furthermore,

the men who dance are wearing objects beautifully crafted, daggers that are set in golden hilts hanging from silver lanyards. Once again, only here in microcosmic form, we have the prominent arts of weaving and metalwork, set in a musical context that echoes the music of Homer's own song. Long before Ovid unified the arts by seeing them all as metamorphoses, long before Wagner aspired to the unity of all the arts or Baudelaire sang of the correspondences of the arts, Homer had created on the shield of Achilles a new world of various arts united.

We might recall here, as another way of highlighting the importance of art, that when Achilles is not in battle, but retreats to his tent, he is found playing his lyre. As a figure of great might, he is not unlike the powerful and destructive Apollo, who accompanies the Muses with his lyre.

Homer magnifies the art of the shield by likening the circle dance upon the dancing floor of the shield to the circular motion a potter gives to a clay pot as he builds and shapes it with his hands. In the end, however, music, which is the dominant art of the shield—the music of dance, song, pipes, and lyre—is an extension of the music of the bard, Homer, who sings his song about art, his song about song. We might well say, in the words of Walter Pater, that in Homer all art aspires to the condition of music and, in particular, Homer's music. Although Homer is impersonal and rarely speaks in the first person, he nevertheless is very self-conscious and his attention to music is a reflex of his own musical art. Such self-consciousness is a hallmark of both the history of art and the interrelated history of literature in the Western tradition.

Homer came to be thought of as blind poet, much like Demodocus, the blind bard at the court of Alcinous; and so he may be thought of as singing of himself. As Hephaistos the cripple may speak to a reality about lame smiths, so the blindness of Demodocus and Homer touches an ancient intuition about the powers of blind minstrels and blind prophets of ancient Greece. The poet's blindness is a tragic gift, and in its poignancy magnifies our sense of how much Homer in fact sees, whether he pictures an entire world at war so vividly throughout his poem, whether he beholds the domestic world so acutely, especially through his similes, or whether he concentrates his observations in his description of the shield.

Homer implicitly competes with the artist whose shield he describes. In *his* shield—a pictorial illusion of complexity beyond anything ever

created in relief, either in ancient Greece or after—Homer surpasses all visual artists or illusionists. But the relations of poet to pictorial artist are circular, since the poet defines himself in terms of the metalworker's imagery in the first place. In other words, the visual art of the smith is the point of departure for the poet. Homer may be superior to the smith, but only by competing with the craftsman, for it is his activity that becomes the poet's imagery and gives substance to the poet's song of the shield. Even before Homer competes against the smith, he speaks of such competition when he tells of how Thamyris the Thracian challenged the Muses in song, for which he was punished by being maimed. The often forgotten story anticipates the story of Marsyas and Apollo or Arachne and Athena.

The competition between Homer and the smith, between poet and pictorial illusionist, is the foundation for a long tradition of comparison or competition between the arts, both within and across artistic media, a tradition that extends down to the present. We find such competition between Michelangelo and Leonardo and more recently between Picasso and Matisse.

In speaking about artists and art, about works of art both real and imaginary, I have approached the greatest of all of Homer's artists, Hephaistos, whose works the poet refers to throughout his poems. In addition to fashioning the shield of Achilles, his masterpiece, Hephaistos also made, we recall, the staff of Agamemnon, which is just one among many objects that we might list in the catalogue of his works. He fashioned the shield of Apollo, the cuirass of Diomedes, a gold and silver bowl for Calypso, and the urn for the remains of Achilles and Patroklos. As an architect, he was unmatched. He built, we remember, the palaces of the gods and the palace of Alcinous adorned by the dogs and torch-bearing youths.

The catalogue of Hephaistos's works would grow over time. Ovid, no doubt competing with Homer, would later present an elaborate description of the palace of Sol, built and richly decorated in gold, silver, bronze, and ivory by Hephaistos. The divine artificer's life as an architect would take a turn in a different direction, however, when, as Milton reports in *Paradise Lost,* he designed the splendid architecture of hell. Hephaistos, to whom Milton refers as Mulciber, thus descended from the heavenly heights of Sol's palace to the darker realm of Satan's abode. The modern epic poet is especially witty in this attribution: recalling

that Zeus tossed the god of the forge from Olympia, he thus implicitly associates the pagan architect's fall with that of Satan.

Homer not only celebrates the works of Hephaistos, but he also gives us details from his life story, his life in art. In effect, the poet delivers to us, however abbreviated, the first biography of an artist in the history of Western literature. Hephaistos achieves prominence on four occasions in Homer's poems. At the beginning of the *Iliad,* when the gods are in conflict during the clash between Achilles and Agamemnon, Hephaistos brings about a short-lived harmony by serving them drink. The gesture is appropriate, in character: this is the artist who turns war into the harmony of art in a magnificent shield. He is next featured at the moment when he makes the shield of Achilles, and later shines in battle when he clashes with the river Skamander, in what is in effect a battle between water and fire, fire being crucial to the god's art at the forge. In the *Odyssey,* he makes his last important appearance in Homer's songs when he discovers that he has been cuckolded by Aphrodite, who sleeps with Ares—an episode that amuses the other gods greatly. Learning of his wife's duplicity, the god of the forge entraps the lovers with a net so subtle that they do not see it. We might well include this artful and deceptive invention in the catalogue of the god's art.

Nietzsche once said that one can construct a biography of a person from just a few anecdotes, and indeed, Homer provides us with some other telling details and minor episodes that fill out the life of the divine smith. Homer alludes in two different accounts to the defining moment in Hephaistos's life story. In the first version, the god says that when he took Hera's side in a dispute with Zeus, the lord of the gods grabbed him by the foot and hurled him into the sky, through which he fell all day until he landed on the island of Lemnos nearly dead. He was, however, rescued and nursed back to health by the people of the island. We learn from the second version of this episode that after his long fall, his mother wanted to hide him, but Thetis and Eurynome took him in and for nine years he stayed with them in a cave where he made various artifacts: brooches, bracelets, and necklaces. These details are not only part of the biography of the artist, but are the seeds of his sense of himself and his place, and since the story of the god's fall and subsequent artistic training is recounted by Hephaistos himself, Homer has originated a new genre, the artist's self-portrait.

So often in biography we encounter the rise of a subject to glory

and then a fall or decline. Ever so many such stories recur in the history of art, for example in Vasari's *Lives* of the artists, where the author speaks in such terms about the decline of Torrigiani, Pontormo, Parmigianino, and many others. At the dawn of literature in Homer, however, we encounter the story in reverse: a fall followed by a glorious ascent, for Hephaistos upon returning to Olympus becomes a great artist.

Nevertheless, fashioning works of great beauty and skill as he may, he is nonetheless ugly, deformed, and ridiculous. His entire being is made up of a series of such antitheses. Whereas Achilles, for whom he makes the shield, is both handsome and fleet of foot, the crippled Hephaistos is ugly and slow. Yet his bride is beautiful; in one version he is married to Charis, meaning Grace; in another, to Aphrodite. Although, as Homer says, he makes tripods that roll about with ease, he limps along with difficulty. He fabricates living maidens with the power of motion, but needs them to support himself. In short, Homer juxtaposes Hephaistos's deformity with the beauty of his work, his lameness with the graceful movement of his creations, his awkwardness of motion as a cripple with the dexterity demonstrated in his art. These dualisms can also be seen in relation to the contrast between the harmony of his art and the discord of the war to which such art is related.

Homer's portrayal of Hephaistos is part of a whole network of related dualities in his poetry. Although Odysseus is handsome by contrast to Hephaistos, his identity is nonetheless defined by oppositions. Antenor reports that long ago Odysseus appeared slow of wit and empty headed, whereas he was in reality astonishingly eloquent and spoke with a strong voice. Similarly, although Odysseus is a man of godlike radiance and beauty, like a work of art by Hephaistos, he returns to Ithaca seemingly a beggar in rags. Such a dualism came to define Homer himself. For, although reputed to be blind, he had penetrating powers of vision, shown by his poetic capacity to make things visible. Homer and his subjects are defined by the contrast between their appearance and reality.

This Homeric distinction became essential to Plato's definition of Socrates, who, famously ugly without but beautiful within, was a type of Silenus. Socrates, who came to personify the very dualism of Plato's philosophy, has everything to do with the Homeric dichotomy between being and appearances. In short, the Platonic dualism personified by Socrates has its taproots in Homer.

Indeed, it is not unreasonable to see the dualism of Socrates, the

contrast between his ugly appearance and beautiful inner being, in rela-
tion to the same dichotomy that defines Hephaistos, since the god, like
the philosopher after him, is portrayed as ridiculous and is mocked. As
Erasmus would later say in *In Praise of Folly,* "Vulcan [i.e., Hephaistos]
has always acted the buffoon at the banquets of the gods and delighted
the company by his limping or taunts or other funny things he says."
We tend nowadays to think of the history of art in which the artist is
heroic if not tragic, and there are many such examples of pathos and
tragedy in this narrative, from Michelangelo to Caravaggio, from Rem-
brandt to Rothko, but Homer foretells another tradition—the story of
artists who are ridiculous. We have briefly noted that such a story ex-
tends from Hephaistos to Boccaccio's proverbially gullible painter Ca-
landrino and his progeny, and to the fat carpenter in the well-known
Renaissance tale by Antonio Manetti, in which the craftsman is duped
into believing he is somebody other than himself. The story of ridicule
in the history of the artist, which has yet to be written in full, extends,
in recent times, to Picasso dressing up as a clown and to Marcel Du-
champ, the clown prince of Modernism, famous for his ludicrous gags,
jests, and jibes. In short, the mythic "Homeric laughter" elicited by
Hephaistos spills into the history of the artist, who is ever so often a
ridiculous figure.

Plato's Hephaistos-like Socrates was absorbed by Boccaccio in the
Decameron to his portrayal of the greatest painter of his day, Giotto. Al-
though the painter achieves great beauty in his work, he is himself, as
Boccaccio writes, ugly. Boccaccio embellishes this Socratic persona
when he portrays the painter in a peasant's cape, disheveled, soaked in a
rainstorm, and mocked by his friend Forese, because the artist's looks
belie his reputation as the world's premier painter. If Giotto's Socratic
persona in Boccaccio's tale is well understood, I should reiterate that the
deep roots of this image of the mocked artist are to be found earlier in
Homer's deformed and ridiculous artificer.

Appropriating Boccaccio's story of a Socratic or Hephaistean Giotto
to his biography of Filippo Brunelleschi, Vasari also later contrasts the
ugliness or deformity of the great architect to the beauty of his work. In
a clever variation on this Socratic theme, Vasari contrasts the shortness
of Brunelleschi with the great heights which he attained when he built
the dome of the cathedral of Florence, which soared high above the city.

In Vasari's *Lives,* there are three different periods in the history of

modern Italian art. The first is epitomized by Giotto, the second by Brunelleschi, the third by Michelangelo, who is the pinnacle of art history. Once again the theme recurs: Vasari speaks of Michelangelo's deformity, his nose broken by a rival, which marked him for life, and Michelangelo himself speaks of his ugliness on several occasions in his poetry, including a long self-mocking poem in which he says his face frightens others.

In another variation on the theme of the ugly artist, it was proverbially said of Giotto that although he painted beautiful figures, the children he sired were, like him, ugly. It usually escapes detection that the idea of comparing one's progeny to works of art descends from Plato, who speaks in the *Symposium* of the works of Homer and Hesiod as the progeny of these authors. The idea was echoed later by Michelangelo, who, growing up in a world saturated with Plato, said, according to Vasari, that he had no need for a wife, since his works of art were his children.

Michelangelo is the first artist to be defined in great detail as the culminating figure in the history of art. Whereas Pliny speaks of Apelles as the perfection of painting, the teleology of his history is not so stringently defined as in Vasari's view of historical progress, which is grounded in the linear history of the Bible, the writings of Joachim of Flora, and the *Comedy* of Dante. In Michelangelo we see the confluence of the two great Western traditions, the Hebraic and the Hellenic. When Michelangelo painted the *Creation of Adam,* Vasari, recalling the biblical sense of God as a potter, compared him to God the Creator, the first sculptor who fashioned Adam out of clay. Echoing Dante, who spoke of God as a smith and thus assimilated the Hellenic idea of the artist to the Hebraic divine artificer, Michelangelo implicitly compares his own art to that of the Olympian smith with whom the Creator was now identified. Like the Hebraic Creator as sculptor and the Hellenic divine smith Hephaistos at once, Michelangelo personified the synthesis of both major traditions in the Western history of the idea of the artist.

The lineage of artists ridiculed for their deformity or ugliness extends beyond Michelangelo to Rembrandt. Writing in the late seventeenth century, Filippo Baldinucci says that Rembrandt wore shabby clothes, a description that evokes Boccaccio's disheveled Giotto in a peasant's cape, and when he observes that Rembrandt was ugly and had a plebeian face, he further magnifies the painter's descent from Giotto. Writing in the following century, Arnold Houbraken also remarks that

as he painted his canvases, Rembrandt was like a bricklayer using a trowel. His suggestion thus links the painter's crude manner of applying a thick impasto to his pictures to the world of rough workmen of the kind that Shakespeare called "rude mechanicals." In *A Midsummer Night's Dream,* these outlandish artisans perform a mock-Ovidian play about Pyramus and Thisbe. That one of them, Francis Flute, is a bellows-mender links them to the world of the forge, the world of the smith. Shakespeare's mockery of these craftsmen is rendered with sympathy, if not affection. Although they are ingenuous and artless in one respect, they are in their own way quite ingenious, as when one of them, Tom Snout, the tinker, is made to play the famous chink in the wall that divides the lovers. Imagine that! Shakespeare expressly identifies himself with these ridiculous but clever artisans, for he has one of them speak of their collective "skill," twice rhyming the word with "will," which is of course the author's very name. Shakespeare is, as we would say, a smith, a wordsmith, in short, a craftsman, like the tinker, carpenter, joiner, and other comic characters who produce the play within his play—which is at bottom the production of the self-conscious playwright himself.

The crude, deformed, or ugly artist pervasive in the histories of art and literature emerges also in the life story told by Roger de Piles of another Dutch painter, Pieter van Laer, who worked in Rome in the early seventeenth century. This artist was said to have had a short body and a head sunk into his shoulders. No wonder he was called "Bamboccio," rag doll. When his biographer adds that "the deformity of his body stood apart from the beauty of his mind," the contrast is especially suggestive of the Socratic tradition.

We encounter another type of Socrates in a painter and printmaker of the same period, Hendrick Goltzius. According to Karel van Mander, when this gifted artist traveled to Rome, he wore shabby clothes so as not to draw attention to himself, fearing harm from outlaws. His dress reminds us of the disheveled Socratic Giotto of Boccaccio. But that is not all. Eventually, a companion recognized the painter by the identifiable deformity he exposed when extending his right hand—a deformity that stood in striking contrast to the grace and eloquence of the monogram on his handkerchief, made with beautiful interlaced lines—or, as we might say, with a "beautiful hand." Here once again we have the archetypal dualism of Hephaistos.

Not all ugly or deformed artists are expressly related to Socrates or Hephaistos. Consider the case of the Bolognese painter Guercino. According to Malvasia, the artist had a significant defect, for he squinted and was therefore *guercio,* hence the name Guercino, which, as a diminutive, also suggests that he was little. Malvasia makes this defect vivid in our imagination by saying that it resulted from an episode in childhood when the painter was sleeping and heard a loud noise, which woke him and caused him to turn around suddenly in such a way that his pupil got stuck in the corner of his eye. Although we do not doubt the factuality of Guercino's defective or deformed eye, one cannot but wonder whether the story isn't a fable devised to make the painter's defect unforgettable.

Of course there are many other artists with deformities who are not associated with Socrates or Hephaistos: Toulouse-Lautrec, for example, who, despite appearances, was capable of rendering arabesques of exquisite grace; and the aged, infirm, indeed crippled Henri Matisse, making brightly colored, lyrical flower forms, as if in a miraculous rebirth of nature herself.

There are of course artists known for their good looks and grace. One thinks of Leonardo, Giorgione, and Raphael, of Bernini, Rubens, and Van Dyck, and let us not forget the dandyish Courbet and Whistler. In these cases the comely appearance and grace of the artist can be seen as mirrored to a degree in his art. But in any meditation on the appearances of artists, the physical beauty of such handsome and dashing figures throws into relief and magnifies our sense of the dramatic contrast between the ugliness or deformity of Socratic and Hephaistean artists and the beauty of their works. I believe that the tradition of contrasting the ugly artist with the beauty of the artist's work that descends from Homer addresses, indeed intensifies, the wonder we experience when we encounter any work of art by a great artist. For no matter how the artist appears, his appearance can never quite prepare us for that of his work. We are always left to wonder how a mere mortal, whether ugly, ordinary-looking, or even handsome, could produce a work so awe-inspiring. There is inevitably a gap between the appearance of the artist and his work—a gap that Homer defined archetypically.

If many artists descend from Socrates, there is a least one who leads us once again to Plato's Socrates and Homer's Hephaistos. I speak of Anthony van Dyck. According to the biographer Houbraken, Van Dyck

went to visit Frans Hals in his studio. Saying only that he was a stranger, Van Dyck asked Hals to paint his portrait. When the picture was painted, Van Dyck praised it but in such a way as not to reveal his identity. Then he took a canvas and, putting it on an easel, invited Hals to sit so he could paint *his* portrait. Hals could tell from the way in which Van Dyck held his palette and brush that he was no novice. He realized, Houbraken says most pointedly, that his visitor was a kind of "Odysseus in disguise" who would soon reveal his true identity. Which is in fact what Van Dyck did when he completed the portrait. At this point, Hals knew it could only have been painted by Van Dyck. Homer casts a long shadow over the history of art.

4. From Homer to Vasari

Hephaistos's influence on the idea of the artist brings us back to Homer himself—to Homer's own competition with Hephaistos, when he sang so brilliantly of a shield more magnificent than anything a smith could possibly make. If Homer competed with smiths past and present, he also inspired the poets who, following him, competed with his poetic art. Inventing the grandiose self-image of the epic poet, he made all epic poets after him conscious of their own status, and this self conscious idea of the epic poet would eventually shape the modern idea of the heroic artist. In other words, the competition of the poets after Homer who sought to surpass him in various ways is not without consequences for the history of art. Let me explain.

Although Homer was an impersonal artist, he was very self-conscious when he competed with the art of smiths. So too was Virgil when he competed with Homer. Like Homer, Virgil was impersonal, but he also sought to surpass him in various respects. An example here will clarify. Homer says that Helen wove scenes from the Trojan War, though he does not identify the episodes that she represented. Virgil, however, describes scenes painted in a temple in Carthage in which particular moments of the Trojan War are explicitly identified. At one point Aeneas even looks upon himself in one of these painted narratives. In competition with Homer, Virgil surpasses his model by creating specific pictorial narratives on a larger, more monumental scale than those portrayed by Homer's Helen.

When Aeneas looks at these images, he foreshadows his admiration, later in the poem, of his own shield: he is so much more the conscious connoisseur than Homer's Achilles. Competing with Homer, Virgil departs from him by dwelling distinctively on the beholder's consciousness of art. We might almost say that Aeneas's subjectivity here is a reflection of the poet's own self-consciousness or what has been called his "subjective style"—a style which points him in the direction of Ovid.

When Ovid wrote his epic—or mock epic, as one might better describe it—he self-consciously parodied his sources in Virgil and Homer. Unlike the earlier poets, Ovid is very personal; for example, his poem is not just about the glory of the Greeks, Trojans, or Romans. Ovid metamorphoses martial glory into the poet's—namely, his own. Ovid's self-consciousness is also manifest in his role-playing. As a kind of Proteus of art, he assumes the personae of all of his artist subjects; he is like his own Arachne, a weaver of a text, just as he is like Daedalus as author of a labyrinthine literary architecture. Moreover, his self-consciousness as a poet is evident in the fundamental idea that all art is metamorphosis. In other words, all of the metamorphoses that Ovid describes are displays of the metamorphoses of his poetry—exhibitions of his own artistic virtuosity.

When Dante wrote the first modern epic, he not only followed Virgil's example, he also relied heavily on Ovid's sense of himself as a poet. Whereas Ovid assumed the personae of his artistic subjects, Dante went a step further to surpass Ovid: he made himself the principal subject of his poem. Here was an epoch-making shift from the Homeric idea of the warrior as hero to that of the poet as hero of his own epic. Dante's self-image as epic poet was fundamental in turn to Michelangelo's persona as artist and also to Vasari's presentation of Michelangelo's Dantesque identity in the *Lives,* wherein the grandiose modern artificer is the summit of all art history.

There is no direct relationship between Homer and Michelangelo's life story or self-portrayal in his poetry. There is no simple timeless pattern to which these artists are reducible. Their creative achievements are unique. Without Dante, however, Vasari's mythic Michelangelo would not be the Michelangelo whom we know so well. Without Ovid, Dante would not be the poet-hero of his own poem, and without Virgil and ultimately Homer, Ovid would not be the self-conscious epic poet so familiar to us. An historical chain extends from Homer to Virgil, Virgil

to Ovid, Ovid to Dante, Dante to Michelangelo, and Vasari's representation of Michelangelo. The crucial link in this concatenation for the history of art is that connecting Dante to Michelangelo, the painter, sculptor, and architect who assumed the persona of the epic poet. But along with the heroic grandeur of Michelangelo's Dante-inspired self-image also came, as we have observed, the antithetical self-mockery of his poetry, in which the artist ridicules his frighteningly grotesque appearance. In this respect, Michelangelo, who is both ugly and ridiculous, leads us back via Vasari's Brunelleschi and Boccaccio's Giotto to Plato's Socrates, but ultimately to deeper roots in Homer, who had created in Hephaistos the complex, paradoxical, if not ironic image of the great but ugly artist—a foundational figure not only for Plato, but, more broadly, for the richly intertwined poetic histories of Western art and literature.

THREE

OVID'S PROTEAN EPIC AND ARTISTIC PERSONAE

I know of no work of literature more wonderful than *Metamorphoses*. Even those who have never read Ovid or have read but fragments of his poem are familiar with many of his stories: Apollo and Daphne, Echo and Narcissus, Pyramus and Thisbe, Icarus and Dacdalus, Orpheus and Eurydice, Venus and Adonis. Ovid's book is about the causes of things, about how birds, beasts, trees, flowers, and rocks came to be, about why things are the way they are. His poem is nothing less than a history of the world from its creation out of chaos through the writing of *Metamorphoses* itself in the age of Augustus Caesar. History, we might say, culminates with Ovid's poem, which is the artful mirror image of the cosmos in the multiplicity of all its forms.

Metamorphoses is a poem about nature, both its physical beauty and the natural catastrophes that mark the world: flood, conflagration, famine, plague. In this respect, Ovid is a realist. *Metamorphoses* is also a history of desire, a multitude of stories of love, lust, passion, and affection, a reminder that the intertwined histories of Western art and literature, enriched by Ovid, are the aggregation of such stories of desire.

When we read Ovid, we become part of a wide community, a community that embraces artists of various types in the modern European tradition who have responded to *Metamorphoses*—from the authors who

forged the *Roman de la Rose* to the poets of our own day inspired by the ancient bard. If Ovid has been read by great artists, he is also read by those who like a good story, a story told well, a story that gives pleasure. In that respect, Ovid belongs to everybody.

As a sustained exploration of form and transformation, *Metamorphoses* is a work about art, artists, and artistic form. Although Ovid's acute attention to artifice of various kinds has often been discussed over the years, often incisively, there is still more to be said about Ovid's sense of art and the artist. The sum of Ovid's allusions to art in *Metamorphoses* is greater than the parts, and the full implications of his vision of the artist are still, I believe, only dimly surmised.

In order to clarify our understanding of Ovid's conception of art, let us recall a crucial, well-known fact about *Metamorphoses*. As a poem inspired in part by the *Iliad, Odyssey,* and *Aeneid, Metamorphoses* is an epic or, as some would say, a mock-epic, which, toward the end, braids the myths of Achilles, Odysseus, and Aeneas, all men of arms and great deeds—in a word, heroes. Yet Ovid's epic is an epic of a different kind, what I wish to call the "epic of art," in which artists of various types, not warriors, are the principal heroes and heroines. Ovid's understanding of mythic artists has its roots in Homer and Virgil—for example, their celebration of the prodigious artistic skill of Vulcan. But magnifying the theme of art in his own epic, giving it a far more extensive role in his poem than in previous epics, Ovid transforms the epic hero from soldier into artist.

Ovid's poem is a *carmen,* a song. In *Metamorphoses,* songs tell stories, and stories are sometimes rendered pictorially in woven images. In his work, Ovid achieves a supreme unity of the arts. Sculpture, architecture, painting, weaving, handicraft, poetry, song, storytelling, and rhetoric are brought together in *Metamorphoses* in a prodigious synthetic art, of which Ovid is the ultimate author, the artist who embodies and unifies all of the arts. In short, Ovid as artist is the superintending hero of his own epic.

In book 1 of *Metamorphoses,* Ovid makes it abundantly clear that his opus differs from previous epics, for unlike the poems of Homer and Virgil, Ovid's focuses attention on the central theme of his own epic—art. With a great flourish of stories about art, Ovid introduces the theme of artifice in its many forms. After an unknown god molded the earth in the beginning, the son of Iapetus, Prometheus, made images of man out

of the clay of the earth, whence the origins of sculpture. Ovid pursues this thread in the story of the son of Prometheus, Deucalion, and his wife, Pyrrha, who, after the flood, toss behind them the stones that turn into human beings. Likening the human forms within stone to unfinished statues during this metamorphosis, Ovid thereby places Deucalion in the line of descent from his father, Prometheus. This genealogy of art reaches its apex later in book 10 in the story of Pygmalion, whose statue made from ivory softens eventually to the sculptor's touch and comes to life.

As a sculptor in words, Ovid also describes the reverse effect of people in the flesh transformed into stone—Battus, Aglauros, Niobe, and all the adversaries of Perseus subjected to Medusa's gaze. For Ovid, sculpture is neither the hard substance that softens and comes alive nor the living flesh transformed into stone. Rather, compounded both of the myths of Pygmalion and Medusa, sculpture in Ovid is ambiguously and more fully than in one myth or the other both a living presence in hard stone and the petrification of the flesh. Ovid gives us the fullest and deepest understanding in all of literature of the existential doubleness of sculpture, forever poised ambiguously between life and death.

In book 1 of *Metamorphoses,* Ovid also begins his sustained celebration of architecture, for example in his evocation of the marble halls of the gods. Although the builder of such sublime architecture is unnamed, we might well attribute it to the gods themselves, of whom Vulcan is the premier figure. Vulcan is the author of the sun god's dazzling palace made of bronze, gold, and ivory and adorned with an illustrated silver door—a work pictured by Ovid at the beginning of book 2 of *Metamorphoses* as he pursues a thread from a story in book 1.

The other principal architect of Ovid's poem is of course Daedalus, designer of the great labyrinth, a work of astonishing ingenuity that deceives the eye in its winding passages, which are likened in their ambiguities to those of the meandering Meander River as it flows back and forth, out to the sea but also, at times, back to its source. Daedalus's ambiguous structure is a fitting simile for the complexity of Ovid's poem, which is plotted with comparable complexity as its fables both foretell and echo each other—for example, the myth of Prometheus foreshadows the tale of Pygmalion, the sculptor whose art echoes in turn that of Prometheus. As sculpture is ambiguous in its play between life

and death, so is Daedalic architecture, which, like Ovid's poem, is ambiguous as it moves in two directions at once.

In book 1 of *Metamorphoses,* Ovid introduces another principal art, painting, which emerges in the myth of Argus, whose head is cut off by the murderous Mercury, after which Juno adorns the peacock's feathers with the dead shepherd's one hundred eyes. When Juno reappears in book 2 of *Metamorphoses,* mounting her chariot borne aloft by peacocks, Ovid refers not once but twice to their pinions as *pictis,* "painted." Juno is for Ovid an originary painter.

Ovid also evokes the art of painting in the myth of Arachne's weaving contest with Minerva, especially when he uses the verb *pingere* to describe what the goddess depicts. By analogy, we can construe Arachne's woven stories as pictorial, such as the myth she pictures of Jupiter's rape of Europa—a cunning revision of Ovid's own version of the story in book 2, in which the maiden is deceived by the "image of a bull." In other words, Arachne, picturing Jupiter as a bull, renders an image of an image. When Arachne weaves with one thousand colors, she stands for Ovid himself, whose richly chromatic text is shot through with colored threads. Blacks, whites, grays, silvers, golds, yellows, reds, purples, pinks, blues, and greens abound in the author's pictorial poetry. Ovid's identity with Arachne is often observed, for the poet, speaking of his text as something woven, thus identifies with the consummate weaver among mortals.

When Arachne weaves the story of Europa, which visually echoes Ovid's telling of the tale in book 2, she alludes to a myth in which the poet celebrates the art of handicraft. For the horns of Jupiter, who appears in the image of a bull, are so perfect in form that they seem to have been made by hand. Seeing the beauty of natural form here (as elsewhere in his poem), Ovid transforms a detail in nature into the artifice of craftsmanship.

Ovid's image of Jupiter as a beautiful, snow-white bull at the end of book 2 of *Metamorphoses* resonates with the similar image of the beautiful, snow-white heifer into which Jupiter transforms Io in the final myth of book 1. In the story of Jupiter and Io we come to one of the most delightful examples of art in the first book of Ovid's poem, the art of storytelling. After the Olympian god takes his pleasure with Io, he transforms the nymph into a cow in order to conceal her from his wife. No fool she, however, Juno is on to his little game and descends to ask,

"Where did the cow come from?" Quick to respond, Jupiter tells a very brief story; he says that the heifer sprang from the earth fully grown. Close readers of Ovid's poem will recognize a little joke in Jupiter's story. The god imitates Ovid, since one of the threads of book 1 of *Metamorphoses* is the series of stories of beings born of the earth: Prometheus's humans are formed out of the earth, the offspring of the giants take on human form when they emerge from the earth, humans are born from the stones of the earth after the flood, and the Python is born from the earth at the same time. In this context, Jupiter's story of yet another earth-born creature reads like farce.

Imitating Ovid, Jupiter in effect becomes a poet, and, although his story of a cow emerging from the ground is preposterous, its conformity to Ovid's series of stories of comparable births gives it, in context, a kind of verisimilitude. Nevertheless, as Ovid says elsewhere in a self-mocking manner, all poets are liars. In the style of Ovid, Jupiter is such a poet-liar. Jupiter's short story within Ovid's poetry is exemplary of the art of storytelling so prominent throughout *Metamorphoses*. It sometimes seems almost as if there are as many storytellers in Ovid's poem as there are stories. In book 10 of *Metamorphoses,* for example, Ovid tells the story of Orpheus, who tells the story of Venus and Adonis, within which Venus tells the story of Atalanta and Hippomenes—another example of Ovid's weaving.

In book 1 of *Metamorphoses,* we meet the consummate storyteller, Mercury, who is dispatched by Juno to assassinate Argus and thus liberate Jupiter's beloved Io from captivity. Disguised as a shepherd, Mercury tells Argus the wonderful story of the origins of Pan's pipes, and after his victim falls asleep during the story the god dispatches him with a blow of the sword. Like all his other storytellers in *Metamorphoses,* Mercury stands for Ovid himself, since it is through the god's lips that he tells the story of the origins of the sweet new music of the pipes. With delicious, often-observed irony, Ovid mocks his own storytelling, since Mercury's story of Pan and Syrinx is obviously a revision of Ovid's tale of Apollo and Daphne. Mercury's narrative, which is ultimately Ovid's own, should arouse interest, but it does not prevent Argus from nodding off. Ovid's capacity to laugh at himself is exemplary—a model to us all.

As verbal art, storytelling is not only linked to the art of poetry, it is also related to the art of rhetoric, the art of speaking well, indeed persuasively. Ovid exhibits this art in the story of the debate between Ulysses

and Ajax over the arms of Achilles, in which the former is an exemplar of eloquence or *facunditas*. Ulysses argues ever so skillfully that Ajax is not worthy of the shield of Achilles because he is unable to appreciate its heavenly art, its virtuoso depiction of sea, sky, and cities. Here the art of rhetoric celebrates the art of craftsmanship.

The intertwined stories of sculpture, architecture, weaving, painting, poetry, storytelling, and rhetoric in *Metamorphoses* grow out of the emphatic celebration of art in book 1 of the poem, as we have said; but, of all the arts with which Ovid identifies, we have left until last the central art, that of music. Ovid's poem, his *carmen* or song, is a song about music that begins with Apollo, the god of the lyre, whose beloved Daphne is transformed into the laurel with which his instrument will always be entwined. In book 1 a short time later, Ovid rewrites this myth and transforms it into the similar story told by Mercury of Pan's pursuit of Syrinx, who is transformed into reeds, whence the origins of the sweet new music of the pipes. In what is arguably the single most beautiful sonority in all of *Metamorphoses,* Ovid evokes the phonic beauty of music as Syrinx prays to her sisters for assistance, *orasse sorores,* a sonorous suggestion of the sweet sussurations of the whispering reeds into which she will be transformed.

Many are the singers of whom Ovid sings throughout his symphonic work: Ochyroe, the singer of prophetic songs; the Pierides, who compete in song with the Muses; Medea, whose songs, like those of Circe, are incantations, enchantments; Canens, whose name speaks of her role as singer; monstrous Polyphemus, who seeks to woo his beloved by playing his panpipes; and let us not forget, within this great chorus of singers at the very end of Ovid's song, Pythagoras, who gives voice to the poet's view of the world in flux. Ovid's use of the verb *cano* here tells us that Pythagoras's eloquent world-picture is more than speech; it is song. At bottom, it is Ovid's song.

All of the songsters in *Metamorphoses* are but a chorus to the great soloist who dominates Ovid's own work of music: Orpheus, the son of Apollo, who gives mythic meaning to the often-used phrase "the power of music." With his lyre Orpheus casts a spell over all of nature. The stones of the earth follow in his path, and trees draw near as he plays his lyre.

When his beloved Eurydice is bitten by a snake and dies, Orpheus's grief is so stunningly intense that everything stops. Even Ovid's perpet-

ual poem, which captures the continuous motion of nature, the pulsating flux of life itself, is now suddenly arrested, and Sisyphus sits still upon his rock to listen. For an unforgettably enduring moment, Ovid's poem is itself still—the ultimate rest in the poet's score.

When the world resumes and Orpheus plays his lyre in grief, all the birds and beasts draw near to listen. He sings many songs, among them that of Pygmalion. It should not escape our attention that the story of a hard statue that comes alive is sung by a singer who is himself seemingly turned to stone in grief at the death of his beloved. Ovid's song about Orpheus's music is not about life or death but about the rhythms of life and death, about how life defines death, about how death gives definition to life.

Ovid sustains his story of stone when he sings of Orpheus's own death, for he is stoned to death by Ciconian women. Whereas stones had previously fallen under the spell of Orpheus, now they are the instruments of his demise. But stones also mourn the bard's death. When the limbs of the dead Orpheus are scattered, his head and lyre float upon the river Hebrus. His instrument makes mournful sounds, his tongue murmurs in doleful harmony with the lyre. When a serpent strikes at Orpheus's head, Apollo intervenes and petrifies the creature's open jaws. Thus ends another of Ovid's stories of stone, in this case one of stone interwoven with music.

Stone and song are also closely interwoven in another of Ovid's stories, which is a myth of the transformation of one form of art into another. In the tale of the treacherous Scylla, who seeks to betray her father Nisus, architecture is metamorphosed into music. The palace of the king rose from walls that sang, because Apollo had once placed his lyre upon its stones, which still resonated with the sound of the god's instrument. Imagine that!

Even the form of a musical instrument provides Ovid the opportunity to intertwine the arts. Describing the wings Daedalus fashions for Icarus, and thus moving beyond the "fine arts," as they have been called, the poet likens their form to that of the pipes of Pan. Through form Ovid unites the art of flying with the art of music. It would almost seem that Ovid, long before Walter Pater, saw all art as aspiring to the condition of music.

No less does art aspire in Ovid to the condition of weaving. The threads of Ovid are woven into the larger fabric of his work as he spins

yarns. Ovid is like the daughters of Minyas, who spin yarn as they tell tales, in other words, spin yarns. They tell the story of Mars and Venus, in which Vulcan makes a net to capture his adulterous wife and her lover, a net so finely spun that it is like the delicate, gracile threads with which Arachne weaves and thus tells her stories. Arachne's weaving is as subtle, Ovid suggests, as the labyrinth of Daedalus, which is threaded by Ariadne. Her golden thread is the clue to the building's form—a form mirrored in the labyrinthine structure of Ovid's own poem. The threads of Ovid's text are also implicitly tied to the strings of the lyres of Apollo and Orpheus, through whom Ovid makes his own music.

Although Ovid's poem is filled with artistic contests, those of Apollo and Pan, Apollo and Marsyas, the Pierides and the Muses, Arachne and Minerva, Ulysses and Ajax, the poet nevertheless achieves a unity or concord of the arts out of such discord. Ovid in a sense competes with Orpheus in song, with Pygmalion and Medusa in sculptural effects, with Daedalus in plotting, with Arachne in the weaving of pictures, but he ultimately achieves an implicit identity with these artists, who, in a sense, are his own personae. In the end, all of the arts are united in the poet himself. The poet is a kind of super-artist who presides over his magnum opus of all the arts.

Neither Wagner's *Gesamtkunstwerk* nor Baudelaire's *correspondances* of the arts, Ovid's synthesis of the arts in *Metamorphoses* is nevertheless an ancient antecedent to all modern explorations of the unity of the arts, just as the poet's self-conscious celebration of himself as a prodigious and multifaceted artist in many forms foreshadows the modern idea of the artist as hero.

Ovid's unified embodiment of all the arts is itself mythic, for the poet is the Protean artist par excellence. Ovid thinks in no uncertain terms of Proteus's capacity to transform himself into a lion, boar, bull, stone, tree, river, or flame as art. Ovid embellishes this art of self-transformation by surrounding Proteus with a cluster of other characters who similarly practice the art of self-transformation: the daughter of Erysichthon transforms herself into a mare, a heifer, and a bull; the river god Achelous transforms himself into a serpent and a bull; the mother of Achilles, Thetis, transforms herself into a bird, a tree, and a tiger; the son of Sleep, Icelos, assumes the forms of beast, bird, and serpent, and another son, Phantasos, wears the forms of earth, rocks, water, and trees. Like Proteus and other Protean figures, ever changing their form, Ovid

is himself a type of Proteus. He appears now in one form, now in another, as he elusively assumes the masks of Pygmalion, Orpheus, Daedalus, Arachne, and the other artists whose stories he tells.

When Ovid transforms himself into a type of Proteus, he does so with extraordinary subtlety. The poet's artful self-transformation thus evokes his definition of art in the story of Pygmalion, where he says that the sculptor's artifice conceals his very art. We can therefore read *Metamorphoses* over and over again without ever seeing that in his extensive celebration of art the core myth is that of Proteus. As Proteus transforms himself into a bull, lion, or serpent, for example, so Ovid transforms himself into an architect, sculptor, or painter.

Of the various metamorphoses in Ovid's poem, the most exalted is that of apotheosis or deification. *Metamorphoses* rises to a series of such transformations toward its conclusion. In the wake of the deification of Hercules, who put off his mortal body and rose beyond the clouds to the stars in a chariot drawn by four heavenly horses, Ovid turns in the final books of the poem to those apotheoses that address the glory of Rome. When Aeneas was purged of his mortal body, he was made a god, as was Romulus, who similarly rose as Quirinus to heaven and took on a new and more beautiful form worthy of the gods, after which his wife also soared heavenward to the stars. These apotheoses, metamorphoses of mortals into gods, are the preparation for the deification of Caesar, whose soul rose to heaven, where he too became a star.

As a prophetic singer, Ovid speaks next of the day when his patron Augustus, who now rules the world, will ascend to the heavens. But this series of metamorphoses as deification, both historical and prophetic, is not yet complete. For in the last lines of his poem or song, which are no mere epilogue, Ovid makes a poetic prophecy of his own fame and glory. He imagines a future when his work will transcend the wrath of Jupiter or time's capacity to consume, a future where the better part of himself will be borne beyond the stars and, if the prophecies of poets are truthful, he will live forever. Thus the ultimate metamorphosis of *Metamorphoses,* the final transformation of the Protean poet.

The story of Ovid's ascent to the stars does not end with his poem, however, for over a millennium later Dante would metamorphose Ovid's ascent into the epic of his own heavenward journey in the *Divine Comedy.* Although ostensibly guided toward the stars by Virgil, Dante, as the poet-hero of his own poem, also writes under the star of Ovid's

"epic of art," which provided the modern poet with an example of extreme artistic self-consciousness. Whereas Ovid appears in multiple guises in *Metamorphoses,* Dante portrays himself as the singular subject of his own "epic of art," which becomes a foundational text for the modern celebration of the artist as hero.

FOUR

DANTE AND THE MODERN CULT OF THE ARTIST

Well over a millennium after Ovid and less than a millennium ago, circa 1300, there began to emerge in Italy, specifically in Tuscany, a new consciousness of the artist—a development that eventually led to the publication in Florence 250 years later of Vasari's *Lives*. A monumental series of biographies of painters, sculptors, and architects from Cimabue to Michelangelo, organized to demonstrate the overall progress of art toward perfection, Vasari's book is seen as the foundation of art history and the broader phenomenon that I wish to call the cult of the artist. The modern fame of the artist as hero in the Western world from the Renaissance masters to Rembrandt, Van Gogh, Picasso, and Jackson Pollock, among many others, extends far beyond art history as an intellectual discipline or field of study. Such glory is closely tied to the rise of the modern art museum and its blockbuster exhibitions of artists as stars; and it is reflected in the celebratory novels, stories, poetry and films about artists that proliferate in our own day.

This aggrandizement of the artist is central to what in the nineteenth century came to be called the religion of art. The elevated status of the artist, called "artificer" by Vasari, is one of the principal distinguishing features of our own culture, since there were no biographies of artists before the modern period. In fact, the celebration of the artist is one of

the many defining features of modernity or, as it is called, Modernism. The famous classical anecdotes about Phidias and Apelles, among other Greek artists of whom Pliny the Elder writes in his *Natural History,* are among the taproots of the modern exaltation of the artist as hero. Despite the glory of such artists in these prebiographical fables, artists remained largely anonymous in ancient Rome and later still in the Middle Ages, as they had been for tens of thousands of years, long before the Greeks—in other words, for most of human history.

The modern idea of the artist as an individual who demonstrates manual skill or poetic imagination has its origins not in the history of art but, as we have seen, in the history of literature, not only in Homer and Ovid but also in Dante. The influence of Dante on modern poetry has been well explored, but surprisingly, his role in shaping the modern view of the artist is still only dimly surmised. In *Purgatorio* 11, Dante wrote famously about Giotto, and what he had to say about the painter's glory was absorbed by Vasari, who quotes the poet's very words. What escapes our attention, however, is the full extent to which Dante's self-reflexive *Comedy* influenced the heroic concept of the modern artist. Dante's persona as poet was easily assimilated to the painter because poetry and painting had been, since classical antiquity, understood to be kindred forms of art. Painting was said to be mute poetry, poetry to be a form of speaking picture. Given this affinity, the glory of poetry could easily be transformed into the glory of painting. And so it was.

Because of his ambiguous place in history, Dante's prominence in the emergence of the cult of the artist is partially eclipsed. Jacob Burckhardt properly saw the poet's quest for glory in relation to the modern, but speaking more fundamentally of Dante's scholasticism as medieval, he thus separated the poet from the early modern or Renaissance artists whom the poet inspired. Dante's self-consciousness as a poet nevertheless foretold the self-consciousness of Ghiberti and Alberti, Cellini and Michelangelo, who, like Dante, wrote autobiographically. Dante brought to his own highly influential self-image as a poet ambitions fueled by the ancient poets who had already quested after glory, and his search for fame was also kindled by modern Italian and French poets, who similarly aspired to renown.

Dante also echoed the artistic ambitions in his own times, the ambitions of sculptors as artificers. When he tells us that Giotto's fame surpassed Cimabue's, he recalls the aspirations of his contemporaries,

Nicola and Giovanni Pisano. Giving the names of both sculptors, father and son, the inscription on the principal fountain in Perugia proclaims that Nicola, the finest flower of sculpture, comes first in art, whereas Giovanni comes next. When Giovanni later signed his pulpit in Pistoia, he reversed their roles in history by stating that he was blessed with higher skill than his father and endowed with greater mastery than any previous artist. Giovanni played Giotto to Nicola's Cimabue.

Dante associates the comparison of Giotto and Cimabue directly with his observation about two poets of his own day: he says that one Guido, by whom he means Cavalcanti, has taken the glory of their language from another, by whom he means Guinicelli. Observing that perhaps one is born who will chase both Guidos from their nest of glory, he implies his own ambitions, which are reflected in the *Comedy,* a work on a scale far surpassing anything ever achieved by either Guido. Although Dante cannot boldly state such ambition in a canto that is about the deadly sin, the *vanagloria,* of pride, his self-conscious competition with his contemporaries is evident.

When Giovani Pisano asserts that he displayed unsurpassed mastery of art in his Pistoia pulpit, he in effect places his work at the summit of art history. With Dante's ironic warning in mind, however, we might well say that Donatello later chased Giovanni from the nest, as Michelangelo eventually surpassed Donatello. Reporting that Michelangelo is now the "cry," having surpassed all artists ancient and modern, Vasari employs the very word, *grido,* that Dante used to describe Giotto's supremacy over Cimabue. Vasari wrote a history that elaborates upon Dante's poem, in which the triumph in poetry and the triumph in painting are implicitly equated. Building on this analogy, the hero of Vasari's *Lives,* Michelangelo, who similarly aspired to glory in art, chose to model himself on Dante, about whom he wrote, "no greater man was ever born."

In order to deepen our sense of Dante's place in the modern celebration of the artist, we must review some of the basic facts concerning his *Comedy,* facts that, although very well known to Dante's readers, should be highlighted here since they illuminate the modern idea of the artist. When Dante begins his poem by speaking of the middle of the journey of "our" life where "I found myself," he establishes himself as a type of Everyman. The original author of the thirteenth-century *Roman de la Rose* spoke abstractly of the poet who pursues his quest for the rose,

but Dante identifies himself with far more graphic detail as the poet-protagonist of his journey toward the heavenly rose. He is both poet and pilgrim, identities that are intertwined, since the quest for artistic perfection is closely tied to spiritual perfection. The relations of poetry and theology in Dante are, as we will see, fundamental to Vasari's image of the artist and later to the modern religion of art.

Although Dante presents himself as a humble pilgrim, no story of an artist, literary or otherwise, in the entire history of the world is more artfully conceived than Dante's account of his journey to paradise—not even Michelangelo's, inspired by Dante's, or Beethoven's heroic story, built out of the Promethean myth of Michelangelo as a type of Creator. When Vasari later refers to Michelangelo as divine, he echoes Dante's biographers, who had earlier spoken of the poet as himself divine.

Dante's poem is a monumental, fictive autobiography rooted in two central facts of his life story: the epiphany of Beatrice to the poet and his exile from Florence. In the *Divine Comedy,* Beatrice guides Dante toward God in the final part of the poet's monumental journey. Although it is an imaginary story based on fantasy, Dante's allegorical autobiography is nonetheless historical, grounded in details from the poet's life, which he presents not as a conventional account in chronological order but by suggestively weaving the facts and circumstances of his life together.

In his autobiographical *Comedy,* Dante writes about his religious and political ideals, about his native Florence, his love of his city, and his condemnation of the city's vices. He writes about his ancestors, family, and friends, his teachers, enemies, and other contemporaries, about the courts at which he flourished in exile, about events of his own day. Because his poem is fictional, it does not follow that it is unhistorical. The distinction we make today between history and fiction, which is of very recent invention, is not one that Dante and his contemporaries would have understood. The Dante whom we know and admire is a composite of Dante the poet who wrote the *Comedy* and Dante the poet who is the subject of his own poem. The identities of these two Dantes are intertwined, historical and fictional at once.

In the fiction of his autobiography, Dante makes himself universal in many ways, above all by typology. Traveling through the desert of hell, he participates in the exile of the Jews; and, undertaking his journey at Eastertide, he identifies his own suffering with the Passion of Jesus. As

the story of Moses and the Jews is rewritten in the Gospels, where the grace of Jesus supplants the laws of Moses, so both biblical texts are rewritten in Dante's allegory: his exile and passion, the exile and passion of the poet.

As a spiritual autobiography, Dante's *Comedy* participates in the tradition of Saint Augustine's *Confessions*. Indeed, his journey to God is inspired by Augustine, even though the saint repudiates his youthful reading of Virgil, whom Dante extols as his mentor and guide. At the same time, Dante's exposition of doctrine throughout his *Comedy* makes of it a kind of *summa theologica* in the tradition of Saint Thomas Aquinas. As much as we dwell on Dante's status as pilgrim journeying toward God, he never allows us to forget that he is a poet, that his pilgrimage is the creation of poetic *fantasia,* which gives shape to the hell, purgatory, and paradise he envisions poetically.

The spiritual matter of Dante's *Comedy* is assimilated to the classical epic tradition of Homer and Virgil. Rewriting the *Aeneid,* Dante embellishes the poet's description of Hades, as, for example, in his own more elaborate account of hell. In a synthetic condensation of genres, Dante writes a modern Christian epic, which, he suggests, surpasses his classical models precisely because it is informed by the truth of Christianity, of Catholic dogma.

Although Dante is humble as he receives guidance from Virgil and Statius, from Matilda and Beatrice, he is nonetheless the sublime hero of his own poem. And here we come to a point so obvious that it is easily ignored. As the subject of his autobiographical epic, Dante makes the poet the hero of the modern epic. Replacing Achilles and Aeneas, who lived by the sword, Dante establishes the poet who wields a pen as the central hero of the epic. Dante is not so much the precursor of the modern artist as hero as he is the inventor and apex of this idea, and all artist-heroes of modernity, descending from him, reflect his exalted stature: Blake, Byron, Wordsworth, Whitman, Rodin, and Picasso. Moreover, all autobiographical art in the modern world takes its measure from the *Divine Comedy,* since it is the unprecedented and unparalleled epic autobiography of the poet or artist.

Dante's exalted stature, literary ambition, and sense of his own place in history are nowhere more vivid than in his encounter in *Inferno* 4 with the great writers of classical antiquity. The poet is here unabashedly proud of the fact that when he visits the "beautiful school" of great

ancient authors, Homer, Horace, Ovid, Lucan, and his guide Virgil, they honor him by making him one of their company. Dante is proud to proclaim that he was the sixth among such luminaries.

In his own view, Dante is not only implicitly greater than his ancient poetic predecessors because of the Christian doctrine of his poetry; he also surpasses them in skill. And he tells us so, for example, in his discussion of the exquisitely artful Ovid. Throughout his own poem Dante echoes *Metamorphoses* in allusions to Medusa, Tiresias, Narcissus, Arachne, Aglauros, Niobe, Procne, Midas, Erysichthon, Meleager, Pyramus, Thisbe, Argus, and Syrinx—allusions that reflect Ovid's authority. But Dante is far more than a modern follower of Ovid. In canto 25 of *Inferno,* where he describes the punishment of the thieves, he urges, "let Ovid be silent about Cadmus and Arethusa" before launching into his own even more spectacular description of a metamorphosis that intertwines snake and human form. With a dazzling display of poetic invention, Dante in effect asserts his superiority over Ovid in the art of poetic metamorphosis, for he is not content merely to mirror the authority of the poets whom he admires.

Dante's extreme self-consciousness as a poet and his poetic prominence are woven throughout *Purgatorio.* In canto 2 he introduces the composer Casella, who celebrates Dante by setting one of his poems to music. In canto 11, as we have already observed, he hints at his own ambition to surpass Guido Guinicelli and Guido Cavalcanti as poets. In canto 21 he presents the poet Statius, who is an important bridge here and in the following cantos between Virgil and Dante's own poetic glory. In canto 24 he introduces the poet Bonagiunta of Lucca, who quotes Dante's poetry and speaks of himself, Giacomo da Lentini, and Guittone as flourishing before the superior *dolce stil novo* of Dante. In canto 26 he presents Guido Guinicelli as his father in poetry, the author of rhymes both lovely and sweet. When Dante praises "modern" poetry, Guido points to the excellence of the Provençal poet Arnaut. Dante thus maps out the poetic terrain of his own day as a means of establishing his own lineage. Arnaut led the way to Guido, who prepared the path that Dante followed triumphantly. When in the next canto Virgil leaves Dante, his great guide crowns him—an act which underscores the modern poet's own ascendancy. Long before Vasari worked out in full the historical development of art leading from one artist to the next and culminating in the crowning of Michelangelo, Dante had already pro-

vided a similar story of poetry, of which he himself was the pinnacle—a history that Vasari's book mirrored in its concept of artistic progress.

Dante's relations to the history of poetry are both exemplary for the history of art and closely tied to his own identity as painter. In the *Vita Nuova*, for example, he is himself an artist, for he tells us that he drew angels on a tablet to commemorate the anniversary of Beatrice's death. Whether fact or poetic fiction, this assertion reflects Dante's artistic persona, and no doubt this aspect of his life as artist is recalled by Leonardo Bruni in his biography of the poet, where he says that Dante drew with distinction.

Far more important to Dante's identity as painter, however, is the way he paints with words. Throughout the *Comedy* he uses the verbs *dipingere* and *pingere* and the past participle, *dipinto*, to convey the effects of what appears painted. Although the poet as painter is a deep convention, this fact of literary history does not diminish the significance of Dante's numerous attempts to speak in pictorial terms, as when he also uses the words *colorare* and *colore*. He speaks of the color of clouds, the light that paints a halo, the light of a star painted in the eyes. He writes of the earth painted with flowers, of painted air and painted angels. He especially pictures the color of faces painted with love, shame, pity, and wonder.

Nowhere are Dante's aspirations to the pictorial more ambitiously expressed, if with apparent humility, than in *Purgatorio* 32, where he invokes Argus: "If I could paint the way the pitiless eyes, hearing of Syrinx, were put to sleep, the eyes whose long watching cost so dear, I would draw as a painter paints from a model how I fell asleep, but let him, who will, give form to sleep." Dante here uses a rich vocabulary of art—*ritrar, pintor, pinga, disegnare, finga*. Emblematic of painting as an ocular art, of painting as applied optics, the eyes of Argus remind us that Dante's poem is itself intensely ocular, is about what the eyes see, about visual or optical experience. *Aprire gli occhi, bassare gli occhi, levare gli occhi, torcere gli occhi, volgere gli occhi*—to open, lower, raise, and turn the eyes— these phrases are just a part of the vast network of ocular allusions in Dante, of which, above all, *ficcare gli occhi*, to fix the eyes, is a dominating form, as he fixes the reader's eyes on his story as something pictured. Over and over again, as his close readers know full well, Dante uses the verbs of seeing—*guardare, riguardare, vedere, rivedere, mirare, occhiare*, and

their various forms—to frame, to picture, what unfolds in his narrative as something seen by the eyes.

Although Dante was heir to a tradition of poetry that spoke endlessly and variously of love entering the lover's eyes, his way of telling the story of his journey as ocular experience moves far beyond this convention. I hazard the suggestion that nowhere in all of literature is there on the scale of Dante's epic such a sustained, complex, and rich description of events as phenomena seen or *viste* as in his *Comedy*. Again and again Dante the pilgrim is exhorted to see (*vedi, vedi, vedi*), and repeatedly he tells us he saw (*vedea, vedea, vedea*). Dante's poem is surely one of the greatest visual works in all of literature, and although we cannot easily measure its exact influence on the pictorial imagination of the great artists of the Italian Renaissance, we cannot ignore its deep affinities with the visual history that extends from Giotto to Michelangelo, from the former's Jesus gazing deeply into the eyes of Judas in Padua to the latter's Sistine ceiling seers, who gaze into the future with spiritual eyes.

Telling us repeatedly what he saw as he journeyed through hell, purgatory, and paradise, Dante always makes us aware of his viewpoint as he looks forward, up, down, or around. Viewpoint is the poet's point of view as he observes the objects of the external world. Viewpoint is perspective, the perspective of the painter or, in this case, the poet-pilgrim, who is a painter in words. As Dante the pilgrim moves through space and gives his multiple viewpoints, he participates in the history of perspective. We are therefore not surprised to read Vasari's claim that Brunelleschi, the inventor of modern pictorial perspective, made studies of Dante's poem, of its sites and their proportions. In the study of perspective, Dante was Brunelleschi's precursor.

If Dante associates his own ascendancy in poetry with Giotto's triumph in painting, Vasari, reversing this relation, connects the glory of Giotto with Dante's greatness. Building on a fourteenth-century tradition, Vasari speaks of the poet and painter as very great friends, even though there is no evidence whatsoever that this was the case, that they even knew each other. As he weaves their lives together, Vasari connects their respective travels throughout Italy, he tells us Giotto made a portrait of Dante, and he even suggests that Dante was responsible for the subjects of Giotto's painting in both Assisi and Naples. The myth of Giotto's association with Dante was so powerful that long after Vasari, in the nineteenth century, there flourished a legend—subsequently for-

gotten, but recently remembered—according to which Dante sat upon a stone next to the Cathedral of Florence in order to watch Giotto build his bell tower. No matter that by the time of Giotto's tower, not only had Dante been exiled, he was dead.

Of all the connections between Giotto and Dante in Vasari's biography (and we have touched on only some of these), one of the most subtle is found in the form of Angelo Poliziano's epitaph inscribed on the artist's memorial in the cathedral, which Vasari quotes in full. Speaking in the first person in the epitaph, Giotto says that he revived the art of painting, that his tower reaches to the stars, and that his deeds are worthy of a long poem. Giotto thus evokes Dante's long autobiographical poem, in which the author celebrates his own triumph in poetry, and not only recalls the aspirations of the ancient poets, notably Horace and Ovid, but more immediately suggests Dante's repeated assertions of his own journey to the stars—a journey to paradise that is indissolubly spiritual and artistic.

Poliziano's fiction of Giotto portraying himself in words evokes a well-known proverb sometimes attributed to him: "Every painter paints himself." Although this proverb is usually related to Alberti's assertion that the self-regarding Narcissus was the first painter, we should recall that Ovid had established the artistic implications of Narcissus in the first place both by comparing the beautiful youth's reflection to a figure in marble and by employing the language of art to describe his image: *forma, imago, signum, simulacrum,* and *umbra.* Furthermore, the path of Alberti back to Ovid was through Dante, who wrote in one of his lyrics: "He who paints a figure cannot realize it if he doesn't become that figure." The Dante who is the subject of his own *Comedy* is the self-reflective *figura* of the poet himself.

Dante's celebration of his own artistic greatness as poet is the point of departure for Boccaccio's *Decameron.* Boccaccio, who commented famously on Dante's poem and wrote a biography of its author, imitated him in many respects, above all, in the form of his book, his 100 *novelle* corresponding pointedly to Dante's 100 cantos. Beginning his book within the infernal context of the plague with a story about a character, Cepperello, who personifies many sins associated with hell, and moving to the final story of Griselda's selfless love worthy of paradise, Boccaccio mirrors the progress of Dante's poem from hell to heaven. For all the earthiness of his own comedy, Boccaccio shares Dante's theological con-

victions. In Boccaccio's book, Dante is the ubiquitous if invisible guide, the Virgil of his own comedy.

Like Dante's *Comedy,* Boccaccio's book is also conspicuously about art. As poets dominate Dante's poem, painters figure prominently in Boccaccio's work—not only Giotto, Bruno, Buffalmacco, and Calandrino, but also the very first artist, God. Bruno, Buffalmacco, and Calandrino are the only characters who reappear over and over again in the *Decameron.* Two of these painters are, above all, tricksters, while the other is their gull. Without such a fool there is no trick, no artifice, no illusion. We recall, for example, how Bruno and Buffalmacco trick Calandrino into believing he is invisible or pregnant. Taken together, these characters are personifications of painting, which is a trick that fools the beholder, who, entering into the fiction of art, suspends disbelief and yields to such artifice. As in painting, so in poetry. Painters are thus the personae of Boccaccio, himself a supreme illusionist, and we happily yield to the author's fictions, as we yield to the illusions of painters.

Without Dante's heroic presentation of himself as poet in the *Comedy* we would not have Boccaccio's portrayal of the mock-heroic artist. For without the heroic there is no mock-heroic. Boccaccio brings the heroic and mock-heroic together ironically in his famous story of Giotto. Echoing Dante's celebration of Giotto's glory, presenting him as the finest painter of his day, Boccaccio, as we have seen, mocks both his physical deformity and ridiculous appearance when the artist becomes disheveled and mud-spattered during a rainstorm. In short, Giotto is magisterial and ludicrous, exalted and mocked, heroic and antiheroic.

Boccaccio carries the mock-heroic to sublime heights in the story following Giotto's, where God fashions the ugly Baronci before he makes any other man, that is, before God fashioned Adam, who is traditionally understood to be the first sculpture, molded out of earth. Boccaccio reinforces this allusion to the creation of man on the sixth day by presenting his story as the sixth tale on the sixth day of *Decameron.* Likening the deformed faces of the Baronci to the defective drawings made by children when they are still learning to draw, Boccaccio is explicit about God's identity as artist. What he is saying here is that before God achieved the sublime perfection of Adam, a masterpiece of sculpture, he was a deficient, indeed ridiculous, artist. The hideous Baronci are evidence of that. God in Boccaccio is the mock-heroic artist par excellence.

As in the companion story of Giotto, who was as ugly as the Baronci, mockery of the artist is based on the artist's heroic image—an exalted image that descends from Dante.

Nowhere, I believe, is Boccaccio's attention to art more profoundly and amusingly appreciated in the entire modern era than in Pier Paolo Pasolini's film *Decameron*. Beginning, like Boccaccio, with Cepperello, Pasolini dwells, however, on the character of Giotto, who, becoming the star of the film, dreams of creating a great spiritual masterpiece, a fresco which evokes both Giotto's *Last Judgment* and Dante's vision of heaven and hell. Playing the role of Giotto, Pasolini recalls Dante's self-representation as poet-pilgrim in the *Comedy*. As he aspires to paint a great visionary work, Pasolini's Giotto is a sublime figure, but in his moments of frenzied inspiration he is also ridiculous or, we should say, self-mocking. Since Giotto is Pasolini's persona in the film, the artist's fresco stands for his own visual art as filmmaker. Sublime and ludicrous, heroic and mock-heroic, Pasolini in the guise of Giotto descends self-consciously both from Boccaccio and from Dante.

When Vasari wrote his monumental *Lives* over two centuries after Dante, his book was not only rooted in the poet's celebration of the heroic artist, epitomized now by the new Dante, Michelangelo; it was written in the prose idiom of Boccaccio. In one very short and familiar story about Giotto, a tale of praise and mockery, Vasari tells us that after the artist painted a fly on the nose of a figure rendered earlier by Cimabue, the latter, fooled by Giotto's illusion, tried to brush the fly away. Vasari's story is a reaffirmation of Dante's claim that Giotto surpassed Cimabue—a claim delivered as mockery of the Calandrino-like Cimabue.

Like Dante's *Comedy* and Boccaccio's Dantesque *Decameron,* Vasari's Dante-inspired *Lives* is a work interweaving theology and aesthetics. The story of artistic development from Cimabue, surpassed by Giotto, to Michelangelo in the *Lives* is the history in three parts (echoing the tripartite structure of the *Comedy*) of the journey of art to perfection—a perfection in art ultimately compared to the perfection of God. Vasari's greatest artist, Michelangelo, is "divine" precisely because the perfection of his art evokes God's perfection. Vasari illuminates this relation of perfection in art to divine perfection in different ways. He tells us, for example, that God seems to have presented through the hand of Michelangelo in his *Moses* the prophetic image of what the perfected body of the

blessed will look like when resurrected at the end of time, and he similarly speaks of the most perfectly proportioned figures in Michelangelo's fresco of the *Last Judgment,* which suggest the perfected bodies of the blessed at their resurrection. In Dante's words, we might well say that for Vasari Michelangelo's art renders an approximation of the "perfect vision" of paradise. We tend to overlook the deep theology that informs Vasari's aesthetics, but for him, as for Dante, the artist and the pilgrim cannot be separated as they journey toward perfection.

Of all the biographies Vasari wrote about the artistic quest for perfection, few are as compelling and influential as his story of Leonardo, a painter who, aspiring to artistic perfection, nevertheless left most of his work unfinished or "imperfect." The *Last Supper* is the most sublime example of such unattained perfection. Although the artist gave majesty and beauty to his Apostles, as Vasari writes, he left the head of Jesus unfinished because he could not give to it the celestial divinity that the image required, or so Vasari pretends. Leonardo could not, Vasari adds, conceive in his imagination the celestial grace and beauty worthy of divinity incarnate.

It generally escapes attention that Vasari's Leonardo, who failed to realize fully the perfection to which he aspired in all his works, but especially his *Last Supper,* is an important ancestor of Balzac's mythic Frenhofer, the archetypal artist of modernity in "The Unknown Masterpiece." Striving sublimely to achieve a supreme masterwork in painting but failing to do so, Frenhofer both inspired and spoke for many modern masters in all genres of art: Zola, Henry James, Cézanne, and above all, Picasso. With Balzac's hero in mind, we can speak of the modern religion of art, in which the artist aspires to achieve the purity of an absolute art beyond his powers, an absolute that Vasari, following Dante, had previously associated with God. Calling his monumental corpus of fiction the *Human Comedy,* Balzac implies that his own heroic vision of art has its deep roots in Dante, in Dante's *Divine Comedy.*

If Frenhofer leads us back to Vasari's Leonardo, the fiction of artistic failure carries us full circle to Dante. For when Vasari speaks of Leonardo's inability to realize the image of divinity incarnate, he evokes the very end of Dante's poem, which tells of the limits of art in its spiritual quest. Leonardo's unsuccessful attempt to render the ultimate mystery of incarnational theology in a work of sublime beauty recalls that final moment of *Paradiso* when the exalted poet-pilgrim, having beheld the

vision of the Trinity, nevertheless cannot find the words to describe it. The poet says of his ineffable vision that "it seemed painted with our image," a phrase that suggests the pictorial image of divinity in the flesh to which Vasari's Leonardo also aspires as a visionary artist. Although Dante ultimately cannot find the words to describe what he has seen, he nevertheless conveys to his readers a sublime image of the heights to which he has journeyed. Telling the story of his heroic and exemplary travels as both pilgrim and poet, indeed as epic hero, Dante not only gives shape to the exalted modern idea of the artist, but also paradoxically defines the very limits of art—the powerful sense of an unattainable absolute that transcends the perfection of art.

FIVE

VASARI AND THE QUIXOTIC PAINTER

Let us now descend from the sublime heights of Dante's paradise to the ridiculous—to the purgatory of art history, in which we encounter one of the most delightful of all artists. I speak of Paolo Uccello. We all know him. He's the lovable fifteenth-century Florentine painted who pictured Sir John Hawkwood, "that ghostly chessman," as Mary McCarthy called him, in the dark Gothic cathedral of Florence. He is also the designer of three equally famous paintings of the Battle of San Romano, chivalric romances in which brightly colored toy soldiers or equestrian puppets deploy their richly patterned lances in, of all places, an orange bower, going to war in a garden.

Uccello has always worked his magic in weird ways. Arshile Gorky kept large photographs of the San Romano battle paintings tacked to his studio wall, and we can almost see the complex, multifaceted forms of the Florentine's highly intricate art dissolving into the evocative, still surreal abstractions that float in the dreamworld of the Modernist's canvases. Italo Calvino, who loved the romance of Ariosto and who even invented a "nonexistent knight," imagined the armor of Uccello's horsemen momentarily voided of human presences, filled with birds, next transformed into crustaceans—all this transmogrified into a fantastical battle between avian creatures and shellfish. Gregory Corso, that

beatnik lyricist who spoke lightheartedly of the "knitted lances" of Uccello's battle, as if evoking so many gigantic knitting needles, listened to the paintings' metallic music, to "each combatant's mouth . . . a castle of song / each iron fist a dreamy gong." Although Uccello's pictures show soldiers dying in perspective, Corso sees them alive for eternity, never expiring, and he wishes to enter into this timeless enchantment. "How I dream to join such battle," he writes, "never to die but to be endless / a golden prince of pictorial war." The playful turn of Corso's fantasy is unmistakable, for he evokes the "flowery tale" of Keats's "Grecian Urn," a pastoral of "happy, happy boughs," of "happy, happy love," of lovers "forever young." Like Keats's lovers, Corso's soldiers, suspended in art beyond time, will never die.

But who was this painter who so fired the imagination of other artists and poets? Will we ever know? Six years before he died in 1475, Uccello wrote to the Florentine tax office, in one of the few documents we have of his life, "I am old and sick, my wife is ill, and I can no longer work." Such utterances by themselves, however, do not a biography make, and it was not until seventy-five years after his death that Vasari wrote the painter's biography in his fabulous *Lives* of the artists. Uccello emerges here, like the personages of his own art, as himself a fictional character. He is a bit of a simpleton or fool, who paints a camel where he should have painted a chameleon. He is an artist lost in the study of his "sweet perspective" when his wife calls him to sleep. He is a painter who entered through such perspective into the realm of uncertainty, as Donatello said when shown one of Uccello's overwrought works. The painter became increasingly melancholic, solitary, and strange, almost savage in his decline, dying in poverty and discontent. Uccello says that the abbot at San Miniato, where he is painting, has given him so much cheese to eat that he doesn't know anymore whether, if this diet is continued, he will remain himself or turn to cheese. He reminds us of Boccaccio's goofy Calandrino, another painter easily deceived, who is convinced on one occasion that he is invisible and on another that he is pregnant. He reminds us too of the fat carpenter, who is tricked by Brunelleschi (with the help of Donatello) into believing he is not himself. Playing on Uccello's name, which means "bird," Vasari metamorphoses him into a simple reincarnation of the proverbial Calandrino, whose name also suggests a bird, in this case, a titlark. The word "bird" in Italian also means a simpleton, and as Calandrino is a featherhead, a

dodo, a booby, or a turkey, as we might say, Uccello is a bit of a bird-brain, a gull, a gullible fellow. Who ever heard of a painter who became a cheese?

Why was Paolo Uccello, whose legal name was Paolo di Dono, called Uccello? Vasari claims or pretends that he was so named because the painter, who especially loved birds (as well as all animals), painted them into his works because he was so poor that he could not afford to purchase them. But "who has scared all these birds away?" Italo Calvino asked. There are almost no birds in Uccello's known works, although, as Vasari says, the painter did render "birds in perspective" in one fresco at Santa Maria Novella. Did all the other birds fly away, like those painted by Bartolo Gioggi in one delightful story of the fourteenth century told by Franco Sacchetti? Or is Vasari fantasizing?

Paolo Uccello is part of the menagerie of Vasari's imagination. He is like the strange and eccentric Piero di Cosimo, who draws lots of birds and beasts and is himself a wild man, bestial in his ways. Although Piero, like Uccello, is a painter in real life, his biography, for all its facts, is deeply fictional—a fact that many literal-minded art historians have trouble assimilating, since they ignore the role of fiction in shaping history. To say that Piero's or Uccello's biography is conceived imaginatively is not to deny that the artists existed or that Vasari's biographies of these artists are filled with facts. It is to recognize that these biographies are shaped, are deeply fictive.

Uccello also resembles Leonardo, who similarly loved birds, but whereas Uccello wished to keep them, Leonardo would buy them so that he could release them from their cages, giving them their freedom. A lover of other living creatures, like Uccello, Leonardo brought lizards, serpents, and insects into his studio, where he fashioned a creature like Medusa, or so Vasari pretends, and applied quicksilver to a lizard, adding wings to turn the creature into a sort of terrifying dragon in order to frighten his visitors. Otherwise a paradigm of courtly grace, Leonardo was sometimes just a bit weird and indulged in his own "madness" when he made balloons out of the guts of animals.

Strange artists who love animals are everywhere in the poetical imagination. Vasari says that Leonardo's disciple Rustici, himself a magician, had many snakes in his home. He also kept a porcupine under his table, which rubbed itself like a dog against the legs of his visitors, to their considerable discomfort. Animals were everywhere to be seen in

the house of the painter Sodoma, who was called "Little Fool" by one of his patrons. Sodoma kept badgers, squirrels, marmosets, asses, horses, jays, fowl, turtledoves, even a raven which answered in perfect imitation of its master's voice whenever anyone knocked at the door. Sodoma's house was, Vasari states, a veritable Noah's Ark. The painter possessed all the animals and birds that poor Uccello desired. We do not know all the facts of Sodoma's life, but we can be reasonably confident that Vasari's account of the painter is at the very least a poetical embellishment of the facts, an account enriched by fiction.

Whereas Uccello is related by implication to all of Vasari's strange, animal-loving painters, he is explicitly connected to the eccentric hermetic Pontormo, who also lived in solitude. The art of both painters, Vasari says, comparing them directly, is overdone, too labored, and transcends the bounds of the respective artists' natural gifts. No less than Uccello does Pontormo fantasticate contrived pictorial devices that, leaving the real world behind, reach beyond the boundaries of the acceptable in art.

When we step back and look at Uccello afresh, we see that in the excessive fantasy and obsessive fervor of his quest for perspective, he is the Don Quixote of painters, an artistic ancestor of the Knight of the Doleful Countenance. Poetically seeking to refashion the world in accord with his perspectival dreams that rise beyond "reality," Uccello is a knight-errant of painters, as Quixote, steeped in the conventions of romance, is himself a poet, reimagining the world in accord with his chivalric fantasies. No matter that the Arno Valley of Uccello is far in time and place from the plain of Quixote's La Mancha. No matter that we cannot easily trace the path from one place to the other in the maze of imagination. The simple, foolish, deluded, even mad Florentine painter is a Don Quixote *avant la lettre,* tilting at the windmills of perspectival fantasy. The beloved books of Euclid on geometry and optics are to Uccello what *Amadis of Gaul* is to Don Quixote.

Is not our quixotic painter, possessed by perspective and out of touch with the real world, as Vasari imagined him into being, not the first obsessive artist in the history of art? And if so, is he not one of the ancestors of Frenhofer in Balzac's "The Unknown Masterpiece?" Balzac's crazed old painter had labored for ten years on a portrait of a courtesan, seeking not just to paint her likeness but to invest her with the spirit of life! When he finally reveals his picture to Poussin, the image is

a multitude of fantastical lines, a fog of formlessness. Under this confusion, no less baffling than Uccello's overdone perspective studies shown to Donatello, there does appear a perfectly rendered foot—a dim clue of the unattainable goal of the mad painter, who expires immediately after exposing his "masterpiece."

Although we cannot easily trace the obscure path from Uccello to Quixote, the maze from Uccello to Frenhofer and from Frenhofer back to Uccello is threadable. Half a century after Balzac told his romantic tale of futile artistic ambition, Marcel Schwob retold Vasari's fable of the legendary Uccello, rewriting it through Balzac's own tale of art. Schwob's story, told in his *Imaginary Lives,* is a fable of tender pathos. Lost in the folly of his perspective studies, Uccello lives like a hermit. One day he beholds a young girl, his Beatrice, his Laura, who smiles at him. Noting all the subtle forms of her face, as only he can, Uccello loves her and takes her home with him. In the evenings when Brunelleschi comes to study with Uccello, she falls asleep in the circle of the shadow cast by the painter's lamp. When she awakens in the morning she is surrounded by all the birds and beasts painted by Uccello. Although the artist never painted her portrait, he nevertheless distilled all of her forms in the crucible of his art, likened to that of an alchemist, in which he also gathered all the lineaments of plants and stones, of the rays of light, of the waves of the sea. Lost in his studies like a hermit in his devotion or an alchemist in his search for a universal elixir, Uccello becomes forgetful of the young girl, who eventually perishes, starving to death. Uccello now studies the contours of her inert body, as he once recorded them in life, creating not a portrait as such but new forms of art.

Uccello grows old, Schwob writes, and no one can comprehend his work. One sees in it only a confusion of lines. After working for years on an *oeuvre suprême,* Uccello creates not the image of the earth, plants, animals, or men, but only a jumble of lines. Although Donatello thinks his painting flawed, Uccello believes he has worked a miracle in art. When Uccello finally dies in his garret, his eyes are fixed on the mystery revealed to him, as if he had achieved his unattainable goal. In his hand he holds a round piece of parchment covered with interlacing lines that radiate from the center to the circumference and back again. Schwob's Uccello believes that he has created a masterpiece, whereas all that one sees in his supreme achievement is a confusion of forms like those of Frenhofer.

The labyrinth of literary history is often more complex than we allow. Might we not wonder in the first place about the sources of Balzac's story? Whatever the exact intermediary path might be, it is rooted in Vasari's fables of strange, solitary artists like Uccello, who, aspiring to the perfection of their art, labored slowly and haltingly over a long period of time only to produce works that were confused or deformed. Although Balzac sets his tale in a Paris of earlier times, writing an allegorical "fable of modern art," this fact should not prevent us from penetrating to its taproots in Italian legend. If ever the full history of obsession is written, including the history of the obsessive artist, this account will need to be channeled into the meandering migrations of Vasari's fables of artistic obsession into the mainstream of Modernism.

Balzac's fable of art, appropriated by Schwob and projected retrospectively into Vasari's fable of Uccello, worked its spell on Zola, whose novel *L'oeuvre* (translated with license as *The Masterpiece*) is about the Frenhofer-like artist Claude Lantier, inspired in part by the real painter Cézanne, who later identified himself spiritually "as the very person" of Balzac's story. This fusion of fact and fiction induces vertigo. A real painter identifies with a fictional artist, who descends from an imaginary Boccaccesque painter, who is fabricated from a real artist. In the intricate maze of history, the boundaries between the real and the imaginary dissolve, the real becoming fictional, the imaginary becoming real. Uccello is a type of Calandrino or fat carpenter; Frenhofer, who descends from Uccello, comes to life as Cézanne, who says, in effect, "Frenhofer, c'est moi."

But the story does not end here, for the obsessive Frenhofer also becomes the subject of contemplation for Picasso, some of whose playful drawings for an edition of "The Unknown Masterpiece" evoke the elaborate jumble of lines of Schwob's Frenhoferian Uccello and Vasari's proto-Frenhoferian Uccello lost in the uncertainty of his overly contrived perspective devices—an artist who labors unrelentingly, if not anxiously, against the freight of negative critical judgment and failure. Uccello also comes to mind when Picasso's friend Apollinaire writes in praise of Douanier Rousseau, a painter of animals, flowers, and children, of primitive dreams and jungles, the supposedly naïve painter whom the poet likens to Uccello. The fifteenth-century Florentine painter thus emerges in the modern imagination as a sort of quattrocento primitive

like Douanier Rousseau, although Apollinaire does acknowledge that Uccello's technique is superior.

The labyrinthine paths of Uccello lead us back and forth through history, as through a maze—back to Ruskin, convinced that the painter "went off his head with love of perspective," forward to Joan Miró, fascinated by the artist's pictorial structures, and back again to Swinburne's contemporaries, who saw the poet's very likeness in the *Battle of San Romano.* But before we depart this bewildering network of poetical fantasy, let us attend to one of the most beguiling transformations of Uccello in the modern period, this a poem by Giovanni Pascoli from the *Italic Poems,* recalled by Calvino—a free rewriting of Vasari's biography of Uccello no less imaginary than Schwob's *vie imaginaire* of the painter.

In Pascoli's poetical fantasia, after Uccello returns from the market, where he has seen all the birds he cannot afford to purchase, he sadly paints one of them; he also adorns his room with field, flowers, and trees, filled with all the other birds he could not acquire—titmice, nightingales, swans, ravens, eagles, doves, birds with blue, red, green, and yellow plumage. So lost is Uccello in the contemplation of his beloved, imaginary birds that he is deaf to the bells of the cathedral, sounding the hour of Ave Maria. Saint Francis appears to *frate Uccello,* telling him that he must not covet the little birds, which should be allowed to keep their freedom. Speaking to Uccello as he had once preached to the *uccellini,* the little birds themselves, the saint miraculously brings to life all the birds that Uccello had painted in his house. They fly down to the artist, who blissfully falls asleep as a nightingale sings.

The real Paolo Uccello, as we noted, is a shadowy figure, scarcely known to us from the relatively few paintings and documents that have survived, all of which by themselves hardly constitute a "life." The painter nonetheless looms larger than life in the imagination as a legendary figure. A quixotic, obsessive painter, no less preoccupied with birds than with reaching the unattainable perfection of perspective, he is a great-grandfather of all modern artists, real or imaginary, who strive to achieve the unattainable in their art. But in contrast to the complex, dark temperaments of the Modernists, real and imaginary, of Frenhofer and Cézanne, Uccello, who pursues the complexities of perspective, is, finally, and perhaps paradoxically, a bit of a simpleton. Working in solitude, he is a saintly hermit, a devoted scholar of Euclid, an alchemist

among painters. Scarcely tragic, he is pathetic, sweet, and ingenuous, a primitive, a child, a madman, who embodies the fantasies of Romantic innocence, spirituality, imagination, and even insanity. Contemplating this odd, gentle fool, who was once almost turned into a cheese, as he thought, we can only wonder at the amazing powers of fantasy itself, which has metamorphosed the historical Paolo di Dono into the strange, captivating, and fictional being who haunts our poetical imagination no less than he was once so sweetly possessed by his own strange perspective.

SIX

LEONARDO, VASARI, AND THE HISTORICAL IMAGINATION

Although Vasari's *Lives* of the artists is the foundational text in the formation of modern art history and has consequently inspired a huge body of criticism and scholarship, the investigation of his fecund work remains partial, some might even say superficial. Aspects of his book have been carefully examined, such as his use of sources, his theory of art, and his criticism, but surprisingly little attention has been paid by students of Renaissance culture—by historians, art historians, and scholars of literature alike—to his historical imagination.

As deeply poetical as it is historically shrewd, Vasari's imagination abounds in his fine prose, nowhere more clearly than in the fables or *novelle* which inform his biographies of the artists. Of all these tales one of the richest and most famous is the story Vasari tells of how the young Leonardo, on a small, wooden shield or buckler, painted a monster that was intended to produce the effect of the fabled Medusa. In the nineteenth century, Walter Pater sensed that this story was a fiction, "perhaps an invention," as he said, but he also recognized its "air of truth," by which he meant its historical verisimilitude. Although for a very long time art historians often misread Vasari, either misconstruing his fictions as facts or misidentifying them as errors, in recent years they have returned increasingly to Pater's point of view, recognizing the deeper

truths of Vasari's poetic fabrications. Not surprisingly, Pater's historical acumen in reading Vasari, as in his appreciation of other Renaissance artists and writers, has been undervalued or ignored by modern scholars who have sought to distance themselves from Pater's highly poetic sensibility and aestheticism. The modern scholarly hostility to poetical criticism is, more deeply, a main obstacle to the comprehension of the poetry in Vasari, whose book is still read too cursorily. If we acknowledge, however, that Vasari's poetic sensibility is not inimical to an understanding of history, that it is in fact essential to such historical understanding, we find an unexpected, indeed exemplary, depth in Vasari's historical imagination, nowhere more so than in the still surprisingly little-examined fable of Leonardo's shield.

As the story goes, Vasari writes in his biography of Leonardo, the artist's father Ser Piero was at his farm when he was sought out by one of his peasants, who had made a buckler from a fig tree that he had cut down. The peasant wanted Ser Piero to have the buckler painted in Florence, which the latter was happy to arrange, as he had made good use of the peasant's skill in hunting and fishing. Piero next brought the buckler to the city, where he asked Leonardo to paint something on it. Seeing that the shield was crooked, for it was badly worked, Leonardo straightened it before giving it to a turner, who made the object smooth and even. Leonardo next prepared the buckler for painting, pondering what he might depict that would frighten the viewer with the effect of the Medusa.

Leonardo then brought into his room, which no one else ever entered, lizards large and small, crickets, snakes, butterflies, grasshoppers, and bats, and, out of this multitude of creatures variously combined, he fashioned the image of a very frightening, indeed terrifying, monster, which poisoned the air with its breath. Fire flashing from its eyes, it breathed smoke as it emerged from a jagged rock. So great was Leonardo's love of art that he was oblivious to the stench of the dead creatures employed as models for his monster. Upon completion of his labor, Leonardo sent word to his father that he could come fetch it. Piero soon arrived at Leonardo's house, and Leonardo greeted him by requesting that he wait just a minute. The young painter, returning to his room, then placed the buckler on an easel and adjusted the window so that the light would fall softly upon his painting, then asked his father in to see the work. Ser Piero was shocked, indeed shaken, by what he saw, not

believing he was looking at a figure painted on a buckler. Leonardo pronounced that his work had served its purpose and that Ser Piero could now take it away. Before carrying it off, Piero praised his son's invention, which was miraculous.

The story does not end here. Leonardo's father never returned the buckler to the peasant. Instead, he bought another buckler from a peddler, which showed a heart pierced by an arrow, and gave this lesser object to the peasant, who remained indebted to Ser Piero for the rest of his days. Leonardo's father then sold the shield to merchants for a hundred ducats, and a short time later they sold it for three hundred ducats to the duke of Milan. Thus ends Vasari's delightful, seemingly simple, straightforward story.

Less than five hundred words and only twelve sentences long in the original version, Vasari's fable has eight characters, including the painted monster. Of these, Leonardo, his father, and the peasant are the principal actors. The tale carries us from the countryside of Vinci to Florence and, finally, the court of Milan. The object that lies at the center of the story changes hands no fewer than seven times! The peasant gives it to Leonardo's father, who brings it to his son, who delivers it to a turner, who returns it to the artist, who gives it back to his father, who sells it to merchants, who, in turn, sell it to the duke of Milan. The story, reflecting the place of art in the social hierarchy, evokes the worlds of agriculture, commerce, art collecting, and science. Even more than one might initially realize, it also embodies a philosophy of art, one presented in *novella* form! Vasari's fable is itself a miniature history of art, indeed an allegory of art, which traces the evolution of art from its primordial origins in nature to its final status of refinement and prized excellence at court. The object painted by Leonardo has its beginnings in one of the "arts," that of agriculture. The cultivation of the fig tree here has literary resonance and redolence, for it brings to mind the cultivation of trees in Virgil's *Eclogues,* as Ser Piero's farm also evokes the world of the *Georgics.* A villa, Ser Piero's farm thus suggests the gentleman's life in the country. We enter through Vasari's fable into the world of the pastoral, the allusion to the peasant's fishing calling to mind what Sannazaro referred to as the "piscatorial eclogue." All in all, Vasari's fable reminds us how the urbane city dweller or courtier cultivates himself in the country, in nature, as seen in classical and Renaissance pastoral poetry, in such pictorial *poesie* as Titian's *Pastorale,* where a refined courtier joins a simple peasant

in song, or Signorelli's *Kingdom of Pan,* a paradoxical rustic court. Like such mute poetry, Vasari's word picture finds the roots of art deep in the pastoral greenworld. Nature, his fable tells us, is the very source of art. Vasari's pastoral fable about the refinement of art points toward a striking conjunction in the history of art in Italy circa 1500—the twin birth of the pastoral and the ideal of *bella maniera.* Like the vision of the "perfect manner" in art, that of the pastoral is shaped by the concept of urbanity and sophistication.

The tree felled by the peasant and the shape of the object he makes from it both are wittily and meaningfully invented by Vasari. Immediately before his *novella* of the buckler, Vasari describes in detail a cartoon, then in the house of Vasari's patron Ottaviano de' Medici, that Leonardo made of Adam and Eve expelled from the Earthly Paradise. Vasari is especially interested in the two trees of paradise depicted by the artist. One of the trees is, not coincidentally, a fig tree painted with love and patience, the other a date palm worked with marvelous artifice. What should interest us here is the shape of the palm, for the crown of the tree is, as Vasari says, round as wheels or *ruote.* It cannot escape us therefore that when Vasari describes the peasant making a *rotella* or shield from a fig tree, he has ingeniously grafted the one tree of paradise to the other, giving to the fig, as it is transformed into a *rotella,* the form of the palm, *ruote.* Such fantasy already foretells the way in which Vasari's Leonardo would combine insects and animals as the monster of the buckler.

The fig tree cut down by the peasant thus has its poetical roots in Paradise, in what Vasari calls the "divine world" or *mondo divino.* It alludes to Paradise Lost, for when the fable opens with a man laboring on a farm, we are encouraged to think of how after the Fall the progeny of Adam and Eve were condemned to labor. Like Cain, the peasant on Ser Piero's farm is a tiller of the soil. Vasari's classical pastoral, his georgic or eclogue, has decidedly biblical connotations, pointing us back to the very origins of the manual arts.

Immediately antecedent to his description of the cartoon of the Earthly Paradise, Vasari speaks of Leonardo as *giovanetto* when Ser Piero brought him to work under Verrocchio. In this context, Leonardo is still a youth when he is called upon to decorate the buckler. Vasari's fable is a cameo biography, for it carries us, as we shall presently see, from the painter's childhood to his maturity as court artist. Coming into the possession of the duke of Milan, the buckler foretells Leonardo's career at

the Milanese court. Biography here is tied to history, since the painter's origins in his childhood or *fanciullezza* are coincident with the infancy of art in nature. The painter's beginnings are neatly wedded to the deep origins of art in Vasari's historical allegory.

The peasant in Vasari's story is a crude manual laborer at the beginnings of the story of art, his buckler badly worked, *roza,* rude. After Leonardo brings more art to the object, straightening it, he gives it to a turner, who, as a carpenter, would have belonged to the guild or *arte* of the stonecutters. His improvement of the buckler, which he makes smooth and even, is part of the progress of art as a manual skill, between the original rudeness of the peasant's crude labor and the eventual perfection of the object when, with astonishing skill, Leonardo adorns it. The story as it unfolds follows a trajectory in the larger scheme of the arts from agriculture to woodworking or carpentry to painting, from *rozezza* or rudeness to *delicatezza* or refinement, the state of finish or *finezza*. So fine was the shield, we recall, that Leonardo's father did not even recognize it as object or painting.

Vasari's fable is about hands. The peasant cuts down the tree *di sua mano,* as Vasari says; the buckler then comes into the hands of Leonardo, *tra le mani,* Vasari writes; and with these very hands the object is refined and perfected before passing into those of the duke of Milan, *alle mani del duca.* The word *mano,* from *manus* in the Latin, is the root of the word *maniera,* the term that designates what we speak of as an artist's "manner" or style. Vasari's history of art from its rebirth in the period of Giotto to its fruition in the time of Leonardo is the story of the evolution of *maniera* into *bella maniera,* the perfection of art at the culmination of its history. The fable of the buckler recapitulates the entire sweep of art history, charting the evolution of the object from the rude hands of the humble artificer to the skilled hands of the artist who achieves *bella maniera.*

In Vasari's use of the word, *maniera* has the connotations of social comportment, that is, "manners," even though he uses the word *costumi* to speak of such manners. His story of the buckler as the tale of the evolution of art from rudeness to the polished manner or finish given it by the painter is inextricably bound up with the history of manners or civilization as it evolves from the rude rustic world of the peasant to the *bella maniera* of the artist, whose handiwork finds its way to the summit of the social hierarchy when it rests, finally, in the hands of the duke at

court. The hands of the duke in Vasari's fable are emblematic of the ideals of *la bella mano,* the beautiful hand—a manifestation of *politesse* or polished manners, which are intertwined with the artistic concept of *bella maniera.*

The ascent of the buckler from the farm to the court is part of the larger story Vasari tells of Leonardo as himself a courtly artist. Leonardo is indeed courtly in the fable of Mona Lisa, where the painter, like the lord of a court, summons buffoons and musicians to entertain his subject, as if she were the lady of a court. In a similar manner, Leonardo is courtly in conversation with the duke of Milan when painting the *Last Supper.* Vasari has the prior of Santa Maria delle Grazie criticize Leonardo by likening the painter, who often pauses thoughtfully during his work, to those who stop while plowing the fields. Leonardo then ridicules the cleric, to the satisfaction of the duke, who laughs. Leonardo is here indeed lordly, having long ago left the farm far behind. In the final fable of his deeply fictionalized biography, Vasari famously portrays the death of the artist in the arms of the king of France, as if to suggest that the boy raised on a farm had now risen at court to a sphere above that of the monarch, who, in a sense, pays court to the artist, whom Vasari even calls "regal."

Vasari's juxtaposition, in the life of Leonardo, of the refined manners of the court on the one hand and the rudeness of the peasantry on the other, is firmly rooted in Vasari's biography of Giotto. In the first edition of the *Lives,* Giotto's father is described as *valente* in the "art" of agriculture. The word *valente* means skill, but it means more than that, implying valor also. It is evident that Vasari intends to elevate Giotto's father because he also suggests that the father plows with a hand that is *gentile,* conveying the peasant's gentility. Although rustic, Giotto's father is nevertheless courtly in giving his son over to Cimabue with "singular grace." If Leonardo's father is implicitly a gentleman, Giotto's father is a gentlemanly peasant, whose very gentility foretells his son's rise to the courts of Italy.

The story of the young Leonardo's buckler has other links to the life of Giotto. Leonardo's direct study of various animals and insects, which is suggestive of his implied origins on a farm, is rooted in the story of Giotto the young shepherd, also at one with nature, as he portrayed one of his sheep on a stone slab. When Giotto grew up he made a perfect O, which demonstrated his virtuosity and led to his employment at court.

In a similar way, Leonardo made a display of skill on an O, which is what a *rotella* (literally, little wheel) is, and this object, finding its way to court, foretold, as we have observed, the boy's fortunes there.

Leonardo's relations to Giotto in Vasari's historical imagination cut even deeper. In his *vita* of Giotto, Vasari appropriates a story from the *Trecentonovelle* by Franco Sacchetti with all its social dimensions. According to Sacchetti's fable, assimilated by Vasari, a clownish simpleton wanted a shield, in this case a *palvese* or pavise, decorated with his coat of arms. The simple little man asked Giotto if he would do the painting. The artist was scornful of the dimwitted clown, who was behaving as if he were of the royal house of France. And so, in mockery, he painted on the shield a helmet, a gorget, iron gloves, cuirasses, greaves, a sword, a knife, and a lance—in other words, real arms, not a coat of arms. When the bumpkin protested, Giotto replied, "If you were one of the Bardi that would be fine, but who were your ancestors anyway?"

Vasari ingeniously fuses the story of a shield with the story of an O, since the *rotella* is such a *tondo*. The confrontation of Vasari's story of a shield with Sacchetti's is suggestive. We see that as Sacchetti's fool was socially pretentious, so was Vasari's peasant, who, also wanting a painted shield, aspired to an object of social status, class, and refinement. As Sacchetti mocks his booby, so Vasari ridicules his bumpkin. For he tells us that the peasant was overjoyed to have a shield with an artless image of heart and arrow, a shabby valentine acquired from a peddler. In matters of art, he had no judgment. Like Sacchetti's fool, he was *tondo*, lacking in wit.

Vasari's fable is rich in other social implications. Leonardo's collection of insects and animals still bespeaks the countryside, so much so that Walter Pater, embellishing Vasari through Wordsworth, wrote as follows: "The lizards and glow-worms and other strange small creatures which haunt an Italian vineyard bring before one the whole picture of a child's life in a Tuscan dwelling—half castle, half farm—and are as true to nature as the pretended astonishment of the father for whom the boy has prepared a surprise." Among his lizards and butterflies, as if directly in nature, Leonardo is, we have observed, like the boy Giotto among his sheep. There is some sleight of hand in all this, since Leonardo is in fact at work in the city. What Vasari has achieved here is a paradox, a new "version of the pastoral," an urban pastoral which reverses the

movement in the conventional pastoral of the city dweller into the country.

Leonardo, as Vasari pictures him in his urban studio with his "strange species" of creatures gathered in the country, evokes the encyclopedic impulses, the taste for the marvelous, the zeal for collecting of the sixteenth century. He is like all those sixteenth-century princes who retired to their *studioli*, their *Wunderkammern*, to investigate nature's marvels. The Leonardo who records the specimens of nature is a scientist, his investigations in a secret room calling to mind the traditions of Renaissance science or magic codified in "books of secrets." The monster he creates from his studies as a naturalist is a product of magic. Leonardo's secret investigations here stand behind the modern fascination with the "mystery" of the artist, with the identification of him as the very type of his near contemporary, Dr. Faustus. Leonardo is a Faust *avanti la lettera,* and the charge of "heresy" Vasari brings against him magnifies this association.

Indeed, the monster made by the Faustian Leonardo had diabolical connotations, for when Vasari likens it to the Medusa, he alludes to a creature which Dante, in *Inferno,* had in fact linked to the heretics. Leonardo's pursuit of "natural philosophy" at the expense of religion, his very heresy, is described by Vasari in conjunction with the artist's fabrication later of another terrifying monster, when the artist took a lizard and added to it a horns, eyes, beard, wings, and quicksilver to make it quiver. This is almost certainly the moment Castiglione captures in *The Book of the Courtier,* where he speaks of an artist, meaning Leonardo, who has departed from the true path of his art. Speaking of Leonardo's philosophical pursuits, he refers to his "strange conceits and new chimeras." The latter figure of speech is especially appropriate here, since the chimera, part goat, part snake, and part lion, belongs to the very realm of fantasy evoked by Vasari in his portrayal of Leonardo's monsters. The Medusa-like monster on Leonardo's buckler is just such a chimera.

Monsters are ambiguous creatures. If they have connotations of bestiality, evil, and vice, they also bring delight in their very strangeness. Montaigne, in his essay "On Liars," says that although the "chimeras and fantastic monsters" of his own imagination make his mind ashamed of itself, he cannot deny the pleasure that they give in their strangeness. Such monsters abound especially in the world of romance, a literary genre which brought special delight to courtly readers. When Ariosto

describes a horrendous beast—part wolf, fox, lion, and ass—carved in marble on the well of Merlin, he pictures a work of art that illustrates a monster analogous to Leonardo's. Vasari surely delighted in Ariosto's fantasies, which he brought to bear in his own romantic fantasy à la Ariosto of Leonardo's orc-like monster belching smoke and flashing fire from its eyes. Whereas Ariosto is graphic in his description of a beast with a wolf's head, ass's ears, and lion's claws, Vasari never explains to his reader exactly how Leonardo's *animalaccio* corresponds to bats, snakes, and lizards. He leaves it to his reader, participating in the fantasy, to imagine the beast himself, to create his own chimera, to imagine how crickets, butterflies, and grasshoppers might have been deployed. Even Shakespeare is more detailed in his use of insects in *Romeo and Juliet,* where Mercutio pictures Queen Mab's chariot with its wagon spokes of "long spinners' legs," its cover made from "the wings of grasshoppers." A certain charm, however, plays over Vasari's vagueness, in the root sense of *vagare,* "to wander," for the reader must wander in imagination from the tiny scale of Leonardo's insects to their implicit magnification in the imaginary features of his monster.

Vasari's fable of the buckler contains within itself a full theory of art. Leonardo's close attention to animals and insects bespeaks a *naturalità,* to borrow a word used elsewhere by Vasari in his life of Leonardo, at the same time that the monster also depends on *fantasia,* the result being *capricciosa,* as his father says. The painter's adaptation of different creatures *variamente adatta,* as Vasari says, reflects the ideal of *varietà,* a requirement of artistic excellence. The result is a work truly *miracolosa*—what Vasari elsewhere calls a *maraviglia.* All of this—imitation, fantasy, variety, etc.—is part of the conventional Renaissance theory of art. Vasari is far more subtle, however, when he speaks of the creature's terrifying aspect, *orribile* and *spaventoso.* Observing that Leonardo's father was shaken, *scosse,* as he looked at the Medusa-like monster, Vasari attributes the terrifying aspect of the fabulous creature to the work of art itself. He is implying that the work of art creates terror, what he elsewhere speaks of as *terribilità.* In a similar way, he says that the *Mona Lisa* inspires in all artists "fear and trembling," *tremare e temere.* As Vasari often aestheticizes religion in his description of artistic grace, he aestheticizes the primordial myth of Medusa, domesticating mythic terror as the terror of art, its *terribilità.*

We have by no means exhausted the shrewdness of Vasari's exposi-

tion of theory embedded in fiction. When Leonardo's father beholds Leonardo's monster and can scarcely believe it is a painted figure, he is fooled by the painter's art, which is, in Vasari's vocabulary, an *inganno*, a visible trick or illusion. The word "illusion," we recall, is rooted in *ludere*, "to play," and Vasari's frequent references to art as play point toward the modern emphasis in "aesthetics," in Schiller and Kant, of the central role of play in art. When Walter Pater writes poetically that Leonardo's painting on the buckler elicited his father's "pretended astonishment," he brings out Leonardo's play. Focusing on the monster as the "experiment of a child," the reflection of "child's life," Pater dwells romantically on the artist's childhood, foretelling Freud's investigation of Leonardo's childhood and the modern fiction in which Vasari's tale of the buckler was refashioned into "children's literature."

Art, Ovid said famously in *Metamorphoses*, conceals art: *ars adeo latet arte sua*. This notion was assimilated by Castiglione to his concept of *sprezzatura* as "art that does not seem art," *vera arte . . . non pare arte*. The deep Ovidian notion of art is no less alive in Vasari's fable of Leonardo's buckler, in which the father does not first recognize that he is looking at a painting. Although Leonardo opened the door to his father when he knocked, Leonardo effectively concealed his art in his shocking illusion. The young painter also exhibited *sprezzatura* in the root sense of the word, *disprezzo* or "scorn," when he addressed Ser Piero after the latter had got over the shock of the monster. "With this work," Vasari has Leonardo say, "I have accomplished what I set out to do; take it, therefore, since it has served its purpose." Leonardo addresses his father with hauteur, almost with *disprezzo:* if not with disdain, certainly with condescension, an air of triumphant superiority tersely and confidently expressed. As Ser Piero stood above his peasant in the social hierarchy, now Leonardo rises above his father by outwitting him through an art that seems not art, proclaiming his skill with haughtiness.

Although he has been fooled, Leonardo's father pulls off his own ruse when he does not return the shield to the peasant, selling it instead to certain merchants for a hundred ducats. Buying another shield with a painting on it from a peddler, he gives this fraud, if you will, for it is neither fake nor forgery, to his grateful laborer. A short time later, when the merchants who had acquired the buckler sell it for three hundred ducats, three times what they paid for it, they themselves have tricked Ser Piero. As Vasari implies, *l'ingannatore s'inganna*, "the trickster fools

himself." Vasari's story carries art into the world of Florentine commerce, into the hands of crafty merchants, who prize it for its monetary value, as what we now commonly call "commodity." In the end, however, when it comes into the hands of the duke, the buckler ascends, finally, from the marketplace into the realm of the court, where art as *sprezzatura,* as seemingly artless skill, is appreciated. It was during his time at the court of Milan that Leonardo's art would be prized, in Vasari's word, for its *nobilità.* We recall that Vasari's fable began with a story of humble labor that resonated with the fall from Eden; it ends in a court, which, in traditional terms, is the earthly equivalent of the court of heaven itself—a paradise on earth, here presided over by a lord of what we might speak of, in the large sweep of the fable, as Paradise Regained.

To underestimate or ignore the fiction in Vasari's book is to diminish, if not trivialize, his work. For as the reading of but a single fable shows, Vasari is not merely using facts or employing rhetoric in the service of verisimilitude or decorum: he is creating a deep historical fiction, an allegory of art, that reflects with its own courtly flourish or *sprezzatura* the subtle relations among art, poetry, theology, art theory, allegory, biography, history, etiquette, and economics. Vasari's story is as instructive as it is pleasurable, but his reflections on agriculture, science, collecting, commerce, carpentry, the psychology of art, mythology, pastoral, and romance are rendered with such facility or *facilità,* to use his word, that we can all too easily underestimate the panoramic scope, richness, and ultimate complexity of his historical imagination. Art historians are discomfited by the role of fiction in history; in short, they often do not know what to do with it, they frequently do not know how to recognize it; or, even when they sense its presence, they quickly pass it by, diminishing it, patronizingly, as anecdote or rhetoric. Doing so, they fail to approach the heart of Vasari's work, the very poetry of historical imagination that makes him, far more than just an "art historian" in the modern sense of the word, a great and enduring historical writer. In the reading of Vasari's commanding text, we have scarcely scratched the surface, for the analysis of the fable of Leonardo's buckler points toward a far more nuanced and subtle understanding of Vasari's book than currently prevails—a comprehension that embraces the role of the poetic or literary imagination not only for its own sake as art, but in the formation of what we might well call *historical imagination.*

SEVEN

VASARI AND THE AUTOBIOGRAPHY OF MICHELANGELO

In the history of the autobiography of the artist, Michelangelo occupies a central but still shadowy place. This is so because although he did not write an autobiography as such, he did respond to Vasari's biography of him by influencing the biography written a few years later by Condivi to set the record straight. Commentators generally agree that Michelangelo's voice can be heard through Condivi; in other words, Condivi's biography of Michelangelo, though in some measure still difficult to gauge, is a reflection of Michelangelo's life story and in this respect is autobiographical. An important piece of evidence supporting this claim has been virtually ignored. I speak of the strikingly close relations between what Michelangelo says in the long letters he wrote in self-defense and the apologia of Condivi's biography of him. Our sense of Michelangelo's autobiography is reinforced by the confessional character of his poetry, filled with anguish consistent with that expressed in Condivi's text and in the totality of the letters. Indeed, the letters can be read collectively as autobiography. What remains fascinating in all of this is our uncertainty about what is fact and what is poetical embellishment or fiction in the biographies and letters. Much has been written on this subject in recent years, but further investigation can clarify the role of the literary imagination in such writings, which enrich our sense of the

artist. Various episodes in the life of Michelangelo enable us to chart the development of the artist's biography and autobiography.

Let us begin with Vasari's story of the *tondo* Michelangelo painted for Agnolo Doni, as told in 1550 in the first edition of the *Lives*. Having finished the painting, Vasari writes, Michelangelo had the picture delivered to his patron by a messenger who brought with him a bill for seventy ducats. Doni, who thought he knew what the picture was worth, replied that forty ducats would suffice, whence Michelangelo dispatched the messenger again to inform his patron that he could now pay one hundred ducats or send the picture back. When Doni, who liked the painting, then replied that he would pay the originally agreed-upon seventy ducats, Michelangelo, because of his patron's breach of faith, doubled the price, obliging him to pay one hundred forty ducats. Triumphant, Michelangelo had the last word, or so the story goes.

In the recent literature, Vasari's account is sometimes quoted as if it were a true story. When Condivi wrote his biography of Michelangelo in 1553 to correct Vasari's errors, he did not retell Vasari's story; he merely said that Michelangelo was paid seventy ducats for the picture. There are some commentators who think the story is a fiction, although they cannot establish its fictional character any more than those who believe it to be a true story can establish its factuality. Suffice it to say, Vasari's story is true to life, true to the disputes that arose between artists and patrons, and true to a whole series of stories told by him and others about how artists have the last word and get what they want from their patrons.

There are questions to be asked. If the story of Michelangelo's dispute with Doni is a true story, why does Condivi, who collaborated with his hero to correct Vasari's errors, not report the dispute? Does he imply that this is not a story sanctioned by Michelangelo as an account of what happened or what Michelangelo wanted in the record? How did Vasari come to know the story in the first place? Did he invent it in order to explain how Michelangelo triumphed over a patron? Or did he have it from a still unidentified source?

These questions are by no means trivial, nor are they rendered moot by the fact that the story has verisimilitude. We are not locked here into the radical positivist's pursuit of what really happened, a quest that informs the scholarship that sees Michelangelo's life as a series of discrete facts or factoids or takes these "facts" too easily for granted. On the

contrary! For if an event described in the life of Michelangelo did not happen, then it belongs to a different sphere of human experience that needs to be acknowledged and explored. I am speaking of the poetics of history. If we read a story in the life of Michelangelo as an instance of verisimilitude and leave it at that, even though it is invented, then we choose to ignore the richness of the historical imagination.

If the story told by Vasari and ignored by Condivi is a fiction, as I suspect, it is a work of historical fiction or art. If the story is a fable, it is a reflection of the imagination, which takes on an active role in the shaping of history. The historical imagination, which is too often ignored, needs to be appreciated for its own sake. Such imagination, as we have observed, is itself an historical fact.

Condivi's text, which reflects Michelangelo's sense of his own life, cannot be divorced from the first edition of Vasari's *Lives,* the very template for his own reframing of the biography of the artist. New editions and translations of both of these texts continue to appear, but the complex relations of these intertwined texts remain partially obscure. Although the story of Michelangelo's clash with Doni is not part of the Michelangelo story in Condivi, we might well ponder its absence as itself a significant fact. In other words, we are left to speculate as to why the story of Michelangelo and Doni does not appear in Condivi's biography. We are thus reminded that what a biography or autobiography excludes can sometimes be as pregnant with implications as what it includes.

Let us turn to another anecdote from the life of Michelangelo: this one, neither in Vasari's first edition nor in Condivi, first appeared in Vasari's revised book in 1568. Based on a tale in a Venetian joke book, it is a story that is sometimes recounted as if factual, but is almost universally recognized to be fiction—once again a fiction true to the historical facts.

The anecdote pertains to the figure of Minos, whom Michelangelo painted in hell in his *Last Judgment.* Pictured entwined by a serpent, the figure was said to be a representation of the papal master of ceremonies who had ridiculed the artist for shamelessly painting a work filled with nudes more appropriate to taverns or baths than a papal chapel. The story is thus true to the fact that Michelangelo was indeed attacked in many quarters for the nudity of the figures in his fresco. We generally ignore the implications of the story, which is a sly allusion to Minos's

identity in Dante; we in turn ignore the implications of the figure of Minos in the fresco for the appreciation of the poetic ingenuity of the anecdote in Vasari. Let me explain.

Minos, as portrayed by Dante in the fifth canto of *Inferno,* is the judge of the dead in the place of judgment at the entrance to hell, the figure in Dante's word of *giudizio.* He is the opposite of the supreme judge on high in the *Last Judgment.* The tale of Michelangelo's condemnation of the papal official to hell in the guise of Minos is, therefore, a story of Michelangelo's own judgment or *giudizio* as he condemns his critic to a place in hell as the infernal judge. That the serpent which circles around Minos bites his genitals is an appropriate punishment of a figure whom Dante places immediately before the lustful, although Michelangelo embellishes Dante, who does not describe this detail of the serpentine bite.

Michelangelo portrays Minos with the conspicuous ears of an ass, a sign of bestiality, and even more than that: they allude specifically to King Midas, of whom we read in Ovid's *Metamorphoses.* Midas, according to the poet, made an ass of himself when he misjudged a musical competition between Apollo and Pan and mistakenly awarded the laurels to the latter, upon which Apollo transformed Midas's ears into those of an ass. Like the papal official long after, Midas was a bad judge of art. The one judge, Midas, resonates with the other, Minos, in what is a sly conflation. For both names, each of two syllables, begin with the same rhyming "Mi" sound and end with "s"—a spark of wordplay that no doubt would have delighted Ovid and might well have jumped the gap from his Latin to Michelangelo's Italian. The identification of Minos with Midas is reinforced by the fact that both were kings.

Himself a supreme judge in matters of art, as Vasari attests in his celebration of the *Last Judgment,* Michelangelo shrewdly skewered three judges, conflating them in a hell scene where Midas (a poor judge of art portrayed as Michelangelo's critic) and Minos (the infernal judge) are one. A wonderful condensation of Ovid and Dante, the *Last Judgment* alludes to two kinds of judgment, aesthetic and theological, marvelously united in the poetic fantasy of Michelangelo, an *alta fantasia* ultimately sanctioned by the supreme judgment of God.

If the anecdote about a bad critic or judge of art points us in the direction of Michelangelo's pictorial wit, the wit of the fresco also leads

us to an appreciation of the anecdote. For the story of the flawed art criticism of the papal functionary is rooted in the image of the Midas-like figure of Minos. In other words, the ass's ears of the figure evoke a mythic story of art criticism in Ovid, which is the point of departure for the modern story of the failed art critic, who is punished for his transgression.

In short, just as the anecdote is a clue to Michelangelo's meaning, his clever allusion to Midas's flawed judgment is a clue to the theme of poor judgment in the poetic anecdote. The story of Michelangelo's papal critic was not invented by Vasari, but the biographer uses it to good effect when he integrates it into the artist's biography. Capturing a moment in the artist's life when he condemns a critic, the fresco (as interpreted in the anecdote) is autobiographical, for it reveals the artist's biting wit as he punishes a critic. The story is a fiction but one that is true to Michelangelo's self-defensive way of dealing with his critics.

The anecdote also points to an uncomfortable fact about modern art-historical accounts of Michelangelo's fresco. In this modern scholarly literature, art historians write various unwitting fictions about the *Last Judgment*. They frequently identify figures in the fresco who were subjects in the painter's biography. In other words, Minos pictured as Michelangelo's critic Biagio da Cesena is not the only figure in the fresco who has been identified in a kind of historical fiction. It is almost universally believed that Michelangelo portrayed himself in the flayed skin of Saint Bartholomew near Jesus in the upper register of the fresco. It is one thing to say that Michelangelo, who saw himself as like a martyr saint, would have identified himself with Bartholomew. It is quite another to say that he portrayed himself as the saint. No matter that the features of Batholomew's flayed skin are indecipherable. If we want to see Michelangelo here, we will not be denied.

Michelangelo's fresco is far more than an image in which the artist supposedly portrays himself. It is a gallery of portraits, of personages who figured in Michelangelo's life story, or so it has been said. Modern commentators have sometimes recognized Pietro Aretino, who, like Biagio da Cesena, criticized the painter, as the figure holding Michelangelo's flayed skin. Some historians have found in the fresco Tommaso Cavalieri, the subject of Michelangelo's intense love and devotion, and at least one art historian has claimed that Saint Lawrence might portray Lorenzino, who assassinated Michelangelo's hated enemy Duke Alessan-

dro de' Medici. Another scholar has argued that Michelangelo's patron, Pope Paul III, also appears in Michelangelo's work. All in all, the fresco becomes an imaginary illustrated autobiography, appropriate to an artist who assisted Condivi in the telling of his own life story. It does not matter that some, if not all, of these identifications are probably fabulous. The fresco lives in our imagination as a great autobiographical fable filled with allusions to Michelangelo's suffering, his harsh treatment by critics, his politics, love life, and spirituality. The so-called portraits of his contemporaries are modern historical fictions, like Vasari's Biagio da Cesena, although they lack the literary wit of Vasari's tale, or rather the tale that Vasari repeats from an earlier source.

The story of Michelangelo's Minos addresses a period late in the artist's life; whereas the story of Michelangelo's feud with Agnolo Doni, which we have discussed above, comes from a moment earlier in his life, not long before he undertook the decoration of the Sistine ceiling. Other stories take us back to the very beginnings of his life as an artist. I want to speak of two of these episodes, where once again, as in the Minos *novella,* works of art have implicit autobiographical associations.

Perhaps the most controversial pertains to the *Faun,* which the artist is said to have carved in the Medici garden when he was approximately fifteen years old. The work was so impressive that it attracted the attention of Lorenzo de' Medici, who put the young Michelangelo on salary, brought him into the Medici household, and gave a job to the artist's father. Although in 1550 Vasari alludes briefly to a damaged ancient head that Michelangelo copied in the garden, the story of the *Faun* only appears for the first time in the pages of Condivi in 1553. Vasari would later assimilate the anecdote in his revised edition of the *Lives* in 1568. It is reasonable to suppose that Condivi had the details of the story from Michelangelo himself.

Many commentators take the story at face value and believe it to be true, whereas others (myself included) suspect it is a fiction, which is not to deny the possibility that to some degree it is rooted in fact. Others are not so sure. For example, when there was a exhibition of Michelangelo's early work in the National Gallery in London not many years ago, the catalogue included a lengthy discussion of Michelangelo's studies of antiquity, but the story of the *Faun* inspired by an ancient work was not considered, from which one might conclude that the author was less than sure about the factuality of the story.

Leaving aside the uncertainty surrounding the *Faun,* I am not going to argue here that the story is a fable; rather, I am going to consider the story's fictive character and relations to similar stories about art that are fictions. I will dwell on various literary implications of the story, looking at the way in which the story is shaped and the way in which it is linked to the traditions of imaginative literature. Finally, I am going to emphasize the autobiographical implications both of the story itself and of the *Faun,* which is in some measure a portrayal of Michelangelo. First, a summary of the story, then the commentary.

According to Condivi, the young Michelangelo was brought into the Medici garden, which was full of ancient statutes. One day, the story goes, Michelangelo came upon the head of a classical faun that so pleased him that he decided to make a marble copy. Applying himself with great diligence to the work, Michelangelo imparted to his head a fantasy absent from the ancient sculpture. He rendered an open mouth, which revealed all the teeth, whereas his model was so worn that its mouth was all but obscured.

When Lorenzo came upon the young artist as he polished the sculpture, he was filled with wonder and, although he praised it, he teased Michelangelo by saying, "Oh, you have made his old faun with all his teeth, but don't you know that those in old age lack some?" To Michelangelo it seemed a thousand years till Lorenzo departed, but when he finally did so, the young artist hollowed out one of the teeth and smoothed down the gum so that it appeared the tooth had come out at the root. He then waited for Lorenzo to return another day. When the Magnifico came back and saw what Michelangelo had achieved, he recognized the youth's good nature and laughed at his simplicity. Observing the perfection of Michelangelo's work and young age, Lorenzo was determined to support his talent, and so the great patron took the youth into his house, where he treated him as a son.

Assimilating Condivi's account in 1568, Vasari embellished it by saying that when Michelangelo made the *Faun* it was the first time he ever touched marble and chisels, suggesting, in other words, that the *Faun* was Michelangelo's initial essay in sculpture in stone. Vasari made explicit, indeed dramatized, what was only implicit in Condivi.

The story of the *Faun* is richly suggestive when compared to the structurally similar fable written not many years earlier by Antonfrancesco Doni, the so-called *mezza novella,* a tale also about Michelangelo,

which was also assimilated by Vasari in the 1568 edition of the *Lives.* The story concerns Michelangelo's dealings with his faithful assistant Topolino. In this *novella,* or more properly, *novellino,* or little story, Michelangelo plays the same role that Lorenzo assumed in the story of the *Faun* in regard to the artist's younger self.

In Vasari's version, when Topolino blocked out several figures in marble, Michelangelo was overcome with laughter at their deficiency. The clumsy sculptor then made a figure of Mercury, which he brought to Michelangelo for his consideration even though it was not yet polished. At this, Michelangelo told his hapless assistant that he had made the legs from the knees down too short, making of his Mercury a sort of dwarf. It is of course only appropriate that Topolino, whose name means Little Mouse, should make a miniaturized Mercury, for as Michelangelo is said to have remarked elsewhere, "every painter paints himself well."

Responding to Michelangelo's criticism of his statue, Topolino ejaculated, "Oh, no problem, I'll take care of it, leave it to me." And Michelangelo again laughed at Topolino's simple ways. Undaunted, Topolino next cut off the legs of his Mercury below the knees, adding marble pieces in order to lengthen them. Finally, in order to conceal the clumsy joins of the work (what he had done was a no-no in Renaissance practice), he covered the legs with buskins: a rather ridiculous form of deception. When Michelangelo saw the statue again, he both laughed and marveled at the way in which his clumsy disciple was obliged by necessity to find a solution to an artistic problem that a skilled artist would never have faced in the first place.

Doni's story of Topolino and Michelangelo, as retold by Vasari, is the type to which the tale of Lorenzo and the young Michelangelo belongs. In both cases, a patron or patron-like figure judges the work of an artist who is both ingenuous and ingenious. Michelangelo's naïveté can be excused because he is still young, whereas Topolino is, as Michelangelo says, both clumsy and crazy. Both stories are amusing tales of the judgment of artistic talent, although admittedly the tale of Michelangelo and Lorenzo is of far greater moment. For it is the story of an original work of genius—the story of his discovery by a great patron, who takes him under his protection.

Whatever the facts of Michelangelo's time in the garden, the story of the *Faun* has the form of a *novella,* like that of Doni's *novella.* As a *novella* of artistic origins, the fable of the *Faun* is deeply rooted in a tale

told by Ghiberti and retold by Vasari of how Cimabue discovered the simple young shepherd Giotto drawing sheep in the ground with a stone and then cultivated the boy's talent. Whereas Giotto emerges directly from nature in a kind of pastoral or eclogue, Michelangelo is cultivated in a garden, a more refined form of nature. The fact that Michelangelo did indeed frequent the Medici garden does not diminish the deep literary and mythic significance of his origins. For when he told Condivi that he carved a *Faun* in the garden, he was describing a primordial goat-like creature still linked to the sheep in the natural world of Giotto.

Whether accepted at face value or doubted, the story of the *Faun* is of the deepest significance for our understanding of Vasari's *Lives*. When he assimilated Condivi's story, Vasari did something he frequently did elsewhere in the *Lives,* as when he appropriated Doni's story of Topolino. Lest we undervalue his work according to modern, Romantic notions of genius, we should appreciate the fact that Vasari melds these appropriations into a synthetic whole. Vasari presided over the *Lives* as a superintending intelligence who gave shape to the material he gathered, and he was never slavish in his use of the material. When he writes that Michelangelo "had never touched marble or chisels" before carving the *Faun,* he dramatizes, as we have seen, Condivi's account of Michelangelo's first essay in sculpture.

Vasari was building on Condivi's account, which only implies that when Michelangelo picked up the marble and chisels to carve the *Faun* he did so without any instruction whatsoever. This is a very Michelangelesque thing to do, since the artist famously would have one believe that in all respects he was self-taught—even though modern scholars have recognized Bertoldo's or Benedetto da Maiano's influence on his sculpture, Giuliano da San Gallo's influence on his architecture, Ghirlandaio's influence on his painting, and the reflection of Ficino, Poliziano, and Lorenzo de' Medici in his poetry.

In the final analysis, we are drawn back to the probability that when Condivi reports the story of the *Faun,* he is transcribing a *novella,* and even if the form of this fable has roots in the fiction of Doni, it comes directly from Michelangelo's own poetic imagination. The *novella* of the *Faun* is in effect an "unpublished story" in the sense that, although we have always known it, we have not adequately heeded its poetic richness and its origins in the imagination of Michelangelo himself. Worrying excessively about what exactly happened in the garden, we have failed

to see sufficiently how the *Faun* belongs to the broader story of Michelangelo's poetic fantasy reflected in his painting, drawings, architecture, sculpture, and poetry—most notably in the numerous fantastical heads that are part of his architectural inventions, above all, in the grotesques of the Medici Chapel.

We might observe that the story of the *Faun* is at Michelangelo's own expense, since his naïveté is mocked by Lorenzo de' Medici, but we need only recall that such self-mocking is not uncommon in Michelangelo's self-conception—from his famous self-ridiculing poem on the torment he experienced as he painted the Sistine ceiling through a late poem, "I'sto rinchiuso come la midolla," in which he mocks both his own physical decrepitude and the inadequacies of his art.

Significantly, the latter poem, composed circa 1550, is close in date to the fable of the *Faun* told to Condivi. Although this poem (Girardi 267 in the standard listing) is known to Michelangelo scholars, it is undervalued because we exalt the serious poetry of a Neoplatonic, Dantesque, or Petrarchan flavor and pay less attention to Michelangelo in a comic mode. But this long poem, a masterpiece of comic anguish, is highly significant as autobiography and deserves to be more widely known. Written in terza rima, this *capitolo* is self-consciously an imitation and parody of Michelangelo's beloved Dante, whose life story is a model for Michelangelo's ascent. Michelangelo describes his own suffering and portrays himself as if he has descended into a kind of hell. As in his famous "Giunto è già 'l corso della vita mia," which Vasari quotes in full in 1568, Michelangelo here repudiates his earlier art and poetry. His self-abnegation is delivered as farce, rich in wonderful grotesque imagery not dissimilar to that of the grotesque, deformed *Faun*. As he plays in the fable of the *Faun* on the fact that old fauns do not have all their teeth, Michelangelo plays in his poetry on his own teeth in old age, saying that they are like the keys of a wind instrument at whose touch his voice sounds or does not. Whereas he mocks the deficiency of his early art that indecorously rendered all of the *Faun*'s teeth, in the poem from old age he similarly ridicules himself by saying of his drawings or scribblings that they are only good for wrappings, innkeepers, latrines, and brothels, adding that the figures he renders are so many puppets.

Although this dark poem is replete with expressions of despair and pain, and although Michelangelo tells us he is old, decrepit, and broken, it is nonetheless comic in character. For it is filled with humorous effects,

as when Michelangelo describes the hornet buzzing in his head, which he likens to a jar, or he evokes the cricket singing all night in his ear. He lives in a little room where there are gigantic piles of shit outside, and the air is filled with the stench of piss.

The laughter that such imagery provokes reminds us how Michelangelo laughed heartily at Topolino's follies and deformities, and it brings us back to Michelangelo's first work in stone, the laughing *Faun,* which we can construe as Michelangelo's own persona. (Vasari surely did this when he embellished the account by saying that the *Faun* had a broken nose, a fact that evokes the mythic broken nose of Michelangelo himself.)

When Michelangelo told his tale of the *Faun* to Condivi, he joined the great tradition of Tuscan fabulists from Boccaccio and Sacchetti to Doni and Vasari, all of whom wrote playfully and engagingly about the delights of art. More than art history in the narrow sense of the term, Michelangelo's fable of the *Faun,* a wonderful *novella,* is one of the most revelatory fables of art in the entire Renaissance.

As a story told in old age about the artist's youth and his origins as an artist, the fable of the *Faun* can be associated with another moment in Michelangelo's autobiography that tells of his youthful art and the discovery of his talent. I speak of a tale in Condivi that has sometimes been alluded to in the literature, but has not come into focus in the Michelangelo scholarship. As the story goes, when Michelangelo carved a forgery of an ancient sleeping Cupid, the cardinal who acquired the work learned that it had been made in Florence. Indignant at having been deceived by the forgery, he sent a gentleman to that city to find the author of such deception. Pretending to look for a sculptor to do work in Rome but in fact searching for the author of the *Cupid,* the visitor eventually was directed to the house of Michelangelo. He asked the artist to show him some work, but, not having anything to display, Michelangelo took a pen and made a rapid drawing of a hand so deftly that the visitor was astonished. When the gentleman interrogated the artist, Michelangelo confirmed what was now suspected, that he had indeed made the *Cupid.* The visitor then urged Michelangelo to come to Rome, where he could recuperate the sum of money that was still coming to him for the sculpture and work in the service of the cardinal. And so, wishing to collect what was owed to him and wanting to see

the city that was represented to him as a great place to display his talent, Michelangelo set off for Rome.

Although the drawing in pen and ink is true to Michelangelo's youthful practice, the story, as retold above, has receded from the literature and has even been referred to as "apocryphal." This is a curious choice of words, since the term has several meanings, one of which is "of uncertain authorship or authenticity." In this case, however, the story probably comes from Michelangelo himself. In other words, Michelangelo is probably its author; the story is thus authentic. The term "apocryphal" also suggests "fictitious," or "sham," and here we come to the heart of a problem that plagues those scholars who explore the biographical sources of Michelangelo. For the word "fiction" often makes their hair stand on end! It is easier to ignore the story than to confront the possibility that it is a fiction.

As historians, we want understandably to establish the basic facts of the artist's life, whether, for example, of Michelangelo's activity in the Medici garden or of his education in the Medici household. We are less inclined, however, to explore the way in which such facts are poetically transformed or intertwined with fiction. We are thus inclined, whatever the exact facts, to search for evidence of the presumably lost *Faun* Michelangelo made in the Medici garden rather than ponder the form of the story of the sculpture, which comes to us in the form of a *novella*.

When we resist the fictional character of such biographical writing, Condivi's or Vasari's, we ignore an essential *fact* about such writing—that is, its poetical or fictive character. How Vasari, Condivi, and Michelangelo gave shape to biography is part of the historical record, and to dismiss elements of history by calling them "apocryphal" is to leave out an essential part of history. Perhaps the fact that some scholars today are indifferent to how they themselves write partially explains their apparent indifference to how Renaissance authors wrote, or to the fictive character of their writings. We are here talking about the form of such writing, and, although the word "form" is now often disparaged, it is nonetheless a part of history, itself an historical fact.

The story of the drawing of the hand does not reflect an episode that in fact took place in the 1490s. It is a poetic invention from the early 1550s, when Michelangelo gave shape to his life story. His fable is nevertheless a part of history, the history of Michelangelo's poetical

imagination. Michelangelo's fictive shaping of his life story is itself probably *factual,* a fact from his life at the time when he spoke to Condivi.

Why might Michelangelo have invented such a story? Like the story of the *Faun* in the garden, the story of the drawing of a hand dramatizes the discovery of the artist. As Lorenzo, marveling at the *Faun,* discovered Michelangelo's gifts, so the gentleman from Rome, stupefied by the drawing, discovered the talented artist whom he sought. The story, a story of origins, is also a dramatic account of how it was that Michelangelo first went to Rome.

It surely does not escape us that in a story in which the visitor searches for the hand of the artist who made a successfully deceptive work, the artist should draw a hand. We recall here that in Michelangelo's story to Condivi the visitor to Florence initially conceals the fact that he is seeking the author of the *Cupid.* If Michelangelo indeed made a drawing of a hand in the 1490s, this hand would be an interesting coincidence in a story about the search for a "hand." But if Michelangelo invented the story of the drawing of the hand in the 1550s as part of his account to Condivi, as I am urging, then the hand of the drawing is a witty invention. For, in this case, the drawing of the hand metaphorically portrays the hand the visitor seeks. Rendered deftly, the hand Michelangelo drew embodies the dexterity of Michelangelo's own skilled hand, which had so adroitly carved the *Cupid.*

Condivi's (and thus Michelangelo's) reader, well versed in the stories of artists, especially Vasari's, will recognize that in shaping the fable of the hand as a demonstration of skill to a visitor seeking a talented artist, Michelangelo was reshaping the story of Giotto's O. Vasari had previously written about a visitor from Rome in search of a talented artist for whom Giotto drew a perfect O as a demonstration of artistic skill. Like the hand, the O was emblematic of its author. For just as the hand that Michelangelo drew was an emblem of his own hand, the O that Giotto rendered was a condensed emblem of his name, with its doubling of the O sound.

The significance of the story is even richer when we consider the context of its invention. We recall that, in the first version of the *Lives* in 1550, Vasari writes an apostrophe to Michelangelo's hands, celebrating them as "divine hands" or *divine mani.* He does this in the sentence immediately before his description of the *Creation of Adam* where we see, as he observes, the "right hand" of God. Vasari is implicitly comparing

Michelangelo's divine hand to that of *deus artifex,* since in the proem to the *Lives* he had spoken of God, when he fashioned Adam, as the archetypal artist.

Michelangelo was indeed grateful to Vasari for the celebration of this hand, and he pointedly returned the compliment by sending Vasari a sonnet in which he praised the author of the *Lives* for his "learned hand." Michelangelo pursued Vasari's theme when he told Condivi of the dramatic moment of the discovery in his youth of his hand in the self-reflexive drawing of a hand. The drawing of the hand was in effect a portrait of Michelangelo's own celebrated hand—a youthful adumbration of its future fame.

Ignoring the story of the drawing of the hand or casually regarding it as "apocryphal," we miss a moment of artifice, of poetry in Michelangelo's life, which can be linked to the substantial corpus of poetry in which he alludes to his own art. The story of the hand is itself a *poesia,* an *invenzione,* which, giving shape to Michelangelo's life, is deeply fictive.

I have said it before and will say it again: we have scarcely begun to consider adequately the fictional depths of Michelangelo's biography as it was given form in the sixteenth-century literature. The "facts" of Michelangelo's "life" are delivered to us ever so artfully by his biographers, and such fiction is itself, as I have urged, an historical fact! Instead of being terrified by the word "fiction," as so many scholars seem to be, we should seek to ponder the interrelations of fact and fiction. As has often been said, one cannot write fiction without facts. The obverse is also true: one cannot deliver the facts unalloyed, that is, without fiction.

If the story of the drawing of the hand is "apocryphal," we might well say that it is so not in the sense of "inauthentic" or "sham" but in the root sense of the Greek word, which means "secret, hidden." When we extract the marrow from the bone of Michelangelo's tale, we discover an exemplary fable, linked in the artist's imagination to the fable of the *Faun,* as a tale of his youthful origins as an artist. What is lost sight of when we ignore the story of the hand is not a lost drawing but a lost *novellino,* a lost *poesia,* in which the artist, through his biographer, celebrates his own gifted hand, the origin of his future glory.

EIGHT

BALZAC AND THE FABLE OF FAILURE IN MODERN ART

Although Michelangelo began his life in art so brilliantly with his marble *Faun* and the stunning forgery of an ancient Cupid, among other works, he ended badly—at least that is what he thought. For in old age he rejected the errors of his art, which he condemned as a form of idolatry. Glorified by Vasari for the perfection of his art, Michelangelo was nevertheless in his own mind a failure. His work was not adequate to his spiritual aspirations; it could not bring peace to his soul. We are deeply moved by the pathos and spiritual quest of his haunting final *Pietà,* which the artist hacked away at until several days before his death, but this sculpture is, as one of his finest critics has called it, a wreck. In other words, strictly speaking, a failure.

The artful essayist Philip Lopate once remarked that 99 percent of all attempts to make works of art are failures. His statement seems reasonable enough, and we accede to its apparent truthfulness—even if we do not have the faintest notion how many works of art are in fact failures. We think of art and failure together, however, precisely because their conjunction is one of the deep themes in the history of Modernism, one of its commanding plots, especially in the writings of artists themselves, authors of imaginative literature who anxiously but tellingly return time and time again to the theme of the failed artist. Born of the

historical circumstances in which it is written, inevitably given form by them, fiction is true to these circumstances and thus helps to shape and define our understanding of history.

Balzac's "The Unknown Masterpiece," as we have already seen, is a central fable in this larger story. It is the tale of the aged, deluded, indeed quixotic, painter Frenhofer, who labored for ten years on a portrait of a courtesan which, when it was finally revealed, emerged as a confused mass of color and jumble of lines, a work the artist burned when he came to see that in the end it was "nothing." Filled with "doubt," as Balzac said, Frenhofer aspired to the absolute, to the realization of what was "unknown" to painters, to what was beyond their ability to achieve, an artistic perfection impossible to realize in the modern world. Associated by Balzac with both Satan and Prometheus, Frenhofer is no less a transgressor, himself a Faust among painters, seeking to fathom the secrets of his art.

Balzac's tale was rewritten by Émile Zola in his novel *The Masterpiece,* the pathetic story of the rejected painter Claude Lantier, who hanged himself in front of his modern "masterpiece." Zola embellishes Balzac's bitter theme, for whereas Frenhofer had destroyed his painting, along with his other works, Lantier more explicitly destroys his own life. Zola's painter was not only modeled on Balzac's; he was also inspired in part by his boyhood friend Cézanne, who identified himself intensely and bitterly with Frenhofer. The real painter's much-discussed "doubt" is rooted in the fictional painter's anxiety. Picasso, who also saw himself as a type of Frenhofer, spoke of Cézanne's "anxiety," employing the word adapted by Balzac to characterize his imaginary painter. Cézanne's "anxiety," Picasso observed, was his legacy to all artists.

The theme of the artist's "doubt" and "anxiety," which extends into the realm of literature, is nowhere more conspicuous than in the work of Henry James, who validates Oscar Wilde's claim that Balzac invented the nineteenth century. Taking the French master's lesson to heart, James rewrites Balzac (to cite just one example) in his short story "The Middle Years," the tale of an aged, dying writer, Dencombe, who, having "done all he should ever do," nevertheless did not "do what he wanted." What the dying Dencombe dreaded was that "his reputation should stand on the unfinished," adding, finally, "our doubt is our passion." The purest form of James's homage to Balzac, however, is "The Madonna of the Future," the story of the quixotic, Frenhofer-like

painter Theobald, who has worked for years on a picture of the Madonna, seen by no one. When it is finally revealed, the painting is even more radically unfinished than Frenhofer's, for it is an empty canvas, the ultimate symbol of the failure of art. The unfinished canvas would come to be the sign of art's failure and would appear again later in Moravia's novel freely translated as *The Empty Canvas,* the existential story of an artist unable to fill the void in his life which was epitomized by the canvas, the "void of unessential night," empty, silent, indifferent.

Frenhofer's "doubt" hovers over Russian literature as well. In a haunting tale, "The Portrait," saturated with the Hoffmannesque fantasy of Balzac, Nikolai Gogol writes of a mad painter, Chartkov, who possessed by the devil and driven to the ultimate, peculiarly modern question "Did I ever really have any talent?" Before Frenhofer this is not a question we will find in the story of the artist from Apelles and Zeuxis to Raphael, Rubens, Poussin, and Rembrandt. When Gogol's painter asks, "Didn't I deceive myself?" does he not come to Frenhofer's ultimate understanding that, in the end, he has been a failure? His response to such self-knowledge opens up a new possibility of violence. Instead of annihilating his own works, Gogol's painter, spending huge sums of money, buys up all the finest works of art he can find in order to destroy them. Bringing these rival works of art home, he tears them into little pieces and stamps on them as he laughs with fiendish glee—a sign of the ultimate, frenzied insanity that consumes him. Over a century later Robert Rauschenberg would famously erase a drawing by his friend Willem De Kooning. The devil's work had become neo-Dada farce.

Sometimes writers project the anxieties of the modern artist, of his sense of failure, into the past. In his monumental *The Death of Virgil,* Hermann Broch embellishes the historical account of how the Roman poet wished to have his great epic destroyed if he did not return from a journey. In Broch's pages this story is creatively expanded into an "imaginary conversation" between Virgil and Augustus, in which the poet inveighs against the inadequacies of his poem, insisting that its "imperfections" go deeper than anyone can imagine. Caesar's response is to indict Virgil, as if the writer were an ancient Frenhofer. "The doubts that every artist harbors about the success of his work, in your case," Augustus tells Virgil, "have degenerated into a mania." In a large historical irony, Virgil, whose work gives definition to the idea of the canonical "masterpiece," is now seen in the modern period as himself afflicted

with the malaise of Modernism. He is overwhelmed by artistic inadequacy, ironically unable to achieve the epic work that shapes our concept of what a masterpiece is or, should we say, was.

The sense of artistic failure echoes through the chambers of Modernist fiction. In a famous passage of his great novel, Proust has the fictional novelist Bergotte ponder his entire oeuvre with a negative judgment on himself when he looks at Vermeer's *View of Delft*. That is how I ought to have written. . . . My last books are too dry, I ought to have gone over them with a few layers of color, made my language precious in itself, like this little patch of yellow wall." As in Balzac and James, the painter's art is the mirror in which the writer sees the reflection of his own flawed work. The painter clarifies the writer's self-doubt, his sense of imperfection, his inability to create a masterpiece.

It does not surprise us that Frenhofer, who haunts modern fiction as he informs the consciousness of modern artists, is still very much with us. Witness the film of Jacques Rivette, *La Belle Noiseuse,* which freely reworks Balzac's story, giving to Frenhofer a distinctly and not inappropriately Picassoid persona. Picasso's own anxious identification with Frenhofer has resurfaced in the pages of the *New Yorker,* where the critic Adam Gopnik has described Picasso as "the great master who never was." Echoing Balzac and Picasso's own intense identification with Balzac's character, the critic says of modern painting in general that what makes it "interesting is its inability to offer polished meanings, secure achievements, and neat Old Masterish careers." In Gopnik's indictment, Frenhofer's failure casts its shadow over our age, the age of artistic anxiety, as Auden might well have said.

Much of the modern reflection of Frenhofer's anxiety is painfully serious, but such pathos should not obscure our sense of the way modern writers play with the theme. By using the word "play," I imply that such literature mirrors the play of modern art itself, filled with irony, jests, and parody—a play evident, for example, in the *blague* of Manet's *Olympia,* a travesty of Titian's *Venus of Urbino,* in the "caricature" that is Picasso's *Demoiselles d'Avignon,* a "hoax," as Matisse justly observed, in the subversive, spirited pranks of Duchamp and in the paler japes of his followers. Even a vein of such humor is evident in James's otherwise deeply painful "The Madonna of the Future." Before the revelation of Theobald's blank canvas, the author drolly has a character say, "I fancy, myself, that if one were to get into his studio, one would find something very

like the picture in that tale of Balzac's—a mere mass of incoherent scratches and daubs, a jumble of dead paint!" The suggestion wryly misleads the reader, for whereas Frenhofer's picture was filled with incoherent marks, Theobald's is totally empty. Herein lies a deeper irony, however, for by making his painter's canvas blank, James is faithful in a sense to Balzac's symbolic description of Frenhofer's painting as ultimately "nothing."

The playful variations on Balzac's tale are countless. Let us remember briefly the French Symbolist Marcel Schwob, who portrays the Florentine painter, Paolo Uccello, obsessed by perspective, as a Renaissance Frenhofer in his *Imaginary Lives*. In fact, he rewrites the biography of Uccello through Balzac's story, projecting the fable of artistic failure back into the past, much as Broch did in his fiction about Virgil. In the end, Uccello's work is a failure, a jumble of lines. If he is a touching character in Schwob's hands, he is also amusingly bizarre, whimsically odd, not nearly so pathetic as Theobald or Frenhofer.

Uccello is like Ferdinand-Octave Bruat, the writer from the book *Bizarre Deaths* by Schwob's contemporary, Jean Richepin. Whereas Uccello is a personage from the distant past, Bruat is a distinctly contemporary figure. Although he is without talent, he awakens one day with the bright idea that he is going to write a "masterpiece" of "modernity." He never publishes his sonnet, "Bonjour, Monsieur," because he is persuaded to flesh it out into a drama of the same name. Working on his play over the next five years, he sees that his "masterpiece" is inadequate, and, dedicating the next ten years to its amplification (shades of Frenhofer), he transforms it into a gigantic novel of twenty-seven volumes, a work of truly Balzacian proportions that suggests *La Comédie Humaine*, not to mention Zola's *Les Rougon-Macquart* in its very proportions.

This does not conclude Bruat's heroic labors à la Frenhofer. Realizing finally that he must "condense" his work if he is to transform it into a "paragon of modernity," he spends the next ten years toiling to reduce the twenty-seven volumes to their pith, *mon chef d'oeuvre*, as he says: a sonnet entitled "Bonjour, Monsieur." We now find the aged, obsessive Bruat, come full circle, on his deathbed; his friends eagerly await a reading of his poem, seeking the key to the mystery of his art in a single word, as Bruat, murmuring "Bonjour, Monsieur," expires. In Richepin's parody of Balzac, the ultimately empty title of Bruat's Frenhoferes-

que labor is the equivalent of Frenhofer's canvas, which is effectively "nothing," eradication in the extreme. Carrying Balzac's theme to the pitch of farce, Richepin makes his quixotic poet into a caricature of Frenhofer, no less fanciful and capricious than Schwob's amusingly innocent Uccello, lost in the jumble of his perspectival fantasies.

One of the more amusing tales illustrating our theme is found a short time later in a book with the Paterian title *Appreciation,* by Leo Stein, critic and collector, who was overshadowed by the larger presence of his redoubtable sister Gertrude. The painter Degas, Stein writes, was "proverbial" for his lasting dissatisfaction with his works, "the feeling that after all, even when most finished, they were not so." The collector Henri Rouart, Stein continues, owned one of Degas' finest pictures, which the painter wanted to retouch. Now for the best part. To prevent Degas from touching the picture, Rouart had it held to the wall with a padlock. (When Stein asked Rouart about this detail, he was told that the story of the padlock was a "fiction.") The collector nevertheless continued to keep his eye on Degas when the painter left Rouard's house each week after their customary dinner on Thursday, despite the fact that the painting in question was too big to be hidden under the artist's cape. Or so the story goes.

True to the theme of the artist's "anxiety," to his sense of not achieving a masterpiece, Stein's amusing anecdote places Degas in the line of Frenhofer and, as Stein suggests, of an even deeper tradition. Discussing the artist's "dissatisfaction with his work," Stein invokes a Renaissance example, telling the story of Titian, who had many pictures in his studio that he regarded with a "hostile eye." This tale is based on the fact that Titian's final works were painted in such an abbreviated manner that they seemed unfinished. Titian might well have said, "Frenhofer, c'est moi"; that is, if history were written backward, which in effect it is.

The comedy in the history of modern art and literature, shaped by writers of fiction, is particularly acute in Max Beerbohm's "Enoch Soames," a story in his collection of tales *Seven Men.* The fin-de-siècle author of a book called *Negations* and of a poem entitled *Fungoids,* Anxious as to whether his work is a success and, thus, whether a failure, Soames makes a pact with the devil in order to travel one hundred years into the future to discover how posterity regards his achievement. Beerbohm is here sending up the entire tradition of the damned modern

artist's associations with the devil, from Frenhofer to Dr. Faustus, even before Thomas Mann enters the story. When Soames arrives in the future, 1997, he discovers that he is written up in a biographical dictionary as a mediocre, imaginary writer invented by Max Beerbohm. Alas! Here, in the play of the "real" and the "imaginary," we have Beerbohm turning himself into a fictional character—but a fictional character true to life, for he reflects on the modern artist's failure to achieve a masterpiece. Beerbohm's imaginative self-metamorphosis, by the way, reminds us of what the imaginary poet Charles Wychwood once said: "Reality is the invention of unimaginative people."

Sometimes the comedy of modern art emerges in the strangest places. In a mystery novel, *The Burnt Orange Heresy,* Charles Willeford creates an amusingly Duchamp-like painter, Jacques Debierue, the author of a famous work that is an ornate, empty frame—the ultimate "unknown masterpiece." When the narrator of the novel, an ambitious critic, gains access to the reclusive artist's new studio after the latter's move to the United States, he finds only suggestively unused tubes of paint and empty canvases. He has discovered that Debierue was a fraud who posed as a painter but produced "Nothing"—the ultimate caricature of Frenhofer. The "finished, varnished, luminous" masterpiece glowing on the museum wall existed only in Debierue's "febrile mind." Afraid to risk failure, he had never "painted a picture of any kind in his entire life." Setting fire to Debierue's studio, the critic destroys the evidence that the artist, in fact, never painted. The ruthless, ambitious critic forges, however, a single painting by the artist, the basis for the criticism he writes of the painter that ironically determines his and Debierue's success. For in an encyclopedia of art he writes an entry on the painter longer than those on such greats as Goya and Michelangelo. Debierue, who in the end fared far better than Enoch Soames, though he produced nothing, or perhaps because he never painted, was indeed a fraud.

Debierue the impostor and his forger critic throw into relief Frenhofer's implicit "forgery" of a "masterpiece." Whereas Debierue's critic knowingly burns all the artist's canvases to conceal such failure, Frenhofer burns his work only after discovering his own failure. The critic who contributes to the fraud magnifies a major theme in the modern history of art, that of fraudulence or inauthenticity, a corollary of the very idea of failure. No wonder the forger becomes a central character in modern fiction, whether Owen Gwyon the copier of Flemish pic-

tures in William Gaddis's monumental, Joycean *The Recognitions* or Francis Cornish the "picture faker" in Robertson Davies' more popular *What's Bred in the Bone.* Sometimes the forger comes forward to speak of his duplicity. In his charming, wittily entitled memoirs, *Drawn to Trouble,* the forger Eric Hebborn tells many splendid stories of how he faked works by the masters that fooled the experts. Given the fact that Hebborn is a faker, we don't know exactly when to believe him, exactly what to believe. The artist as forger, in fact and fiction, is in the modern period crystallized in Thomas Mann's *Confessions of Felix Krull,* an "impostor," a confidence man described by the author as both "artist" and *blagueur.* Though not a painter as such, Krull epitomizes the inauthenticity of art in the modern period when the "masterpiece," authenticity itself, is no longer possible.

Nowhere does the ongoing mockery of the idea of the "masterpiece" appear in more pithy form than in Julian Barnes's novel *The History of the World in 10 1/2 Chapters.* An entire chapter is dedicated to Géricault's *Raft of the Medusa,* a work monumental in scale, ambition, and heroic achievement, a true masterpiece that epitomizes the grand tradition from Michelangelo to Caravaggio to David. The result of immense study and labor, Géricault's picture illustrates a horrendous subject, filled with pain, suffering, and despair, worthy of Dante. Delacroix, Barnes tells us, was so overwhelmed by Géricault's work that he left the painter's studio and ran like a madman all the way back to where he lived on the Rue de la Planche at the far end of the Faubourg Saint-Germain. This vivid account sets the stage for Barnes's report of what Géricault said about the painting on his deathbed: "Beh, une vignette." I do not know if Géricault actually spoke these words—I doubt it—but even if he did, Barnes exploits them ironically to undercut the very idea of the "masterpiece." For Géricault was here seemingly dismissing his work, a vignette, as nothing really, a mere bagatelle, if you will.

And this brings to an end (at least for the moment) our brief sketch of the modern artist's obsessive, at times quixotic or Faustian, quest to achieve a "masterpiece," a goal seemingly no longer possible to attain. For although Frenhofer, Lantier, Theobald, Dencombe, Chartkov, Uccello, Bruat, Bergotte, Degas, Enoch Soames, and Jacques Debierue may never have achieved the perfection to which they aspired in the fables of modern art, Barnes is telling us that not even the traditional "masterpiece" is a masterpiece—only a vignette, something rather

smaller than we had believed. Hermann Broch had already seriously broached this point when he had Virgil expound on the defects of his masterpiece manqué. Now, however, as if in the mocking spirit of Debierue's Duchampian fake masterpiece, the historical masterpiece is erased, history itself effaced, as if the masterpiece had never existed. We have come a long way from the heroic aspirations of the Romantic Frenhofer to Barnes's autoironic and self-dismissive artist, but we must recall that if Frenhofer's pathetic gesture was truly grand, his achievement was in a sense even less than that of Barnes's painter, for as Frenhofer came to see, his picture, his "masterpiece," his very achievement, was not even a coherent vignette, it was "nothing"—*rien!*

This story is both truly dreadful and comic, but it cannot be ignored, for it is told over and over and over again—by Balzac, Zola, James, Gogol, Schwob, Richepin, Proust, Beerbohm, Leo Stein, Broch, Moravia, Willeford, and Barnes, in fables English, French, Russian, German, Italian, and American, in stories that are a significant part of the global history of modern art and literature, of Modernism. Many of these writers are minor figures, some have been forgotten, others can be dismissed, but it does not escape notice that among our writers, Balzac, Proust, James, and Broch, we encounter figures who are themselves central participants in the heroic if not tragic story of Modernism that they help to define. Their achievement is part of the irony of Modernism, an art that aspires to great heights but is ultimately doomed, like that of Kafka's "hunger artist," whose grotesque self-deprivation is the acme of artistic abjection, abnegation, annihilation. This story can be expanded seemingly ad infinitum by countless other recent examples: Peter Ackroyd's *The Last Testament of Oscar Wilde,* in which the protagonist pathetically proclaims his ultimate failure, concluding, "I have betrayed my own gifts"; Thomas Bernhard's *The Loser,* in which a pianist named Wertheimer, unable to achieve the excellence of his fellow student Glenn Gould, abandons his art by committing suicide; or Antonio Tabucchi's fable of Ovid in his *Dreams of Dreams,* a fantasy of the ancient poet who dreams he has become a gigantic butterfly, with consequences horrendous and pathetic. Reciting his poetry to Augustus, Ovid emits the incomprehensible sounds of an insect, only to be brutally rejected by the emperor—as if in a monstrous inversion of Broch's story of Virgil's relations to Augustus. As Kafka had rewritten Ovid in his metamorphosis of Gregor Samsa into an insect, Tabucchi rewrites Kafka. For whereas

Samsa still had the power of speech, Ovid the butterfly cannot speak at all. Like many of Ovid's own most poignant characters, Tabucchi's Ovid has lost the gift of language: the ultimate privation of the poet, his very medium. "Don't you hear my poetry, Ovid cried, . . . but his voice was a faint whistle." More than a dream, Ovid's dream in Tabucchi is a nightmare, a nightmare of the artist's ultimate and grandiose failure—a nightmare from which Modernists, despite the irony, jests, parody, drollery, and *blagues* of James and Proust, Picasso and Duchamp, Richepin and Barnes, strove mightily to awaken.

NINE

MYTHS AND MYSTERIES OF MODERN ART

Ever since Homer, nearly three millennia ago, told the tale of the shield made by Hephaistos for Achilles, writers and artists have been telling stories or writing fables about art. Sometimes such fables are passed on as matters of fact, as when Picasso, who was born at 11:15 P.M. on October 25, 1881, according to birth records, would later tell the charming tale of his nativity at midnight. This seemingly casual alteration of the facts, a mere rounding off of numbers, is not so innocent and not without poetic significance, since, according to legend, midnight was the hour of Christ's birth. We cannot forget here that when Vasari described the nativity of Michelangelo, he pictured the advent of the messiah of art. "Seldom any splendid story," Dr. Johnson once said, "is wholly true." Or, if it is wholly true, we might add, its "truth" rises above the condition of mere "fact."

Sometimes the fable of art has been carried to the pitch of high farce and fantasy, as in William Beckford's largely forgotten, late eighteenth-century *Biographical Memoirs of Extraordinary Painters,* the mock-heroic "lives" of imaginary artists. Of all these artists the greatest was Aldrovandus Magnus, the epic painter whose labors on a heroic cycle of painting were tragically terminated when his supply of canvas vanished in a great conflagration, which, singeing the beards of his disciples, caused the

painter to die of grief. His epitaph, written by Professor Clod Lumpewitz or "Dim Wit" and rendered in English by John Ogilby, who was immortalized in Pope's *Dunciad,* likened Aldrovandus to Alexander the Great: the one died for want of worlds to conquer, the other "for lack of canvas." Here in a peak of parody, a summit of satire, the whole Renaissance tradition of the heroic artist goes up, you might say, in smoke.

That tradition is epitomized in the monumental *Lives* by Giorgio Vasari, unarguably one of the great novelistic authors of the modern period and the "father" of the modern history of art. As Ovid's myth of Pygmalion and Pliny's fables of Apelles became legendary, so eventually did Vasari's fables. Giotto drew a perfect O with a single flourish, Fra Filippo Lippi fled the Medici palace to pursue his carnal urges, and Paolo Uccello was so enamored of his "sweet perspective" that he refused to come to bed when called by his wife. The story of Uccello entered into the global imagination of literature, where it merged with the tale of Don Quixote, the greatest illusionist of them all, tilting at windmills. As his niece observed and as he himself later said, Quixote was himself a poet, an artist, whose romantic "picture" of the world is one of the masterpieces of art history. Although Vasari's artists were real people, not imaginary characters like Quixote, our sense of their reality is vivified, indeed magnified, by his fables in much the same way that Quixote is made "real" to us, comes to life, thanks to Cervantes' fictive powers.

Vasari's power as a fabulist is equally evident in his description of actual works of art. Painting the *Last Supper,* he tells us, Leonardo had difficulty imagining the head of Judas, since he did not think he could find a model for one so evil as the apostle who betrayed Christ. Centuries later, Vasari's fantasy would fire the imagination of the Czech writer Leo Perutz, who devoted his novel *Leonardo's Judas,* an imaginative portrayal of Leonardo's iniquitous traitor, to the question of what such a person was like. Vasari also pretends that Leonardo encountered a similar difficulty imagining the visage of Christ and therefore never finished it. Although there is no reason to doubt that Leonardo painted Judas's head, Vasari shrewdly comments on the theological problem confronting any painter who would seek to probe the mystery of incarnation by painting the image of God incarnate. The fiction of the unfinished fresco is keyed to a deep theme of Vasari's biography of Leonardo, the painter's tendency to leave works unfinished or "imperfect." This issue arises sig-

nificantly, if not paradoxically, in the life of the artist who, as Vasari says, brings "perfection" to the art of painting.

As Vasari said, Leonardo's inability to finish or perfect his paintings, despite the perfection of his ideas, is of enormous consequence to the fable of art and has everything to do with the modern historical concept of the artist doomed to failure because he can never achieve perfection. A version of this modern fable is found in E. T. A. Hoffmann's tale of the mad painter Berthold, in "The Jesuit Church in G." As a tale of an artist who struggles mightily to bring to completion a great masterpiece, the story is reminiscent of Vasari's biography of Leonardo, and it fore-shadows Balzac's tale of Frenhofer's similar struggles with a masterpiece. Although Berthold eventually completes his great painting, his self-doubts and his Promethean and diabolical character as described by Hof-fmann, are strikingly evocative of Balzac's painter. The similarities be-tween Balzac's story and Hoffmann's tale of Berthold have been generally, if surprisingly, ignored, despite the fact that the latter's influ-ence on Balzac is frequently observed. We follow Hoffmann's story, as if in a perfect genealogy, to Balzac, who, we might almost say, rewrote the tale of Hoffmann in "The Unknown Masterpiece," the fable of the mad painter Frenhofer to which we have returned over and over again, in-deed obsessively.

Leonardo's problem in the *Last Supper,* as Vasari suggested, was theological, the difficulty of rendering perfectly the mystery of divinity incarnate. But the modern artist, the modern "Leonardo," is preoccu-pied with the perfection of art as such, for in the wake of modern "aes-thetics," art in all its purity had become a substitute for religion. The perfect modern painting, "absolute" in Balzac's terms, is unachievable in its very transcendence. Discussing Leonardo's *Last Supper,* Vasari had addressed the way in which art and theology were intimately united. Now, however, in the art of Frenhofer and Picasso, the work of art, no longer informed by the certitudes of religion, could not achieve the perfection to which religious art traditionally aspired, no matter how heroic the painter's efforts. As Picasso said, the painter "never finishes," for he "can never write the end."

The modern artist or "Leonardo" modernized in the fiction of the nineteenth and twentieth centuries, unable to achieve the perfection which he seeks, suffers an anguish not yet experienced by Vasari's Leo-nardo. Writing *The Romance of Leonardo da Vinci,* ultimately a meditation

on art and religion, Merejkowski portrays Leonardo as a Renaissance Frenhofer who, filled with "doubts," is "always dissatisfied with what he has already done," as he strives for the "unattainable" and therefore "almost never completes his works." By the time Freud discovered Leonardo in Merejkowski's novel, the sense of art's futility had become commonplace, and Freud speaks of this condition when he says that Leonardo "has some dim notion of perfection, whose likeness time and again he despairs of reproducing." This "Leonardo" lives on in Pär Lagerkvist's novel *The Dwarf,* set in a Renaissance court, where the painter Bernardo, conspicuously modeled on Leonardo, proclaims in anguish, "all my efforts have been in vain," "all that I have created is imperfect and unfinished." Lagerkvist's faux Leonardo could almost be speaking for Picasso in confessing that his painting must remain unfinished. As Picasso put it, the finished work is "killed."

Picasso said something else of great significance in the story of modern art when he observed that the quest for unattainable perfection in art "sometimes becomes an absolute obsession." For the story of the modern artist's failed aspiration to the perfection beyond his grasp is inevitably the story of obsession, an obsession with the absolute which can never be achieved, not by Berthold, not by Frenhofer, not by Theobald, not by Bernardo, all of whom, like Picasso and the "Leonardo" of Merjkowski and Freud, are obsessed with the unattainable. All of these artists, real or imaginary, have their origins in Vasari's Leonardo, an artist who "never finished anything" because he could never achieve the "perfection" to which he aspired. It is easy to ignore the centrality of "obsession" in the story of modern art, in the history of what is called "Modernism," precisely because "obsession," now become a cliché for all desires in modern culture, is thus taken for granted.

When Freud wrote his analysis of Leonardo, *Leonardo da Vinci and a Memory of His Childhood,* he was acutely aware of the possibility that he had written a "psychoanalytical novel," and there are many who think that this is exactly what he did, since his hypotheses, often not buttressed by the facts, were based on the fantasies of Merejkowski's romance. Be that as it may, Freud saw in the legendary smile of the painter's works the remembrance of the maternal smile, which therefore provided a clue to the mysterious expression of *Mona Lisa.*

All such explanations have their roots in Vasari's fable of the *Mona Lisa,* one of his greatest fables, even though it is, as we often fail to

observe, only one sentence long. Vasari writes that Leonardo employed musicians and buffoons to amuse his sitter in order to avoid the melancholic air typical of portraits; the result was a smile that Vasari describes as "divine." If the effect is extraordinary, it follows that the cause should be as well. Vasari's fable poetically provides a cause that is truly extraordinary, since painters in the Renaissance did not use entertainers to amuse their sitters in order to achieve such remarkable results. Vasari's fable, like those in Ovid's *Metamorphoses* or other tales in the pages of the *Lives,* is a poetic reflection on the "origin of things," in this case an explanation of how a marvelous smile came to be. The art of Leonardo's portrait thus inspired the art of Vasari's fable. His tale, which has become legendary, enables us to see Mona Lisa as if in real life, smiling as she is entertained, as if she were a lady at court, and, suspending disbelief, we are happy to believe Vasari's fiction.

We can, in fact, associate the *Mona Lisa* in modern fable with the ancient myths of Ovid, which are still very much alive in the modern period, indeed to a surprising degree, given Modernism's supposed rejection of classical antiquity. In his romance of Leonardo, Merejkowski describes the *Mona Lisa* in terms which evoke one of Ovid's greatest myths, that of Narcissus. As the painter worked on his portrait, the novelist writes, Mona Lisa "became a feminine double of Leonardo himself," for "she was smiling upon him with his own smile." In the end, he says, suspending the laws of optics, Leonardo and Mona Lisa "were like two mirrors reflecting themselves in one another." Merejkowski calls to mind Ovid's fable of Narcissus gazing lovingly upon his own reflection in a pool, a myth which took on artistic meaning in the Renaissance when Alberti called Narcissus "the first painter," when it became proverbial to say, "every painter paints himself." Merejkowski's mythologized account, which occupies a central place in the history of explanations of Mona Lisa's smile, is a fantasy true to the painting. For his fantasy addresses the sense we have that Mona Lisa's revolutionary inwardness, the painter's suggestion of her mind or psyche, is a result of the artist's projection into his subject. Kenneth Clark effectively set forth the novelist's point another way when he wrote of the picture "as so full of Leonardo's demon that we forget to think of it as a portrait." More than a reflection of the painter in the narrow sense, the picture is a reflection of his psyche. Every painter paints himself.

In the pages of *Metamorphoses,* the myth of Narcissus, the first painter

whose love is unrequited, is metamorphosed into the story of Pygmalion, the sculptor whose love is fulfilled. Ovid's tale of the artist whose statue comes to life, like his myth of Narcissus, has broad currency not just as the subject of particular works of art but as a deep theme in what is abstractly called "the history of art." This is not the place to present a catalogue raisonné of allusions to Pygmalion in the modern literature of art, but we must look at some prominent examples in order to see how ancient myth remains very much alive in the modern period. Once again we are drawn back to Vasari's portrayal of Mona Lisa.

When Vasari pictures the Mona Lisa as "alive" (*vivo,* a word that echoes throughout his description), he writes that one can see the very beating of her pulse, a figure of speech that evokes the pulsing "veins" of Pymalion's statue under the sculptor's hand as he feels her come to life. Vasari's most famous allusion to Pygmalion is found in his discussion of Donatello's *Zuccone,* for when the sculptor addresses the statue, urging it to speak, he does so because his work appears to be alive. Remaining mute, however, the statue recalls Narcissus's silent reflection, which Ovid had in fact likened to a sculpture in stone.

As in Ovid, the myths of Narcissus and Pygmalion are often intertwined. In his seventeenth-century treatise *On Statues,* Gian Andrea Borboni speaks of the duke of Modena, gazing upon his portrait bust by Bernini, as a "new Narcissus," and when the duke addresses the sculpture he is, in Borboni's words, a "new Pygmalion." Bernini himself identifies with Pygmalion when he carves the statute of Pluto and Persephone. In an astonishing detail, the god's hands press into the seemingly soft flesh of Persephone and recall the manner in which Ovid's mythic artist presses his hands into his hard ivory statue, which comes to life. Pluto's hands, we might also say, are by extension those of the artist, himself a modern Pygmalion who has seemingly metamorphosed marble into the living flesh of a woman. In the following century the wonderful Winckelmann, writing his *History of Ancient Art,* assumes the persona of Pygmalion when he likens himself to Ovid's sculptor as he tries lovingly, indeed passionately, to bring his beloved Apollo Belvedere to life in words of voluptuous rapture.

In the nineteenth century the modern theme of Pygmalion, which has taproots in Vasari's poetic apostrophe to *Mona Lisa's* vital beauty, modulates into a story of artistic impossibility or failure, explored by Balzac. In "The Unknown Masterpiece," the eventually failed perfec-

tionist, Frenhofer, delivers himself of a long discourse on the defects of a painting of a female figure by another artist, which he finds lacking in the "breath of life," which is as "cold as marble to the touch." The allusion to Pygmalion is made even more obvious when Frenhofer says that "the blood does not flow beneath the living skin" of this painted figure, who therefore stands apart from the pulsing *Mona Lisa* and, ultimately, the living statue of Ovid's artist. In other words, the painter criticized by Frenhofer is a failed Pygmalion. What we do not know, cannot know, at this point in Balzac's story is that Frenhofer, despite his ambitions and vision of what art should be, is himself doomed to the same fate.

Frenhofer also proclaims of the painter whom he likens to a failed Pygmalion that the fire of Prometheus had died out in his hands many times, for various passages in his defective picture have not been "touched by the divine flame." The association of Pygmalion with Prometheus is based on the fact that, like Pygmalion, Prometheus was also a sculptor whose work was brought to life. An outlaw, punished for stealing fire from the gods, Prometheus animated his statuary with heat from the sun. At the dawn of modernity, in the Renaissance, Leonardo was likened by Lomazzo to the mythic Titan who emerges as the type of the heroic artist celebrated by the Romantics. In the modern period it is not uncommon for such figures as Michelangelo and Beethoven to be regarded as Promethean; in fiction, from E. T. A. Hoffmann's Berthold to Somerset Maugham's Charles Strickland in *The Moon and Sixpence,* the artist is likened to Prometheus. Using the words "new Prometheus" to describe Strickland, Maugham employs a phrase charged with meaning, for these words evoke Mary Shelley's characterization of Victor Frankenstein as a "modern Prometheus." A great artist, the Promethean Strickland is also, like Frankenstein's creature, a monster, a figure of evil.

Heroic outlaw and criminal, Prometheus is the classical model for one of the great mythic figures in the modern world, Faust, condemned to the fires of hell for his diabolical transgressions, as Prometheus had been enchained for his rebellion. The diabolical Strickland, who "delved into the hidden depths of nature" and "discovered secrets which were beautiful and fearful too," was as implicitly Faustian as he was explicitly Promethean. The artist as Faust first emerges, however, in Balzac's Promethean Frenhofer, who had already sought to penetrate the "secrets"

of nature. Balzac reinforces this identity by presenting Frenhofer as a magisterial figure of great learning, and when he says that Frenhofer worked for ten years on his masterpiece, he echoes Goethe's introduction of Faust, who had devoted ten years to his studies. Frenhofer's labors on his unfinished masterpiece and Faust's studies of the same duration are seemingly echoed by Merejkowski's assertion that "after ten years' pondering," Leonardo had not sketched the first outline of the head of Christ in the *Last Supper*. Describing the artist before the blank area of the fresco where the head was to go, saying the artist was impotent and perplexed, the novelist further conjures up Frenhofer. If Leonardo's inability to finish his works stands behind Frenhofer's unfinished masterpiece, now Frenhofer's futility has become Leonardo's incapacity!

Faust's aspiration to penetrate the mysteries of nature defines the modern fable of Leonardo. A near contemporary of the historical Faust, the learned doctor from whom the myth was fabricated, Leonardo was seen already in the Renaissance as a magus, steeped in alchemy, as Vasari says, and in other occult pursuits. The nascent sense of Leonardo as Faust is sustained by Vasari's description of the artist in the first edition of the *Lives*, which was suppressed in the revised edition. Leonardo, Vasari writes, "departed from all religion, perhaps placing knowledge higher than Christian faith." In Michelet's words, Leonardo was "Faust's Italian brother," reminding us that Balzac's Faustian Frenhofer, who failed to achieve perfection in his art, had his origins in the imperfect strivings of the Renaissance Faustus. Portraying Leonardo, Walter Pater also invoked Faust's "mass of science" in Goethe, and, following both Pater and Michelet, Freud would speak of the artist, "insatiable and indefatigable" in his "thirst for knowledge," as a type of Faust.

The emergence of Faust in the modern history of art, in fiction or in the story of Leonardo, where emphasis was placed on the relations of art to science, became a powerful theme of modern art history. Indeed, Faust's pact with the devil assumed a major role in the story of art. After emerging as a figure of overwhelming grandeur in Milton, Satan works his spell and casts a broad shadow over the world, notwithstanding its increasing secularization. In the last century, for example, he plays a conspicuous allegorical role in two exemplary novels of monumental scale about "evil empires," Thomas Mann's meditation on art in Nazi Germany, *Dr. Faustus,* and Bulgakov's phantasmagoric portrayal of Satan's place in that nightmare of Stalinist Russia, *The Master and Margarita.*

All of Satan's epiphanies as the incarnation or personification of evil in the world as recorded by Marlowe, Milton, Goethe, Hawthorne, Mann, Bulgakov, and many, many others are part of his life story, but although the "biography of god" has recently been written and even his fictional autobiography published not long ago in Italy, we still have no definitive biography of Satan, whose contributions to art history, colossal, monumental, supernatural, are beyond measure.

In the early modern period, when the artist is usually seen as godlike or saintly, the devil's role in the history of art is rare. Although unnamed, he makes an appearance in Vasari's fable, which we have only touched upon, of the fiendish painter Andrea del Castagno in one of the writer's most enduring fictions. It tells how the envious artist betrayed and murdered his talented friend, the painter Domenico Veneziano. The satanic artist, Vasari claims, portrayed himself in one of his works as Judas, a fitting sign of his diabolical identity. Only in the nineteenth century, however, does Satan come to the fore in the artist's biography. Hoffmann's painter Berthold, caught in a "devilish hoax," says that "the devil lures us with puppets, to which he gives angels' wings." Balzac's Frenhofer, closely related to Hoffmann's Berthold, has a "diabolical smile," a hint that this obsessed artist is possessed by the devil—a reminder of the way in which the modern concept of obsession as a psychological phenomenon is rooted in the earlier notion of spiritual or demonic possession.

The devil's possession of the artist's soul is the subject of a story by Balzac's friend Théophile Gautier. Entitled "The Painter," it appears in his collection *My Fantoms*. Gautier writes of the painter Onuphrius, terrified by the devil, who brings the clock hands forward and adds a mustache to one of the painter's works, an idea that was appropriated more famously and facetiously by an avant-gardist nearly a century later. Seemingly possessed by the devil, Onuphrius soars over the Louvre, where he beholds among the works of Delacroix and Ingres one of his own paintings, which creates a buzz of admiration among the onlookers. The picture seems even better than Onuphrius recalls, and he is moved by his own genius, until he discovers that the work has been signed by one of his friends in an act of "villainous plagiary." This is but a single episode from a series of fantastical happenings in Onuphrius's life worthy of the demonic apparitions of E. T. A. Hoffmann. In the end, Onuphrius, who had the potential, as Gautier says, "of becoming one of the

greatest artists," becomes instead "one of the strangest of our madmen," squarely in the glorious genealogy of the modern, mad painters Berthold and Frenhofer.

Whereas Gautier's tone is exceedingly playful, if not ironic, Gogol is far more grave and terrifying in his fable of demonic possession of the artist, "The Portrait," a story which we have already had occasion to explore in various ways, if too briefly. But let us resume our reading of this tale. After Chartkov the painter acquires the portrait of an old man, he finds that there is something very strange about the figure that went "beyond art." The subject's eyes are "living, human eyes!" Contemplation of the picture does not uplift the soul but creates terror as the eyes bore into Chartkov, for he cannot escape those "terrible eyes." When the old man exits the picture, passing through the frame, he leaves the painter one thousand rubles, which he eventually spends to buy up many great works of art, all of which he destroys in a fiendish rage of spite and jealousy. Conscious finally that he has "destroyed" the best years of his own career, the embittered, deluded painter goes mad. At his deathbed all those who gather around the painter look like fearful portraits reminiscent of the demonic portrait that has led to his doom. He begins to see that painting doubled, quadrupled, multiplying everywhere; diabolical portraits stare down upon him from all around, their living eyes boring into him as he dies surrounded by the slashed remains of those works of art he has destroyed. The painter's downfall began when the terrifying subject of the portrait he had acquired, seemingly the devil incarnate, tempted him with the bag of undreamed of wealth. Surely this was the work of the devil, who presides supremely over the doom of an ambitious artist.

In Gogol's horrific tale, it is as if the myth of Pygmalion, the fable of a work of art coming alive, had been infected by Satanism. This is by no means the only occasion when these two threads of myth are interwoven in the fabric of modern art history. Hawthorne's classic tale "Drowne's Wooden Image" makes this connection explicit. The mediocre woodcutter Drowne mysteriously creates an image of a woman so lifelike that he is now seen as a "modern Pygmalion." When the captain of the ship for which the sculpture was made appears in public with a woman who resembles the statue, it appears that the work has become flesh. Such a sudden change in Drowne's work, which was conducted in great "secrecy," cannot go unexplained, and an old Puritan points to

the source of Drowne's inspiration when he mutters, "one thing is certain, Drowne has sold himself to the devil."

Even when Satan is not mentioned in the modern fable of art, one senses his presence. In Edgar Allan Poe's "The Oval Portrait," a dark, gothic tale of gloom, an obsessed, indeed possessed, artist, painting a portrait of his wife, is more truly the spouse of his art than of his neglected model. As he paints, as he is absorbed into his art, growing wild with ardor, he rarely turns his eyes from his work to regard his wife's countenance. When, finally, the painter, having finished his work and "entranced," looks at his portrait, he cries out, "This is indeed *Life!*" He then turns to his wife and finds that she is dead. In an utter inversion of the tale of Pygmalion, the spirit of the painter's wife has seemingly passed into the picture. Had Hawthorne's old Puritan witnessed this metamorphosis, surely he would have proclaimed that the portrait was the work of the devil. Can there be any doubt that Poe's unnamed painter, wild, moody, passionate, tremulous, and entranced, as seemingly mad as Frenhofer and company, was possessed? Here at last is a story of success in modern art. Poe's painter, in contrast to Frenhofer, Chartkov, or Onuphrius, achieves "life" in art. But at what price? The sacrifice of his wife! Not until Oscar Wilde's *The Picture of Dorian Gray,* which similarly broods on the intimate and mysterious relations between portrait and subject, do we encounter a story so chillingly diabolical, a fable typical of what was referred to as the author's diabolism.

If Poe's implicitly diabolical portrait painter is a type of Pygmalion who, in a sense, takes the life of his subject as he brings new life to art, Mark Twain's Satan in the long tale *The Mysterious Stranger* is more like Prometheus when he creates tiny living creatures out of clay. Twain's Promethean Satan, the nephew of *the* Satan, Satan the Younger we might call him, destroys his very own creatures; he is himself perfectly satanic. As the inversion of God the Creator, the archetypal artist, Satan is the sublime destroyer. He epitomizes the destructive power of the modern artist.

The devil's role in art is also explored by Somerset Maugham in his portrayal of the Gauguin-like Strickland in *The Moon and Sixpence.* Cruel, selfish, brutal, sensual, and odious, Strickland "had the devil," was "possessed by the devil," as Maugham reiterates, adding that his art was a form of "black magic." Possession and obsession are here again closely connected. Observing that Strickland, before he reached Tahiti,

was "harassed incessantly by his struggle with technique," Maugham says he "managed, perhaps, less than others to express the vision that he saw in his mind's eye." Maugham's painter, who reminds us of Frenhofer or Leonardo, prompts the novelist to say that "no artist achieves completely the realization of the dream that obsesses him." Like Frenhofer, Strickland is a man "not quite sane," a man possessed by the devil, seemingly unable to achieve the ideal to which he aspired.

Whereas Frenhofer never achieves the masterpiece to which he has devoted his very being, Strickland, who ends his life as a leper in Tahiti, does realize a "strange masterpiece" when, at the last, blinded, he fills his jungle hut with paintings. These extraordinary works fill Dr. Coutras, who describes them, with the same feeling he had when he went to the Sistine Chapel, where he was "awed" by the greatness of Michelangelo, by his overwhelming genius, which made him feel small and insignificant. Nothing, however, has prepared Dr. Coutras for Strickland's works, which are "obscene," "troubling," making him "uneasy." Gazing upon Strickland's work in horror, he is like Conrad's narrator at the climax of *Heart of Darkness,* seized by "terror." In "the clutch of an unseen horror," Maugham's doctor confesses that he is not altogether sorry when Strickland sees to it that his great work is "destroyed" by having the hut burnt down. "I think Strickland knew it was a masterpiece," Dr. Coutras continues, adding in almost biblical language suggestive of God's creation: "he had made a world and saw that it was good." But he inverts the idea of God the Creator when he says of the diabolical artist's destruction of his own work that he did it "in pride and contempt."

How do we take the measure of Strickland's artistic self-annihilation? He is not the Michelangelo who, Vasari says, burned his drawings in old age, presumably in order to conceal the effort that went into his masterworks. Nor is he the bizarre neo-Vasarian Aldrovandus, who never realizes his masterpiece when a great conflagration consumes all his canvas. Nor is he even the Frenhofer who burns all his works in disillusionment when he sees that his failed "masterpiece" is "nothing." Strickland gives undreamt-of meaning to the words of Picasso, who said that painting is a "hoard of destructions." Descending from classical antiquity, the Renaissance and Romanticism, the Promethean, Faustian, and satanic, Strickland is the supreme type of the modern artist as anti-

hero, an outlaw, who exposes himself to the "agonies of the damned" in the very blaze of self-damnation.

The role of Satan in the story of modern art is closely tied to the emergence of the artist as criminal or immoralist. In his novel *Justine* the satanic Marquis de Sade defends Michelangelo for crucifying a young man in order to copy his very agonies in a *Crucifixion*. A similar, even more horrific story was told a short time later about Giotto in a book called *The Arts and Artists*. Also intending to paint a *Crucifixion,* the artist induces a man "to suffer himself to be bound to a cross" for an hour, after which he will be released and handsomely rewarded. Murder is here combined with the depths of duplicity, for once he has his victim secure, Giotto grabs a dagger and plunges it into the man's heart. He now could effectively imitate in painting the agonies resulting from his "foul treachery." Both of these stories exemplify what De Quincey, followed by Oscar Wilde, spoke of as the "fine art" of "murder."

As the artist is criminal and murderous, so his works take on the character of crime and immorality. Leonardo's *Saint John,* whose flesh "no one would go out into the wilderness to seek," as Pater says, gazes out with a "treacherous smile." Leonardo's saint, as a character in Merejkowski's novel observes, has "the impiety of the devil" and is the forerunner not of Christ but of the "Antichrist." The smile is no less dangerous when it appears on the face of Mona Lisa, a "vampire," as Pater calls her, whose treachery is mocked by Aldous Huxley in his story "The Gioconda Smile." For the woman of this tale, whose smile evokes Mona Lisa's, is a murderess. The sense of the "unfathomable smile" in Leonardo, "sinister," as Pater says, points back to Vasari's incipiently Faustian artist, who had already passed mysteriously beyond conventional religion and morality when he exalted science above religion.

As Leonardo's works came to be regarded as mysterious, their chiaroscuro evoking mystery, so did their creator come to be seen as a mystery. In the wake of the eighteenth-century sense of the mystery in the sublime, reflected in the gothic romance, Leonardo's legend merged with the modern fiction concerning the artist as himself a mystery. The mystery of the artist had, in effect, become one of the "sacred mysteries" of Modernism. Hoffmann's tale of the strange Berthold, the Leonardesque painter who struggles to complete his masterpiece, is an early mystery story about art, foretelling Balzac's more explicit "mystery" of the

more enigmatic and elusive Frenhofer, whose roots also lie in Leonardo's thwarted aspiration to perfection.

This mystery would be probed by one of the greatest detectives of the era, Freud, and by the legion of psychoanalytical critics who, following his approach, would probe correspondences between the artist's psyche and his work, now assumed to be virtually universal. The Narcissus-like reflection of the artist in his work thus took on new psychological depth. The key to these detective investigations of the mysteries of artistic identity was sexuality, which draws us back once again to the erotic desire that lay at the heart of the myth of Narcissus, the primordial painter.

With the development of the story of the obsessive artist as a mystery in Balzac and Hoffmann, we find that the artist's critics or biographers, entering into the spirit of the artist, came to be themselves obsessive in their quest of the artist. Frenhofer is, in a profound sense, Balzac's double, his doppelgänger, his Narcissus-like twin, who reflects the novelist's own obsession with the unattainable absolute. Speaking explicitly of his "obsession" with Leonardo, Freud finds in the artist's obsession with science his own reflection. Saturated with Balzac, Henry James had, before Freud, codified in fiction the story of the would-be biographer's obsessive search for the clues that would unlock the mystery of the artist, most notably in *The Aspern Papers,* the tale of the quest for the hidden letters of a dead poet that would provide a key to the mystery of the artist. James's approach would be assimilated into the writings of biographers of artists, real and imaginary, as mystery stories, indeed detective stories—from A. J. A. Symons's *Quest for Corvo* to Ian Hamilton's *In Search of J. D. Salinger* and A. S. Byatt's suggestively entitled *Possession.* These are all works in which the artist is now the subject of the biographer's or novelist's obsession, the analogue of the modern artist's own obsession. The fable of the obsession with the artist, of which there are countless recent instances, for example, Peter Ackroyd's *Chatterton,* Amanda Prantera's *Conversations with Lord Byron,* and Michael Frayn's *The Trick of It,* is a parable of the modern obsession with art and all its mysteries, a parable more often than not now written with a large quotient of irony and with a sense of the very futility of such obsession.

Nowhere is the delineation of the quest for the artist more delightfully present than in James's classic story "The Figure in the Carpet," the deeply ironic, teasing tale of what the author drolly speaks of as a

critic's "obsession" with the "mystery" or "secret" of the novelist, the clue to which lies "hidden" deep within his work. The critic's quest to penetrate this secret, futile as it is obsessive, mirrors the obsessive artist's own failed attempts to penetrate the mysteries of art itself. As in art, so in biography, and the secret of James's artist is ultimately never "unveiled." Following Flaubert, and like Walter Pater, James believed that art ultimately is "impersonal" or, as T. S. Eliot would later say in the wake of all these writers, "depersonalized." This modern tradition of criticism that suggests limits to the biographical approach to the artist is the countercurrent of the pervasive psychoanalytical theory of Modernism, rooted in the myth of Narcissus, typified by Freud and his followers, who would discover the reflection of the artist, his life or personality, in the work. At its extreme, the idea of artistic impersonality would eventually reach its apogee in Roland Barthes' classic pronouncement of the "death of the author"—depersonalization in the extreme, when the corpse of the artist was buried once and for all.

Writers in the twentieth century, undaunted, have dared to resurrect the artist, to pursue his ghost, to speculate on the mysterious relations of his life to the work—from Somerset Maugham's *The Moon and Sixpence,* a novel about a painter whose "secret has something of the fascination of the detective story" to Julian Barnes's *Flaubert's Parrot,* another detective story of obsession, in which the narrator, an amateur of the French writer, aspires to know "exactly what Flaubert was like." In the paradox of Barnes's profoundly ironical book, Flaubert is always before our very eyes, but always elusive, our efforts to know him ever frustrated by such phrases as "we shan't ever find out," "the truth is not recorded." *Flaubert's Parrot* is saturated with the artifice and guile of Nabokov's *The Real Life of Sebastian Knight,* the metabiographical novel about a novelist which is not only rooted in Symons's quest for Corvo, published just a few years before Nabokov's book, but also has its previously undetected taproots in the ironies of Henry James's detective fictions about writers. The relation of Nabokov's novel about the mysteries of artistic identity to the fiction of Henry James remains as obscure as it is profound, for Nabokov's admiring readers, ever attentive to the novelist's smallest secrets, have so far failed to detect the clues to his indebtedness to the "Master."

Like James, who, building on the fantasies of Hoffmann and Balzac, invented the type of detective story in which the literary artist is the

narrator-detective's quarry, Nabokov carries irony to an extreme pitch, probing its every nook and cranny, in his own wry but poignant tale of the narrator's "quest" to know his half-brother Sebastian, to hunt down the "ghost" of the writer to whom he is intimately related in more ways than one. As the "secretive" Sebastian Knight could not tolerate "sham mystery," so Nabokov rejects the clichés of the conventional detective story in his own tale of detection. Although the biographer in Nabokov's book never penetrates the artist's "secret," he does discover that any soul may finally be ours if we "follow its undulations." Nabokov's diction here, or rather that of his narrator, who is the double impersonation of Sebastian and Nabokov himself, is suggestive, for the "undulations" of which he speaks bring us, full circle, back to the pool of Narcissus. Only now the ripples of water dissolve the reflection into something far more subtle and complex than mere reflection, reminding us one last time, as Nabokov intended, of the vagaries of the bedeviled biographer's obsessive quest to penetrate the mysteries of artistic identity—one of the very deep themes in the pool of modern fiction about art.

The mystery of the artist persists, and nowhere more manifestly than in the recent writings on Leonardo. In his novel *The Memory Cathedral: A Secret History of Leonardo da Vinci,* Jack Dann's subtitle still points to the idea of those "secrets" that lie at the heart of Leonardo's legend, and George Herman has written a novel, *A Comedy of Murders,* in which Leonardo, employing his scientific analytic skills, is a detective investigating murders at court. If not the mystery itself, he is still enveloped in the aura of mystery. As with Sherlock Holmes and Professor Moriarty, the detective and the criminal are each the double of the other. Leonardo, the sleuth, is the obverse of the traditional identification of Leonardo with evil, with the devil.

The mystery of artistic identity is not the peculiar province of Modernist fiction, which is saturated with irony and obsession, with notions of imperfection and failure. It pervades the scholarship of modern art history, as susceptible itself to fiction and myth as fiction is responsive to history. The fabulist's sense of the "demonic" lingers in Kenneth Clark's characterization of Leonardo's "almost blasphemous" *Saint John;* the traditional Faustian view of the artist persists in the scholar's portrayal of Leonardo's "passionate curiosity in the secrets of nature," of "his inhumanly sharp eye." Indeed, the figures of Leonardo's art, Clark asserts,

are not human, but "symbols of mystery." The mystery resides in Leonardo's supposed self-portrait as an old man now in Windsor Castle, which is less a self-revelation than an idealized image. The so-called self-portrait, Clark concludes, is "remarkably unrevealing." In other words, it remains a mystery. Clark's Leonardo still resembles the artist of Freud, Merejkowski, and Pater, as he evokes a galaxy of elusive modern artists, real and fictional, from Frenhofer and Flaubert to Sebastian Knight.

Over and over in Leonardo's writings, it has been said, one encounters the lament "Who will tell me if anything was ever finished?" As Leonardo's pursuit of nature was never completed, so many of his works were left unfinished. These words from Leonardo's notebooks lead us back through the ages, through the legend of Leonardo, past Vasari's fables, to the artist himself, to his "unanswered question" whether anything can ever be completed or perfected. In this repeated, if not obsessive, question, we discover the juncture of Leonardo and Balzac's Frenhofer, the origins of Picasso's claim that a painting is never done; and we find here, too, the deep roots of our own peculiarly modern and pervasive sense of the mystery of art, the sense that it ever eludes us, that our own obsessive detective investigations of it will remain incomplete, will never be finished. As Leonardo illuminates the diabolical Frenhofer, Frenhofer illustrates the bedeviled Leonardo, and in both figures we find the imperfect reflection of Modernism.

TEN

TOWARD A MOCK–HEROIC HISTORY OF THE ARTIST

At the very beginnings of our story, the artist is a figure of grandeur or magnificence. In the Hellenic tradition, Hephaistos is the great artist whose work transcends anything made by any mortal contemporary with Homer or earlier. In the Hebraic world, God the Creator is a glorious figure who creates a masterpiece when he fashions Adam. In both cases, however, the divine artist can also be seen as ridiculous or mockheroic. Hephaistos, as we saw, is deformed and clumsy; he is ludicrous, a source of the laughter of the gods. And although he eventually achieves perfection, as Boccaccio jokes, God the Creator previously made works that were deformed and ridiculous.

As the cult of the artist emerged in modern Europe, beginning with Dante and elaborated by Boccaccio, Vasari, and others, there emerged along with the image of the artist's greatness an image of the artist as a ludicrous figure. Throughout this essay we have cited numerous examples: Hephaistos cuckolded by his wife; Giotto, ridiculous in his sodden, disheveled clothes; Michelangelo, who laughs at his own deformity in his poetry and who is mocked when he carves an old faun with all of his teeth; the fat carpenter, who is tricked into thinking he is not himself; Uccello, who fears he might turn into cheese; and the silly Topolino, who carves a statue of a dwarfish Mercury. These are just a few examples,

which can be multiplied manyfold with examples not retold here but available in various collections of anecdotes.

One could thus write an extensive history of the artist from Giotto's jest when he paints a fly on the nose of a figure by Cimabue through the jokes of Picasso—a sustained history of comic anecdotes about parody, satire, farce, and wit that is antithetical to the kind of narratives that art historians write, which are filled with stories of pathos, tragedy, and suffering. The playfulness of many of the stories about artists reflects the essential fact that art is an exalted form of play; artists are consequentially playful in their jokes, jibes, and witticisms.

The history of art as play and of the artist at play has never been written in full because art historians are for the most part not playful when they write (although there is evidence that they can be playful in their nonprofessional everyday lives, which lie beyond the scope of this book). If I have thus far only hinted at a history of the artist which would be comic or mock-heroic in tone, I want to look here at the stories of two artists whose life stories are ridiculous and belong to this larger narrative. The first is a tale by Balzac entitled "Pierre Grassou," which is not only a farce but also a serious, bitter indictment of the bourgeois taste for mediocrity. Strangely enough, although the pathetic painter who nevertheless succeeds is the very opposite of the great Frenhofer who fails, the story of Grassou is generally ignored by Balzac scholars and art historians concerned with Frenhofer. The second story I want to tell here, this one from "real life" and not fiction, is that of Douanier Rousseau, who, we remember, is a kind of twentieth-century Paolo Uccello. In the story of Rousseau, a kind of biographical sketch, we find a great deal of humor. In both stories, the simple subjects of our narratives are played off against other artists who are grander in the scale of their ambition. If Grassou is implicitly set against Frenhofer, Rousseau presents himself in opposition to Picasso. But before we turn to the "reality" of Rousseau's story, let us begin with Balzac's fiction of Grassou, whom we might well call Pierre le Fou.

In "Pierre Grassou," the painter's mediocrity, his lack of self-criticism and passion, his banality, and the vapidity of his work deepen and clarify our understanding of Frenhofer's heroic, indeed tragic, grandeur. Whereas Frenhofer sought to transcend the boundaries of art, Grassou, who takes the name of his hometown, Fougères, is satisfied to copy the great works of the past. The story of his "success," at bottom a travesty

of Frenhofer's tragic tale, is both comic in its absurdity and venomous in its satirical indictment of the bourgeois taste that exalted Fougères.

Born to a virtuous family in the provinces, Fougères begins his career as a clerk in a shop that sells art supplies; he eventually moves to Paris, where he begins to paint. After his submission to the Louvre exhibition of 1819, a pastiche based on Greuze, is rejected, he visits a former teacher, who, criticizing Fougères' poor draftsmanship, among other deficiencies, urges the would-be painter to abandon art. Fougères nevertheless sells his failed picture and eventually other imitations to a cunning art dealer for a modest sum in order to eke out an existence.

The pathetic, untalented painter nonetheless pursues his modest career for ten years—recalling Frenhofer's ten-year pursuit of a "masterpiece"—before submitting another pale entry. This time he copies a work by Gerard Dou and sends it to the art exhibition of 1829. The painter disguises his plagiarism adequately, and the judges, feeling pity for the artist, accept his feeble entry, which enjoys a certain success among those wanting in sound judgment and leads to a series of commissions. The big break in Fougères' career comes when his dealer arranges for the painter to do a family portrait of a bottle merchant. With caricature and an almost Daumier-like bite, Balzac likens the famous merchant to a melon, the wife to a coconut, the daughter to an asparagus. To make a long story short, one thing leads to another and the painter becomes engaged to the daughter. The poor painter's financial success is now seemingly secure. But that is not all.

Invited to lunch at the country estate of the bottle merchant, who admires our antihero as a great artist, Fougères is shown the family's picture gallery, which is filled with the paintings of great masters, works of enormous monetary value, works by Titian, Rubens, and Rembrandt, among others. And what does Fougères behold? One hundred and fifty paintings, half of which are from his own brush. Stunned and speechless, he learns that his own feeble imitations of the old masters have been acquired from his picture dealer as originals, purchased for huge sums. When he tells the merchant that these works are his own, his potential father-in-law is scarcely disappointed, since all he cares about is the monetary value of the paintings. As the painter of expensive pictures, Fougères rises in the art collector's estimation. He marries the merchant's daughter, who comes to him with a substantial dowry. Though mocked by his fellow painters as a painter without talent, he flourishes in bour-

geois circles as a portrait painter, and when the story ends, he is a candidate for the Academy. Thus the absurd triumph and success of the empty Fougères.

These are the spare facts of Fougères's story, the story of his "success," recounted here without adequate attention to Balzac's artifice, to the biting sarcasm, which colors his account of the pathetic antithesis of Frenhofer. The boring, vacuous Fougères typifies the lack of seriousness of the art world, the poverty of bourgeois taste. A supreme mediocrity, he cannot draw or compose; his use of color and of lights and darks is deficient. In his passivity, he lacks the vision and serious ambition of Frenhofer. As Frenhofer says, great artists are not imitators, but poets. Fougères, however, is a mere imitator. For Frenhofer painting is a passion; for Fougères painting is accommodation to the bourgeoisie.

Frenhofer is an enduring figure who, aspiring to greatness as a painter and resisting the facile formulas of art, comes to be seen as the model of Modernist ambition in art, whereas Fougères, despite his apparent success, has sunk into oblivion. When he confronts all of his imitations in the bottle merchant's collection, all the fake Titians and Rembrandts he has artlessly manufactured, Fougères proclaims that he is "himself twenty great masters." With delicious irony, Balzac has the hack painter say in effect that he has painted many masterpieces.

Apparently eclipsed by Frenhofer, Fougères is nonetheless an enduring figure. His feeble imitations of masterpieces foreshadow the proliferation of art as commodity in the modern world. Every expensive, third-rate imitation of a modern masterpiece that finds its way into an art collection, and every pastiche of Modernism used to decorate a stylish home or corporate office, was painted by a modern Fougères. When modern critics, disregarding the aesthetic virtues of art, see such art only as "commodity," and when collectors treat art primarily as an investment, they join the company of Fougères's admirers. Fougères may be forgotten, but his progeny have multiplied and flourished in the modern marketplace of art, where taste, sensibility, and aesthetic judgment have often gone up in smoke, along with Frenhofer's heroic aspirations.

Our second mock-heroic biography of an artist is one drawn from real life. I speak of the story of Douanier Rousseau. When we think of Douanier Rousseau we imagine a charming, naïve, childlike, indeed gullible man, a dreamer who was the subject of practical jokes, a painter of primitive, innocent dreams, of jungles, harlequins, ballplayers, chil-

dren, animals, and flowers, all rendered in a simple style that sets his works apart from the sophisticated, highly self-conscious, often violent paintings of such contemporaries as Picasso. Nonetheless, in a legendary remark, Rousseau said to Picasso: "We are the two greatest painters of our age—you in the Egyptian style, I in the modern." We smile at this seemingly simple, preposterous claim, thinking of Rousseau's innocent pictorial fantasies, such as *Le Rêve*, where a naked woman, reclining upon a divan improbably set in a dense, lush jungle—a symphony of greens filled with exotic flowers and fruits, bright birds, lions, and an elephant—listens to the music of a snake charmer in the serene nocturnal glow of a magical moon. When asked about the sofa in the virgin forest, Rousseau commented on the richness of its color, adding on another occasion that in this picture of a dream, he had kept his "naïveté."

If one is naïve, surely one does not know it, and Rousseau, contrary to his persona, was anything but naïve. As Rousseau's lawyer sensed, Rousseau has made fun of his contemporaries by assuming a mask of naïveté and innocence before the world. The persona or mask that he wore was the work of cunning and guile, the counterfeiting of innocence. The primitive Rousseau is a forgery, like all the fake Rousseaus that cropped up in Paris after his death—a self-forgery, if you will. It is said that Apollinaire was largely responsible for the mythology of Rousseau, that Apollinaire was Rousseau's Vasari, but just as Michelangelo superintended the creation of his own myth, given final shape by Vasari, so did Rousseau supervise the shaping of his own legend in the hands of others. This point has previously escaped detection.

Apollinaire observed that Rousseau had "so strong a sense of reality that when he painted a fantastic subject, he sometimes took fright and, trembling all over, had to open the window"—a story that recalls Vasari's tale of Spinello Aretino terrified by his own painting of the devil. According to another story that appeared in *Le Temps,* when peace was reached between Russia and Japan, Rousseau innocently painted the rulers of both countries holding hands in the nude, and the police, seeing an offense to the sovereigns, confiscated the picture. In a related story told after his death, Rousseau was persuaded by Alfred Jarry to take up painting, to execute a picture of Adam and Eve in paradise. The painting, which had trees covered by fruits like red balloons, caught the attention of a policeman and Rousseau was charged with indecency. When the magistrate dropped the charges, Rousseau offered to paint his wife.

This detail is related to the earlier account of a trial at which Rousseau was charged with *faux et usage de faux*. After the trial, Rousseau bowed to the judge and said: "Thank you, Monsieur le Président, I will paint the portrait of your wife."

Rousseau had been charged for his involvement in a theft perpetrated by his former music pupil Gabriel Sauvaget (remarkably well named given the primitive world of Rousseau's iconography). In the account of the trial that appeared in *Le Temps,* which reads like a hoax, we learn that Sauvaget furnished Rousseau with false papers that allowed him to draw twenty-one thousand francs from a bank, of which Rousseau retained one thousand francs for his efforts. Rousseau's defense was based on his innocence of financial affairs. Not knowing anything of forgery or fraud, he pleaded, he had been duped. His defense, less than innocently, was based on press notices that described his paintings as childish, and one of his jungle pictures, *Singes dans la forêt,* was presented in evidence to show the lamentable naïveté of the artist who, aspiring to serious art, painted in a childlike manner. Rousseau acted with simplicity during the trial and it has even been said that his behavior contributed to his acquittal. Was such comportment not a form of *usage de faux?*

Rousseau was the butt of numerous jokes, which he probably encouraged because they enabled him to develop his artful persona. When he told his friends, for example, that he was visited by ghosts, his companions placed a skeleton that was moved by pulling strings between casks at the Halle aux Vins. To their surprise, when confronted by this ghost, Rousseau calmly bowed and asked it if it had come for a glass of wine. Who is the gull in this story? Certainly not Rousseau.

Nor was Rousseau so innocent when he submitted to the *Comédie Française* an absurdist, almost Jarryesque drama in five acts said to have been composed by himself and a certain Mme. Barkowski. Of Rousseau's make-believe collaborator one commentator has written, "Nothing seems to be known of Mme. Barkowski." Another distinguished critic of Rousseau has written that her identity is uncertain. The play begins with the farcical flight of a canary from its cage, whose departure causes Yadwigha much sorrow. The first scene may be all about a *canari,* but like the entire play, it is a *canard.*

The aviary of Rousseau's critics is filled with gulls, including the scholar who wondered if Mme. Barkowski were not the mysterious Yadwigha herself—as if Yadwigha were any more real than Ubu Roi.

Yadwigha is best known to us as she appears upon her divan in the jungle, dreaming her dream of the jungle in *Le Rêve*. Is this painted dream the innocent vision of a childish artist whose jungle art was presented in court as evidence of his naïveté?

Said to be blind to the primitive character of his own work (although "primitiveness" is the essence of his persona), Rousseau was shrewder than we realize when he said that he and Picasso were the greatest painters of their era, Picasso in the Egyptian style, he in the modern. The remark is not nearly so stunning as it appears if we free ourselves from the cage of Rousseau's canaries, gulls, and boobies and recognize his subtle, highly sophisticated sense of modern art and of his place in it. For all its *fausse naïveté,* Rousseau's *Le Rêve* is a very self-conscious work, a delightful parody of Manet's *Olympia* so subtle that its apparent innocence belies its coy and pointed allusiveness. In Rousseau's painting Yadwigha impersonates Olympia on a couch drolly transported from the boudoir to the forest. The giant flowers that surround her head in the form of an imaginary corona take the place of the flowers in Olympia's hair. Rousseau's jungle is itself an exaggeration of flowers held by the servant in Manet's painting in a bouquet that had already been caricatured by Manet's contemporaries. Rousseau's domesticated lionesses ironically play the part of Manet's cat, the black snake charmer replaces the servant, and the rising snake substitutes for the phallic tail of Manet's cat. We might also note that whereas Olympia covers her pudendum with her hand, Yadwigha's body is rotated into full view of the beholder. As we behold her as voyeurs, a lioness peers at us with large, exaggerated eyes, as if to mock our own intense gaze.

By painting his parody of Manet, Rousseau playfully followed the examples of Picasso and Cézanne, who had earlier parodied Manet's *Olympia,* and of Manet himself, whose Olympia has justly been seen as a *blague,* a parody of Titian's *Venus of Urbino.* Shrewdly playing on the relations between the boudoir and the jungle, between sexual passion and social convention, Rousseau asserts his place in *le genre moderne* and he also mollifies the sexual violence of Picasso's recently painted *Les Demoiselles d'Avignon,* a picture that includes monumental figures *dans le égyptien* of the type to which Rousseau teasingly alluded in his remark to Picasso. The size of Rousseau's painting (nearly ten feet wide and thus exceptional in Rousseau's oeuvre) suggests the ambition of an artist thinking about Picasso's own monumental picture, of a painter whose

"primitiveness" is an index of artifice. If Picasso had teased Rousseau with the great banquet in the *bateau lavoir,* Rousseau was perhaps now accepting Picasso's playful compliment by coyly and delicately teasing the brutality of Picasso's brothel scene, which, like Picasso's earlier parody of *Olympia,* stands in the line of Manet's picture. That critics, still gulled by Rousseau, call him a primitive, childlike *naïf* attests the success of Rousseau's subtle and sophisticated persona. As a cunning self-forger, Rousseau can indeed be charged with *faux et usage de faux.* The "simplicity" of the Douanier, as Picasso surely knew, was as much a fiction as were "Mme. Barkowski" and "Yadwigha." The legend of Rousseau's personality, a hoax, is arguably his greatest work of art—and a work of artifice, made, not begotten!

ELEVEN

THE METAMORPHOSES OF PICASSO

I have chosen to conclude my brief but highly selective history of the artist with Picasso because he typifies in so many ways the basic themes of the history of art we have stressed from the beginning of our story through the dramatic rise of high Modernism. Picasso concludes my meditation precisely because of his self-consciousness, his sense of his own place in the history of art—as if he labored with the thought of becoming the summit of art history in the way that Michelangelo was the climax of Vasari's history of art. Whereas Michelangelo embodied the perfection of art in Vasari's teleological scheme, Picasso saw himself as the pinnacle of the history of art. At the same time, however, he had Frenhoferian doubts, doubts reflected in his sense of never achieving the absolute. Hence his perpetual sense of incompletion.

We observed at the very outset of this essay that the idea of artistic competition, which has been much discussed in scholarly commentaries, has its roots in Homer, where we find the contest between poetry and pictorial art, a rivalry powerfully echoed in the pages of Ovid and Dante both. Artistic competition is central to the history of art from Pliny's account of the contest between Apelles and Protogenes to the rivalry of Michelangelo and Leonardo, the contest between Bernini and Borromini, and the competition of Picasso with Matisse. Rivalry is one of the

deep themes of Vasari's *Lives* and the literature it influenced, one of the deep themes of Western art history and literature.

Picasso, in his thorough and systematic documentation of his own work, sought competitively to place himself at the apex of the history of art. In effect, he was his own art historian who recorded the dates and signatures of his works as his commanding contribution to art history. But let us turn back from the history of art to the biography, to the life of the artist, as he himself remembered it. One of the central events in any biography of an artist is his birth. Witness, for example, the splendid advent of Benvenuto Cellini, so welcome that he was called Benvenuto. The story of Picasso's birth is even more dramatic. We have already observed that whereas his birth certificate reveals the time of his birth to have been 11:15, Picasso claimed to have been born at midnight—the primal hour associated with the birth of Jesus. But the story, as Picasso told it, was even more elaborate.

According to Picasso's version of events, the artist was delivered stillborn and was left on a table, where he would have died if his uncle, a doctor, who was present, had not blown the smoke of his cigar into Picasso's face. Did Picasso's acute sense of death shape the way he chose to imagine his own birth? Is it merely a coincidence that Picasso's uncle was named Salvador, which means "savior," or do we find Picasso's artistic imagination at work to some extent in his fashioning of the story? Might the account in fact be a form of poetical invention, through which Picasso imagined his birth? We will never know what is fact here, what is fiction or poetical embellishment. By blowing into his mouth Picasso's "savior" dramatically inspired him, bringing him back to life from the dead with a miraculous *afflatus* or breath.

The story of Picasso's youth fits well into the history of the child prodigy. We read that when the young Picasso finished a picture by his artist father Don José, he did so with so much skill that his father renounced painting. The story, which is a legend, indeed a fantasy, recalls the story in Vasari's *Lives* according to which Verrocchio abandoned painting when he saw the prodigious accomplishment of his protégé, Leonardo. But was Picasso really a child prodigy? Although the artist later claimed that by the age of twelve he drew like Raphael, the artist's finest biographer observes that the drawings of Picasso in adolescence do not in fact reflect the work of a prodigy.

If Picasso can be seen from the perspective of Vasari, he can also be

regarded, as we have already observed, in the context of Balzac. We recall that Picasso, who illustrated an edition of "The Unknown Masterpiece," identified with both Frenhofer's grandiose ambitions and his doubts. It meant a great deal to Picasso that when he resided in the Rue des Grands Augustins, he lived in the very same street as Frenhofer, with whom he strongly identified. Picasso's identification with Balzac's painter is especially evident in his practice in old age of making variations on the great masterpieces of Velázquez, Delacroix, and Manet. The implication of his serial paintings inspired by great masterpieces is that he could create ingenious variations, but never transcend his models and soar to the absolute, to a masterpiece beyond the exemplars he emulated—no matter how ingeniously.

Whereas Frenhofer was Faust-like and diabolical, Picasso, who had more than a little Faust in him, was made in the mold of another mythic figure of modernity, Don Juan. Picasso equated making a painting, it has been said, with making love, and his life in art is often seen as a reflection of his love life, his works reflections of his countless affairs and marriages. Picasso's legendary erotic desires were unbounded. Marcelle, Fernande, Eva, Olga, Marie-Thérèse, Dora, Françoise, and Jacqueline, were among his *mille e tre,* his 1,003. In the countless portrayals of his lovers, the possessed Picasso obsessively sought to possess each and every one of them, over and over again.

As a type of Don Juan, never fulfilled, never fully satisfied, Picasso is the epitome of erotic desire, which is one of the deep themes of western art and literature that portrays the artist. We recall Apelles' love of his model, Pygmalion's desire of his statue, Raphael's love of the Fornarina, Ingres' pictures of this love affair, Frenhofer's attraction to Poussin's mistress, and Picasso's farcical etchings of Raphael's frenzied fornications with his lover.

We find a similar story of erotic desire in the history of literature, as in the graphic biography of Raphael's contemporary Pietro Aretino—an author who looms large as an author of salacious and scandalous sonnets and other erotic works. Aretino, the Lord Byron of his day, was a truly Priapian figure, whose legend is reflected in the literature of the times. According to a fiction in a poem by Cesare Caporali, which has entered into modern biography as fact, when Aretino saw in Perugia a painting of Mary Magdalene at the foot of Christ with arms extended in a gesture of grief, he placed a lute in her arms. Thus he suggested that she was

making love to her beloved Christ with her music, her serenade. A short time later, the writer turned painter beat a hasty retreat from the town in which he rendered his pictorial jest.

Although there is no known historical link between Aretino and Lord Byron, both of whom achieved fame linked with their lives in Venice, their personae are similar. When Byron famously says that he had "tooled" in a post chaise, in a hackney coach, in a gondola, against a wall, in a carriage, on a table, and under it, his words recall, strikingly, perhaps accidentally, Aretino's *Ragionamenti*, in which one of the characters in a dialogue speaks of the way a woman might stimulate a man to ride her: on a chest, a ladder, a chair, a table, or the floor. What is so intriguing here is the fact that the erotic Picasso was also similar to the author of *Don Juan* in his self-promotion and aspiration to fame, and thus similar to Aretino, who used the publication of his letters to important people in volume after volume to secure his own fame. In Picasso, as in Aretino and Byron, the lust for fame and obsessive erotic desire come together in the mythic persona of Don Juan.

In the history of art and desire, Ovid's *Metamorphoses*, which plays a principal role in the history of the artist, also looms large in the story of Picasso. Not only did Picasso illustrate an edition of the poem published by Albert Skira in 1931, he absorbed its deeper lesson: art is metamorphosis. During the same period when he illustrated *Metamorphoses*, Picasso made a monumental sculpture in iron, *Woman in the Garden*, a work which is a parody of an Ovidian work that Picasso especially admired—Bernini's *Apollo and Daphne*. Picasso transformed the Baroque master's astonishingly lifelike forms in marble into whimsical abstractions in iron, evocations of human figures, plant forms, and hair blowing in the wind.

If Bernini and his biographers saw the artist as the new Michelangelo, Picasso leads us all the way back to Ovid, who not only writes of transformations but who also sees art itself as transformation. Here we come to an important point about Ovid and the history of the artist. There are thousands, indeed, countless works of art inspired by Ovid's poem, some of them major works by such great figures as Michelangelo, Correggio, and Titian, Caravaggio, Rubens, and Velázquez, but only a few of them display the moment of metamorphosis itself, since the appearance of metamorphosis can look grotesque, as when a human being is seen becoming a frog or woodpecker.

Picasso nonetheless thought, as Ovid did, of art as metamorphosis. As Ovid was a kind of Proteus, Picasso was a kind of protean Ovid of the visual arts. Once when he painted a portrait of his lover Françoise Gilot, he came to the realization that she resembled a flower, into which form he finally metamorphosed her when he painted *La Femme Fleur.* As he later told Françoise, "You're like a growing plant and I'd been wondering how I could get across the idea that you belong to the vegetable kingdom rather than the animal." Of her metamorphosis into floral form, Picasso told her, "It represents you."

Nowhere was Picasso more deeply Ovidian than when he placed the handlebars of an old bicycle at the back of a saddle in an upright position, thereby creating a bull with horns, his *Tête de Taureau.* "A metamorphosis has taken place," he is said to have coyly remarked in an impersonal way, as if the metamorphosis had not been effected by himself but by nature. Picasso did not stop there. "Now," he added, "I would like another metamorphosis to occur in the opposite direction." He then imagined a bull's head thrown into a rubbish heap and one day discovered by a person who said, "There's something I could use as handlebars for my bicycle." This, Picasso proclaimed, would be a "double metamorphosis." Picasso would later reinforce his sense of identity with Ovid, the identity of his art as metamorphosis, when he appeared in the film made by Henri-Georges Cluzot in 1956, *Le mystère Picasso*—a film in which Picasso, while drawing on a transparent surface, makes animal and plant forms that are transformed one into the next before one's very eyes, truly a mystery enacted by a magician.

In recent years much has been made of the relation of the artist who creates to magic, of the powerful hold the idea of magic had for Picasso. But Picasso went even further with his identity in a conversation with Malraux. Speaking of style, he expostulated, "Does God have a style? He made the guitar, the harlequin, the dachshund, the cat, the owl, the dove. Like me. The elephant and the whale, fine—but the elephant and the squirrel? A real hodgepodge! He made what doesn't exist. So did I." To put a fine point on it, Picasso once told a Spanish friend, "I am god, I am god, I am god." With this identity we have come full circle beyond Frenhofer, Vasari's Leonardo, or Ovid himself all the way back to the beginning of art history when God, the first artist, made his artful creations. One wonders what Picasso would have thought had he known that even God had screwed up, as Boccaccio said, in his work before he

made Adam. One suspects he would have been amused, but one also suspects that with Frenhoferian doubts—his sense of his work never being completed, with his sense of the infinite possibilities of artistic metamorphosis—he would have identified as well with God's imperfections.

CODA

This book has been a kind of experiment, an essay in which I have attempted to suggest or flesh out just some of the basic patterns in the history of the artist in the Western tradition. There are of course many others. There are different narratives of the artist to which my own is related, stories that have yet to be told. There are quite obviously many things this essay is not, and I am reasonably confident that these lacunae will be filled by future writers.

I have practiced restraint by limiting the book to a length which I believe to be readable. Ever so many art history books are overwritten in the sense that they are so lengthy that they cannot be read easily; some would even say they are bloated, overburdened with examples or information, at the reader's expense. In this respect, they become reference works, books to be consulted, not to be read. Again, I invoke my hero, Peter Whiffle, who urged restraint and brevity. One does not need to put down on paper everything that one knows about the subject. A potentially lively subject can all too easily be deadened by excessive exegesis. Indeed, in the spirit of Whiffle and as an unabashed hedonist, I

have approached my subject in the fervent hope that the stories I have told and retold here haven given some measure of pleasure. Although there is much pathos, even suffering, in many of the narratives I have related, there is ever so much play and fun in these stories as well.

More than the accumulation of facts, hypotheses, and theories, art history as storytelling must be shaped, and I have to the best of my abilities sought to interweave various stories in such a way as to give unity to my overall narrative. If it began with the mythology of God the Creator and of the Greek god Hephaistos, it ended with Picasso's identification with God—an identification that I leave to the reader to ponder. As I have said, much is left unsaid here, and I wish to end by suggesting or hinting at just one of the countless threads or clues one might pursue from what I have fabricated.

Future scholars, for example, will want to fill in details from God's life as an artist. They will turn to Dante's *Purgatorio* 10, where we encounter the three monumental relief sculptures, illustrating stories of Mary, David, and Trajan, which exemplify the virtue of humility. They will recognize, as some have suggested, that these works, which Dante likens to the art of Polykleitos, are the work of God. Although God is eternal, we can develop a chronology of his works, and to the catalogue of his divine masterpieces worthy of the legendary Greek sculptor, we can add the *Purgatorio* reliefs.

Dante's implicit attribution to God of the monumental relief sculptures in purgatory is highly suggestive. For when we think about it, who but God Himself could possibly have built the glorious architecture of the heavenly city, the luminous New Jerusalem? With its perfect geometric proportions, great wall and gates, and its foundations radiant with gems, the divine city built by God is the archetype for so many ecclesiastical buildings, both real and imaginary, throughout the history of Western art. God's role as architect here is perhaps obscured by the mystical way he is presented in the Book of Revelation as the very temple of the city. Such mysticism should not, however, prevent us from recognizing that the invention of this great urban project belongs in the portfolio of *deus artifex,* God the supreme artificer.

In the wake of Dante and the Bible, Vasari would later find God's art even in ancient pagan myth. Writing of Pygmalion, Vasari says in the proem to the *Lives* that the mythic Greek sculptor imparted to his statue *fiato e spirito,* breath or spirit. Vasari reinterprets Ovid in the terms of the

Hebrew Bible, where God, creating Adam (the first sculpture), filled him with spirit. Since Ovid does not speak of *spiritus* in his account of Pygmalion, it is clear that Vasari's rewriting of Ovid is a biblical allegory of Pygmalion as a God-inspired artist. In the monograph that charts God's activity as an artist we can list the Vasarian Pygmalion as one of his disciples, since, like God, he creates his statue with spirit.

If we pursue the story of God's art, which necessarily includes that of his disciples, one finds in the Hebrew Bible another artist of great moment who is filled with the spirit. I speak of the builder of the grandiose tabernacle, Bezalel, who, we read in Exodus 31, was filled with "the Spirit of God" in his knowledge, skill, and workmanship. He did his magnificent work in silver, bronze, and timber with the assistance of Oholiab. Thus we have a genealogy of art that we can trace from God to his protégé, Bezalel, and to the latter's disciple. As a smith, Bezalel also occupies a place in the history of art akin to that of Hephaistos, master craftsman at the forge.

Reading in 1 Kings 5–7, we encounter still another artist in this line of descent, whose works are described in terms that recall those by Bezalel. I speak of Hiram of Tyre, who oversaw the building of the resplendent temple of Solomon, which was overlaid with gold. Solomon conscripted thirty thousand laborers, arguably the largest workforce ever employed on an architectural monument, a force probably larger in scale even than those that built the great pyramids of ancient Egypt. Hiram was also commissioned to build the great palace of Solomon. The descriptions of his works are more detailed than anything we find in Homer; they are among the most significant rhetorical accounts of architecture in the entire history of evocative or poetical writing about buildings. Although we read much about the palace decorations, abounding in images of cherubim, wheels, pomegranates, and palms, we read nothing about the character of the builder. The artist as a person, whose character or temperament matters, descends instead, as we have observed, from Hephaistos. Of course Daedalus and the platonic demiurge are also important figures in the history of the artist who need attention, but I have chosen to leave the role they play in this history to others. Suffice it to say, both are absorbed into the Judeo-Christian history of art of the kind later elaborated upon by Vasari.

The Hebraic history of the artist, we recall, was elaborated upon by Boccaccio, who wrote about God's early work when he described the

creation of the Baronci, those pre-Adamic failed efforts (long before Frenhofer's failure) in which God's work resembled the efforts of children before they learn to draw. The Baronci were so deformed that they had one eye bigger than the other, among many other deformities. Vasari surely had this passage in mind when he wrote about the work of Michelangelo's friend Bugiardini. Describing the latter's portrait of the godlike Michelangelo, whose *Creation of Adam* he had likened to God's work, Vasari says that Michelangelo objected to the fact that Bugiardini had painted one of his eyes on his temple. Whereas God would improve his art, Vasari does not suggest that Bugiardini ever got any better. He remained the second-rate hack he had always been, alas. Fortunately for Bugiardini, the hapless painter had no idea how bad an artist he was. His deficiencies were thrown into relief by their contrast with the virtues of his friend Michelangelo.

According to Vasari, the simple Calandrino-like Bugiardini once told his friend the painter Bronzino that having seen an amazingly beautiful woman, the only way he could evoke her beauty was by saying, "Just imagine that she is a picture from my hand." In his confusing his work with a living woman, there is an implicit reminder of Pygmalion, in a kind of inversion of the myth. At the same time, however, we find something of Narcissus in Bugiardini's self-regard. In any event, we have with this joke yet one more of the seemingly infinite jests that inform the mock-heroic or playful history of the artist. The reader's laughter at the expense of the bungling Bugiardini touches on one of the basic themes in our playful story of the artist: deformity intensifies our appreciation of beauty and form; beauty, or formosity, as it was once called, clarifies our recognition of deformity. Thus the deeply illuminating and foundational antithesis, one among many such dualisms, that lies at the heart of the story of the artist—which extends from God the Creator and Hephaistos to Picasso.

BIBLIOGRAPHICAL NOTE

As I hope I have made clear, my greatest debt is to the artful example of Peter Whiffle, especially to Whiffle's sense of brevity. More than any other writer on art, he has shaped my thinking. For Whiffle's thought and theory of art, I refer the reader to Carl Van Vechten's engaging biography (1922). At the same time, however, I am, as in my previous work, also heavily indebted to the opinions of Tristram Shandy. The fact that his autobiography—one of the great autobiographies of an artist in the modern period—is a work of fiction is, as the reader should know by now, beside the point. I have also written this meditation under the spell of Italo Calvino (1970), especially his delicate treatment of the ideal of "lightness."

More specifically, my book is born of my love of two wonderful classics in the history of writing on the idea of the artist: the brief and beautiful book on the legends of the artists by Ernst Kurz and Otto Kris (1969) and the equally splendid book on the biographies of artists by Margot and Rudolf Wittkower (1969). Although I have been inspired by both of these works, I depart from them by focusing on the role of poetic fantasy and imagination in anecdotes about artists. The Faber book of anecdotes edited by Edward Lucie-Smith (1997) presents a rich array of entertaining anecdotes, including many that I have discussed. Countless other tales included in this anthology still cry out for interpretation.

There are excellent recent works on the artist in the modern period by Hans Belting (2001) and Oskar Bätschmann (1997) to which the reader may also turn. The former presents an especially suggestive discussion of Balzac in relation to E. T. A. Hoffmann, to which my own account is closely related. My book overlaps the work of David Carrier (2003), and also of Catherine Soussloff (1997), among others who have written about art-historical narratives or the idea of the artist. A recent book on Bernini's biographies edited by Maarten Delbeke, Evonne Levy, and Steven Ostrow (2006) should be consulted in any account of the modern biography of the artist.

For an alternative view of biography in which the limitations of the genre are discussed, see the important work of George Kubler (1962). Despite his reservations, Kubler has very interesting things to say about biography, especially in his attention to the obsessions of artists.

The chapter on God as an artist is very much indebted to Jack Miles's brilliant biography of God (1995). My thinking about art and literature is deeply informed by the classic essay on this subject by G. E. Lessing (1984). Similarly, the appreciation of the theme of art in Ovid owes a great deal to the excellent book by Joseph Solodow (1998). Readers will be aware that although I have written about the epic poet's self-image, I have only spoken in passing about Virgil. Any discussion of Virgil and the artist will profit from the work of Brooks Otis (1964).

My understanding of Dante's construction of a literary history in which the poet himself occupies an important place depends on the very valuable commentary of John D. Sinclair on Dante's *Purgatorio* (1975). Charles Singleton's exegesis of Dante's typological allegory (1977) enriches my understanding of Dante. Graham Smith has written an erudite and charming book on the modern legend of "the stone of Dante" (2000).

For a discussion of Balzac's "The Unknown Masterpiece," see Dore Ashton's still invaluable book on the subject (1980) and Arthur Danto's fine essay on the story in Richard Howard's recent translation (2001). I have relied heavily on John Richardson's superb biography of Picasso (1991–2007). For the life and works of Douanier Rousseau, the reader may turn to R. H. Wilenski's work (1940). My thinking about modern myths depends heavily on the work of Ian Watt (1996).

Since this book is less an argument than a series of suggestions and an approach to the subject, I urge the reader to read or reread the novels and stories to which I refer in their entirety rather than search out particular quotations, which in isolation can often be misleading. Moreover, I am confident that in the history of literature countless examples sustain my approach, although they remain unknown to me. Although I include in my selected bibliography translations of the works of Homer, Virgil, Ovid, Dante, Boccaccio, Vasari, Condivi, and Balzac, which I have used extensively, the reader may well choose other translations or turn back to the original versions of their works. I do not cite the particular editions I have used for familiar stories by Poe, Hawthorne, James, Gogol, Nabokov and many, many others, since they are widely available in various editions and are very easily found. I do, however, list some works not well known to readers, for example the stories of Marcel Schwob (1957) and Jean Richepin (1888).

My abiding interest in the intersection of history and fiction has

roots in my earlier book on Walter Pater (1987), whose significance for art history is still strangely underestimated. Similarly, my concern with the history of art as play elaborates upon my book on the wit and humor in Italian Renaissance art (1978), and my attention to the fictive character of Michelangelo's biography is linked to all of my books on Vasari, above all the meditation on the Sistine ceiling as a fictive autobiography inspired by Dante (20004).

The bibliography on the history of the artist is vast. The secondary literature referred to here will provide the reader with a useful and reasonably up-to-date introduction to the subject. No bibliography on this vast topic, however, will ever be complete. One cannot read fast enough to keep up with the burgeoning scholarly commentary on the ever-enthralling history of the artist. *Faciebat*—and farewell!

SELECTED BIBLIOGRAPHY

Ashton, Dore. *A Fable of Art*. New York: Thames and Hudson, 1980.

Balzac, Honoré. *The Unknown Masterpiece; and, Gambara*. Translated by Richard Howard. New York: New York Review Books, 2001.

Barolsky, Paul. *Infinite Jest: Wit and Humor in Italian Renaissance Art*. Columbia: University of Missouri Press, 1978.

———. *Michelangelo and the Finger of God*. Athens: Georgia Museum of Art, University of Georgia, 2004.

———. *Walter Pater's Renaissance*. University Park: Pennsylvania State University Press, 1987.

Bätschmann, Oskar. *The Artist in the Modern World: The Conflict Between Market and Self-Expression*. New Haven: Yale University, 1997.

Beckford, William. *Biographical Memoirs of Extraordinary Painters*. Rutherford: Fairleigh Dickinson University Press, 1969.

Belting, Hans. *The Invisible Masterpiece*. London: Reaktion, 2001.

Boccaccio, Giovanni. *The Decameron*. Translated by Mark Musa and Peter E. Bondanella. New York: New American Library, 2002.

Calvino, Italo. *Six Memos for the Next Millennium*. New York: Vintage, 1993.

Carrier, David. *Writing About Visual Art*. New York: Allworth Press, 2003.

Condivi, Ascanio. *The Life of Michelangelo Buonarroti*. Translated by Herbert Percy Horne. Boston: Merrymount Press, 1904.

Dante Alighieri. *Purgatorio*. Translated by John D. Sinclair. New York: Oxford University Press, 1975.

Delbeke, Maarten, Evonne Anita Levy, and Steven F. Ostrow, eds. *Bernini's Biographies: Critical Essays*. University Park: Pennsylvania State University Press, 2006.

Gautier, Théophile. *My Fantoms*. Translated by Richard Holmes. New York: New York Review Books, 2008.

Homer. *The Iliad*. Translated by Robert Fitzgerald. Garden City, N.Y.: Anchor Press, 1974.

———. *The Odyssey*. Translated by Robert Fitzgerald. Garden City, N.Y.: Anchor Press, 1963.

Hoffmann, E. T. A. "Die Jesuitkirche in G." In *Sämtliche Werke: Historisch-kritische Gesamtausgabe,* edited by Carl Georg van Maassen, vol. 3. Munich: G. Müller, 1908–28.

———. *Tales of Hoffmann*. Edited by Christopher Lazare. New York: Grove Press, 1959.

Kubler, George. *The Shape of Time: Remarks on the History of Things*. New Haven: Yale University Press, 1962.

Kurz, Otto, and Kris, Ernst. *Legend, Myth, and Magic in the Image of the Artist: A Historical Experiment*. New Haven: Yale University Press, 1979.

Lessing, Gotthold Ephraim. *Laocöon: An Essay on the Limits of Painting and Poetry*. Translated by Edward Allen McCormick. Baltimore: Johns Hopkins University Press, 1984.

Lucie-Smith, Edward, ed. *The Faber Book of Art Anecdotes*. London: Faber and Faber, 1992.

Manetti, Antonio. *The Fat Woodworker*. Translated by Robert L. Martone and Valerie Martone. New York: Italica Press, 1991.

Miles, Jack. *God: A Biography.* New York: Alfred A. Knopf, 1995.

Otis, Brooks. *Virgil: A Study in Civilized Poetry.* Oxford: Clarendon Press, 1964.

Ovid. *Metamorphoses.* Translated by Rolfe Humphries. Bloomington: Indiana University Press, 1955.

Richepin, Jean. *Les morts bizarres.* Paris: C. Marpon and E. Flammarion, 1888,

Richardson, John, with Marilyn McCully. *A Life of Picasso,* 3 vols. New York: Random House, 1991–2007.

Schwob, Marcel. *Vies imaginaires.* Paris, 1957.

Singleton, Charles Southward. *Journey to Beatrice.* Baltimore: Johns Hopkins University Press, 1977.

Smith, Graham. *The Stone of Dante and Later Florentine Celebrations of the Poet.* Florence: Olschki, 2000.

Solodow, Joseph B. *The World of Ovid's Metamorphoses.* Chapel Hill: University of North Carolina Press, 1988.

Soussloff, Catherine M. *The Absolute Artist: The Historiography of a Concept.* Minneapolis: University of Minnesota Press, 1997.

Stein, Leo. *Appreciation: Painting, Poetry, and Prose.* Lincoln: University of Nebraska Press, 1996.

Van Vechten, Carl. *Peter Whiffle: His Life and Works.* New York: Alfred A. Knopf, 1922.

Vasari, Giorgio. *Lives of the Most Eminent Painters, Sculptors, and Architects.* Translated by Gaston Du C. de Vere. 3 vols. New York: H. N. Abrams, 1979.

Virgil. *The Aeneid,* Translated by Robert Fitzgerald. New York: Random House, 1983.

Watt, Ian. *Myths of Modern Individualism: Faust, Don Quixote, Don Juan, Robinson Crusoe.* Cambridge: Cambridge University Press, 1996.

Wilenski, R. H. *Modern French Painters.* New York: Reynal and Hitchcock, 1940.

Wittkower, Rudolf, and Margot Wittkower. *Born Under Saturn: The Character and Conduct of Artists.* New York: Random House, 1969.

INDEX